Autodesk 3ds Max 8

MAXScript Essentials

Autodesk 3ds Max 8
MAXScript Essentials

Routledge
Taylor & Francis Group

LONDON AND NEW YORK

First published 2006
This edition published 2013 by Focal Press

Published 2017 by Routledge
2 Park Square, Milton Park, Abingdon, Oxon OX14 4RN
605 Third Avenue, New York, NY 10017

First issued in hardback 2017

Routledge is an imprint of the Taylor & Francis Group, an informa business

Library of Congress Cataloging-in-Publication Data
Application submitted

British Library Cataloguing-in-Publication Data
A catalogue record for this book is available from the British Library.

ISBN 13: 978-1-138-40330-7 (hbk)
ISBN 13: 978-0-240-80858-1 (pbk)

Cover Design: Eric DeCicco

Contributors

Project Coordination
Caitlin Troughton

Authors
Chris Johnson
Ken Maffei
Michele Bousquet
Swami Lama

Technical Editor
Swami Lama

Print Production
Caitlin Troughton

Table of Contents

For additional reference material please visit:
www.routledge.com/9780240808581

Introduction

Welcome to the MAXScript Essentials courseware for Autodesk® 3ds Max® 8. In this book you learn some of the techniques for automating repetitive tasks using the MAXScript scripting language. You will learn how MAXScript can be used to customize 3ds Max to make you more productive.

With MAXScript, you can interact with a 3ds Max scene, and control actions automatically with script statements, or *operations*. You write the operations in text form (the *script*), and 3ds Max interprets the script and executes the operations. These text scripts can be saved and used again at any time. MAXScript encompasses almost all of the 3ds Max features.

Everyone can learn to write scripts at some level. How sophisticated your scripts eventually become depends on three factors:

- Practice—Working with MAXScript and studying scripts that other people have written to help develop your scripting capabilities.

- Basic mathematics—An understanding of basic mathematics is important. A good foundation in trigonometry is helpful.

- Programming experience—Although not necessary, some prior programming experience is very helpful.

The best resource for working with MAXScript is the *MAXScript Reference*, the online Help that ships with 3ds Max. The primary purposes of the *MAXScript Reference* are to provide a comprehensive reference to all MAXScript tools and to show you how to use them. Learning how to use the *MAXScript Reference* is an important part of learning how to script. One exercise in this edition shows you how to look up information in the online reference so you can continue to learn long after you've completed the exercises.

Once you have worked through this material, you'll be ready to look at scripts that others have written. In scripts, you might see scripting methods that you haven't seen before, or some tasks performed differently from the way you do them. In scripting, there are usually several ways to accomplish a given task, and as you write larger and more complex scripts, you will develop your own scripting style.

What's New in the Edition

This edition includes new material that falls into three categories:

* Programming concepts — Concepts that are not unique to MAXScript, but are general to understanding computer programming. In this edition, these topics have been reorganized and are covered in more detail. This edition consolidates and expands upon existing information, such as structs, functions, passing variables, and logical branches.

* Additional Material — Some fundamental concepts in MAXScript are now covered. These topics are not new to 3ds Max 8. However, including them covers important concepts. Topics included are cloning objects, MAX commands, toolbar access, picking scene nodes, picking points, and using the mousetrack command and painter interface. Also included is an article on function publishing and interfaces.

* Additions to MAXScript — Changes to MAXScript since the release of 3ds Max 6. These changes include improvements to the programming language, and additional tools and commands that are available for MAXScript. These topics are noted throughout the book. Among these additions are: a tutorial on using the MAXScript Debugger and iterating through node properties.

The chapters in this book are organized as follows:

In Chapter 1, you begin scripting with MAXScript. You create variables and assign data to them. You learn about scripts and macroscripts. You become familiar with fundamental concepts of computer programming. You finish your work in the chapter by creating a working script. This tutorial spells out all the steps you have to take in great detail.

In Chapter 2, you create custom user interface elements, such as rollouts, dialogs, and utilities.

In Chapter 3, you learn how to access important areas of the 3ds Max user interface through MAXScript.

In Chapter 4, you learn about the underlying structure of MAXScript. You learn how MAXScript classifies different objects, and how to use the MAXScript Reference to look up the commands you need.

In Chapter 5, you work with transforms in MAXScript, particularly with rotations.

In Chapter 6, you learn about a number of additional tools for MAXScript, including string usage, applying modifiers, using lights and cameras, materials, the renderer, and callbacks.

In the Appendix, you find advanced topics to round out your use of MAXScript, such as debugging techniques, using the debugger, and an introduction to function publishing and interfaces. The file input/output tool and using ActiveX controls in MAXScript rollouts are also covered.

MAXScript Basics

Learning the basics of MAXScript is similar

to learning the basics of any other

programming language. In this chapter,

you will first learn how to access MAXScript,

then proceed to common concepts of

programming languages such as syntax,

logic, and program flow. You will then finish

by learning how to code a basic script.

Objectives

After completing this chapter, you should be able to:

* Understand MAXScript basics.

* Use the MAXScript Listener and Macro Recorder.

* Create variables, work with different data types, and use functions.

* Create and modify objects.

* Create arrays and loops.

* Work with both the MAXScript Listener and MAXScript Editor.

Introduction

This chapter provides you with an introduction to MAXScript and some of its most commonly used tools. By the end of this chapter, you will be able to write simple scripts and use both the MAXScript Listener and Editor.

To perform the exercises in this book, you should be using 3ds Max in its default configuration with units set to Generic Units.

Syntax and Organization

A *script* is a series of statements written out in text form. 3ds Max interprets what is written in a script, then performs the action. If the statements are not written correctly, the script will not execute properly, or it might not run at all. The sequence and organization of script commands, called *syntax*, is very precise. Deviations from correct syntax will cause an error in the script. Usually, MAXScript will let you know if you've scripted something it doesn't understand.

It is important to keep your scripts neat and readable. To create scripts that are easy to read, you can indent with tabs and spaces to help delineate special items or functionality. 3ds Max ignores white-space characters, such as extra spaces or tabs, when processing scripts. The examples in these chapters demonstrate one way to indent. You can indent differently, but you should always be consistent.

Comments

You can use *comments* to make your script more understandable to others. Comments are blocks of text in your script, written in plain English, which explain or document what your script is doing or how it is doing it. You should use comments in all your scripts. This is especially important if a script is large or complex.

Comments are not executable script statements. You indicate that text is a comment by placing a double hyphen (--) at the beginning of the comment. You can put a comment on a new line, or on the same line as a script statement. Any text that begins with a double hyphen is ignored. You can put the double hyphens on several lines if you like. For example:

```
b = box()
b.length = 20.0
-- Here is a comment.
-- Here is a second comment, which continues
-- on this line. The next line is part of the script.
b.width = 30.0
```

The next example shows how to place a comment on the same line as a script statement:

```
b = box()   --Create a box, comment is ignored
```

Comments can span several lines if you begin with the two characters /* and end with the two characters */ (or the end of the file). Anything between these characters is considered a comment. Comments expressed in this manner are called *block comments*. For example:

```
s = sphere()
/* We'll place a large comment here
that doesn't require delimiters on
each line because now we are using
block comments.*/
s.radius = 10.0
```

This syntax can also be placed on a single line, between script text:

```
s = sphere /*large radius*/ radius:100.0
```

Multiline Statements

Script statements are executed, or *interpreted*, one line at a time. Sometimes a MAXScript statement can be quite long. You can place long statements on multiple lines by using a backslash (\) to indicate that a statement continues. The following example shows a long script statement written across several lines.

Original script command:

```
torus radius1:10 pos:[0, 0, 20] wirecolor:[225, 230, 100]
```

The same command spread over several lines:

```
torus radius1:10 \
      pos:[0, 0, 20] \
      wirecolor:[225, 230, 100]
```

The text was indented several spaces on each new line. 3ds Max ignores the spaces, but the indentations make it easier for you and other programmers to read.

Variables and Data

In any programming language, items are represented by *variables*. Variables are placeholders or containers that represent (hold) the data in a program. Every variable has a name, which you assign. Examples of variable names are a, b, x, and countNum.

The data that a variable holds is called its *value*. Setting a variable equal to a specific value is called an *assignment*. For example:

```
x = 5
```

In this example, the value 5 is assigned to the variable x. The data type is a number.

The value can be one of any of the *data types* recognized by MAXScript. The most commonly used data types are numbers, strings, and Booleans.

Number Data Types

There are two kinds of number data types: *integers* and *floats*.

* An integer is a positive or negative number with no decimal places. Examples: 0, 1, 2, -10, 345.

* A float is a positive or negative number that contains a decimal point. Examples: 0.0, 33.3, 0.75, -5.8.

If you define a variable and assign it a value of the number data type, you can perform mathematical operations with it.

For example:

```
--Assign 5.0 to x.
x = 5.0
--Assign 6.0 to y.
y = 6.0
--Multiply x and y and assign the result to z.
z = x * y
-- Now z = 30.
```

The data type is determined by whether the assignment has decimal places. For example:

```
-- Assign integer to x
x = 5
-- Assign float to x
x = 5.0
```

If you perform a mathematical operation with variables that all hold integers, the result is always an integer. If at least one of the values is a float, the result will be a float.

String Data Types

The string data type holds text. For example, you could put the text "File not found." in the variable msg, then display it to the user:

```
msg = "File not found."
```

```
messagebox msg
```

Text values must always be placed inside quotation marks to distinguish them from other data types. For example:

```
num1 = 5.0
message1 = "5.0"
```

In this case, you could perform mathematical operations on num1, but not on message1.

MAXScript provides a variety of functions for manipulating strings. These are discussed later.

Boolean Data Types

Another data type that is used extensively in MAXScript is the Boolean. A Boolean can be assigned as true, false, on, or off.

```
ready = true
ready = off
```

The value *on* is the same as the value *true*, while *off* is the same as *false*.

Booleans are used mostly for testing conditions in the script with conditional statements. You will learn more about this usage later in this chapter.

Untyped Variables

When assigning values to variables, you never have to specifically declare which data type a variable is allowed to hold. This is different from other programming languages like C, C++ or Java where each variable is declared along with its data type. Thus MAXScript is an untyped scripting language. By making the assignment, 3ds Max automatically allows you to manipulate the variable according to the rules associated with that data type. For example, you can legally write the following:

```
msg = "File not found."
messagebox msg
msg = 5.6
z = msg + 7.0
```

When assigned a string, 3ds Max lets you manipulate msg as a string. Later, when msg is assigned a number, you can manipulate msg as a number.

With this brief background, you can now start executing script statements.

The MAXScript Listener

There are several ways to execute script commands. The simplest is the MAXScript Listener, an interactive environment for executing MAXScript commands. The Listener is useful for executing individual lines of code one at a time, or for testing a line's validity.

You can access the Listener in the following ways:

- Go to MAXScript menu > MAXScript Listener
- Go to Utilities panel > MAXScript > Open Listener
- From the Mini Listener
- Press the keyboard shortcut F11

Note: Since 3ds Max 7, you can toggle the Listener open and closed with the F11 keyboard shortcut.

To access the Listener:

1. Reset 3ds Max.

2. Choose MAXScript menu > MAXScript Listener.

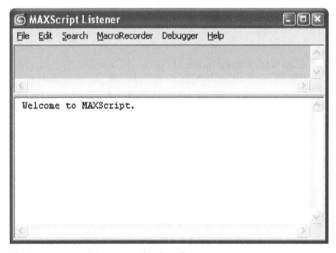

The MAXScript Listener is displayed.

3. Close the Listener.
 The Mini Listener is a pink and white area located at the lower left corner of the interface, on the status bar. If the Mini Listener is not visible, drag the vertical split bar at the end of the status panel to the right to display the Mini Listener.

4. Right-click the Mini Listener. From the menu that appears, choose Open Listener Window.
 The Listener is displayed. In this window, you will see one or two panes. If you do not see both panes, use your mouse to grab the horizontal split bar at the top of the window and pull it down. The top pane has a pink background.

If a 3ds Max operation generates a MAXScript macro command, it is displayed in the top pane. You can type individual lines of code in either the top or bottom pane. Results of the code being run are always displayed in the bottom pane.

In the exercises that follow, you will use only the bottom pane.

5. Move the horizontal split bar back up to hide the top pane.

Using the MAXScript Listener

You can use the Listener two ways.

- You can type commands in the window one at a time. You must press SHIFT+ENTER at the end of each command. When you press SHIFT+ENTER, 3ds Max executes the command and the operation is performed.

- The Listener can also be left open when you run complete scripts, and you can watch it generate return values, error messages, and macro code as your program runs.

The Listener is a text editor, so you can copy, paste, undo, and so forth. The text you type is black; the text that the Listener generates is blue for successful results, and red when errors are reported.

There are other ways to execute commands in the Listener.

- To execute a group of lines, select a group of lines, and press SHIFT+ENTER.

- On your numeric keypad, ENTER is an alternative to SHIFT+ENTER and can be used to execute commands. You may find the numeric keypad ENTER key is faster and easier to use.

If you want to clear the Listener window of all text, choose Edit menu > Clear All from the Listener menu bar. This clears the currently selected pane, either top or bottom.

To enter a simple script statement:

1. Open the MAXScript Listener.

2. In the Listener, type the following, then press SHIFT+ENTER:

    ```
    b = box()
    ```

 A box has been created in your viewports. In blue text in the Listener, you should also see $Box:Box01 @ [0.000000,0.000000, 0.000000]. This means that the command was executed successfully.

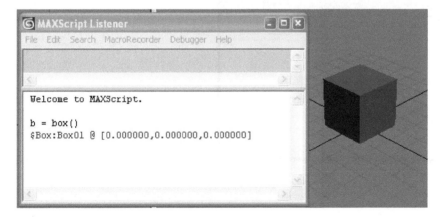

Note: For the exercises in this book, you should press SHIFT+ENTER after every command you type in the Listener, even if you are not specifically instructed to do so.

Functions

The expression box() is called a *function*. A function is an operation and is represented by a *function name*. In the example above, the function name is box. You use parentheses so that 3ds Max knows you are invoking the box function. Another term for a function is *function call*.

When you typed b = box(), you called the box function. All the information about the box you created is assigned to the variable b. You learned about number, string, and Boolean data types, but b is none of these. When you create an object, the data type is specific to that object.

Note: Function names are not case-sensitive. In other words, Box() is equivalent to box().

References

When an object is created, MAXScript generates a *reference* to the object. A reference is an identifier, handle, or token that allows you to access and work with that object and all of its properties. A reference is not simply a name for the box. Just as there are number, string, and Boolean data types, there are object data types. In the case of box(), the function creates a box in the scene, and then returns a reference to that box. You set the variable b equal to the reference, and b contains the box data type. From that point on, if you want to refer to the box, you can just use the reference b.

Class Name and Object Name

The Listener response $Box:Box01 @ [0.000000, 0.000000, 0.000000] is a literal acknowledgement that the box has been successfully created. The first part of this response, $Box:Box01, consists of two parts in the form of *ClassName:ObjectName*. The object name is the name that is assigned to the object. You see this name in the 3ds Max interface, for example, when you press the H key to display the Select Objects dialog. Classes are discussed in much more detail in Chapter 4, but for now, just think of the class as the type of object, in this case a box.

Pathnames

When an object is created, 3ds Max also assigns a *pathname* to the object. You can use pathnames to identify objects in a scene. All objects in a scene are arranged in a hierarchy that you see whenever you open Track View. Pathnames in MAXScript always begin with a dollar sign ($). In the case of the box, the pathname is $Box01. You can use pathnames to describe items in a linked hierarchy, for example, $body/right_arm/right_hand. For more information about pathnames, see the topic "Pathname Literals" in the *MAXScript Reference* Help.

Note: You find topics by name by opening the *MAXScript Reference* Help and selecting the Index tab. In the search field, you then type the name of the topic, for example Pathname Literals. The index displays the topic PathName with 3 sub-topics, one of which is 'literals.' Select the topic in the index list to display it in the main *MAXScript Reference* Help window.

To continue working with script statements:

1. Choose Edit menu > Clear All from the Listener menu bar to clear the pane.

2. In the Listener window, type the following, and press SHIFT+ENTER:
   ```
   sphere()
   ```

 You just created a sphere. You can create any 3ds Max primitive object with functions similar to box(). In fact, you can create almost any object in 3ds Max in this manner, be it primitives, lights, cameras, particle systems, space warps, and so forth.

 Next, let's see what happens if you type something illegal.

3. In the Listener window, type the following, and press SHIFT+ENTER:
   ```
   a = triangle()
   ```

 An error message is displayed in red in the Listener window.

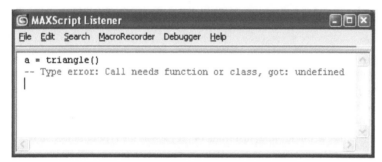

 This means that MAXScript does not know what the function triangle is. There is no triangle primitive in 3ds Max, so this command returns an error.

Pathname Performance (Advanced Topic)

Scripts can be written to operate on all the scene objects. If there are thousands and thousands of scene objects, some scripts can take longer to finish their execution, thus slowing performance. A new feature introduced in 3ds Max 7 has helped alleviate this problem.

A node named cache has been implemented. It is used by MAXScript to resolve pathnames (like $box01) to scene nodes. This optimization primarily comes into play with script controllers that use pathnames. In a scene with 5001 nodes and a script controller that references the 5001st node by name twice, the time for 10,000 evaluations of the script controller went from 147 seconds to 1.6 seconds.

A new checkbox was added to the MAXScript tab of the Preference dialog: *Use Fast Node Name Lookup.*

- When on, scene node names are cached by MAXScript, resulting in significantly faster resolution of non-wildcard pathname values (i.e., $box01) to node values.

- When off, the scene nodes are enumerated looking for a scene node name that matches the pathname.

Object Properties

Now that you can create objects, you will want to view and change their *properties*. Any object you create in 3ds Max has a set of properties, or *attributes*, that define that object.

You can use the reference variable to work with the object's properties. Earlier you created a box identified by the variable b. To access a property of box b, you add a period (.) and then the property name, as in the following examples:

```
b.length
b.width
b.height
```

You will recognize these properties as corresponding to the parameters that appear on the Create or Modify panel when you create a box directly in a viewport.

Because you created the box with the function box(), the box was created with default values for its properties. You did not specify where the box should appear in world space, what size it should be, or how many segments it should have. 3ds Max created the box with default values for all of its properties.

The Listener displays the default box position, 0.000000, 0.000000, 0.000000, but not the default length, width, and height. If you go to the Modify panel and look at the box's parameters, you see that these default values are 25.0, 25.0, and 25.0, respectively.

To find out the properties available for an object type, you can use the *showProperties* function:

```
showProperties <node>
```

You must use the showProperties function on the variable that holds the object, not the object type itself. For example, you should use:

```
b = box()
showProperties b
```

The following would return an error:

```
showProperties box
```

Note: Another way to access the `showProperties` command is the alias `show`.

You can modify an object's properties by setting the properties to new values. For example, the following line sets the box's length to 40 units:

```
box.length = 40
```

Any time you want to see a property's value, you can enter the object and its property in the Listener, and the Listener will return the property value.

To modify object properties:

1. In the Listener, type:
   ```
   s = sphere()
   ```

2. In the Listener, type the following:
   ```
   show s
   ```

 Here, you can see that radius is a property of the sphere data type.

3. To see the current value of the sphere's radius, type the following:
   ```
   s.radius
   ```

4. To change the radius, type the following:
   ```
   s.radius = 50
   ```

 You see the radius change in your viewports.

Additional Object Properties

Some properties are common to all scene objects, such as primitives, helpers, and space warps. These properties are not listed when you use showProperties, but they can be used just the same. For example, every object of this type has a .name property.

Position Property

Scene objects also have properties for the object's position. A position property has a *Point3* data type. A Point3 value is characterized by three numbers placed inside brackets, for example, [20, 45, 10]. For transforms, the three values represent the x, y, and z *components* of the object's position. In this case, x = 20, y = 45 and z = 10. For the position transform, these values correspond to the object's position on the X, Y, and Z axes, respectively.

To access the position property of the sphere you created earlier, you could use the following:

```
s.pos
```

This would return a Point3 value. To access a component of the Point3 value, you use .x, .y, or .z after the pos property. For example, to access the X position of the sphere, you would use the following:

```
s.pos.x
```

The rotation and scale transforms have similar properties. The use of these properties is discussed in Chapter 5.

To Adjust Object Position:

1. In the Listener, type:
   ```
   s.pos = [10, 15, 20]
   ```

The sphere moves to its new position. Notice that the text in the Listener confirms the coordinates in the bracket notation.

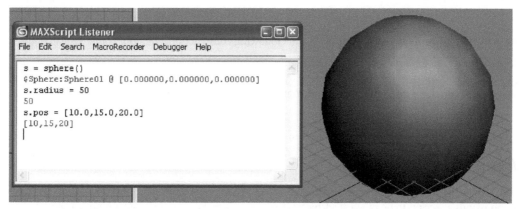

If you want to change the position on the X axis, you might be tempted to type s.x = 50.0. However, .x is not a property of an object, rather .pos.x is.

2. In the Listener, type:

```
s.pos.x = 50
```

This moves the sphere to the position [50,15,20].

Color Properties

You can set the color of an object's wireframe using the .wirecolor property. Like the position property, colors in MAXScript can be represented as a Point3 data type. The numbers in the triplet represent the R, G, and B color values, respectively. Each value can be an integer between 0 and 255, corresponding to the R, G, and B values on a color selector.

* White is [255, 255, 255].

* Black is [0, 0, 0].

* Pure red is [255, 0, 0].

* Bright yellow is [255, 255, 0].

* Medium blue is [0,50,150].

You can assign a new wireframe color to an object with the .wireframe property. For example:

```
s.wirecolor = [40,120,200]
```

You can modify the colors at any time by accessing the .r, .g, and .b sub-properties. For example:

```
s.wirecolor.r = 156
```

You can also put the color in a variable using the color function, then assign it to an object's wirecolor:

```
newColor = color 40 120 200
s.wirecolor = newColor
```

To specify the alpha component for a color, use the following construction, with four colors instead of three:

```
newColor = color 20 120 200 128
```

The fourth parameter is the alpha component. You can access it with the property .a:

```
alphaNum = newColor.a
```

Macro Recorder

The Macro Recorder captures your actions and generates MAXScript commands for those actions. You can save the commands as scripts to be called at a later time, or even place them on the toolbar for quick access.

You can see the Macro Recorder output in the Listener window, in the top (pink) pane. If you can see only one pane in your Listener, use your mouse to grab the horizontal split bar at the top of the window and pull it down to display both panes. The top pane displays the commands as they are being recorded.

Most actions in 3ds Max generate Macro Recorder output. Many buttons on the menu bar, toolbars, status bar, Create panel, and Modify panel generate Macro Recorder output.

One of the more interesting features of the Macro Recorder is the ability to place a pointer to a script on a toolbar. In the following exercise, you generate a simple script using the Macro Recorder and place a reference to it on the toolbar as a macro button.

To use the Macro Recorder:

1. Reset 3ds Max.

2. Open the MAXScript menu and verify that Macro Recorder is turned on (checked). If not, choose Macro Recorder to turn it on.

3. Open the Listener window, and make sure the pink macro pane is displayed. If it is not, pull down the horizontal bar at the top of the Listener to reveal the macro pane.

Note: You do not have to have the Listener window open to generate Macro Recorder output. You will work with it open in this exercise for demonstration purposes.

4. On the Create panel, click Sphere.
 Text is generated in the macro pane. The text is the MAXScript command that creates the sphere along with its attributes. You have not created an actual object in the scene, rather you have generated a sphere object internal to 3ds Max.

You see that the script contains a radius of 0, and other default values for properties/parameters.

5. In any viewport, click and drag to generate a sphere node.
 As you drag, watch the radius value in the macro pane to see it increasing.

6. From the Listener, choose MAXScript menu > MacroRecoder to turn off the Macro Recorder.

7. In the Listener window, select all the text within the macro pane.

Note: If Auto Backup is on, you may see Auto Backup commands generated. If you do not want these commands, turn off Auto Backup with Customize menu > Preferences > Files, or select and delete those commands from the macro pane.

8. Position your mouse over the text in the macro pane and press the left mouse button. Drag up to the main toolbar.

 As the cursor reaches the toolbar, you will see a small plus sign at the bottom of the cursor, indicating that you can drop the MacroScript there.

 A small script icon appears on the toolbar. This icon represents the script recorded by the Macro Recorder.

9. Delete the sphere you just created, and then click the script icon.
 The script runs, and another sphere is created.

10. To edit the script, right-click the icon in the toolbar, and choose Edit Macro Script from the right-click menu.
 The MAXScript Editor window is displayed where you can make changes to the script (now called a MacroScript). The code in this window can be saved as a maxscript (.ms) or MacroScript (.mcr) file.

For more information about customizing the toolbar, editing the button appearance, and MacroScripts in general, see the topic "Defining Macro Scripts" in the *MAXScript Reference* Help.

The Macro Recorder can also be turned on and off from the MacroRecorder menu in the Listener window. Under this menu, you will also see a variety of other options to choose from. The first gives a choice between explicit scene object names and selection-relative scene object names. With these options, the Macro Recorder generates commands for either the selected explicit scene objects or the selection-relative scene objects.

To use explicit and selection-relative scene object names:

1. Reset 3ds Max.

2. Create a sphere in any viewport.

3. In the Listener, choose MacroRecorder menu > Enable to turn on the Macro Recorder.

4. Choose MacroRecorder menu > Explicit Scene Object Names.

5. Delete the sphere you created, and look at the code that the Macro Recorder generates. It should be:
   ```
   select $sphere01
   delete $sphere01
   ```

6. Reset 3ds Max, and repeat the steps above one more time, with one exception. This time, choose MacroRecorder menu > Selection-Relative Scene Object Names rather than MacroRecorder menu > Explicit Scene Object Names.

7. Now, when you record your steps, you see:
   ```
   select $sphere01
   delete $
   ```

Although you deleted a specific object, the Macro Recorder has not indicated it. Instead, the explicit reference to the sphere has been replaced by a dollar sign ($). The single $ signifies the currently selected object or objects.

Using Transform Operations

The next choice in the MacroRecorder menu is Absolute Transform Assignments versus Relative Transform Operations.

1. Reset 3ds Max.

2. Create a sphere by any means.

3. From the Listener, choose MacroRecorder menu > Absolute Transform Assignments. Choose Explicit Scene Object Names.

4. Select the sphere and move it.
 The generated code will look something like this:

   ```
   $sphere01.pos = [20.222, 10.011, 4.75]
   ```

 This sets the position of the sphere to the coordinates specified, regardless of where the sphere was before the line of code was executed.

5. From the Listener menu, choose MacroRecorder > Relative Transform Operations, and then move the sphere. You will generate code like this:

   ```
   move $sphere01 [5.44, 0.0, 0,0]
   ```

 This code moves the sphere 5.44 units relative to wherever it was before the line was executed.

Functions

Functions are vitally important in MAXScript as in any programming language. A function is an instruction, or set of instructions that you tell the computer to perform. Many functions are built into the MAXScript scripting language, and later on you will learn how to create your own functions.

Function Parameters and Signature

You have learned that one way you can use a function is with closed parentheses after the function name, for example, box () . With functions, you can also pass values after the function name that the function can use to perform a task. For example, the color function is followed by three or four values that define the color. For example:

myRedColor = color 55 10 255

When you do this, you provide *arguments* to the function. If you add closed parentheses after the function name, you are calling a function without passing any arguments. When you provide arguments, you omit the parentheses.

For some functions, you must always provide one or more arguments (the *argument list*) to make the function work. For example, the color function requires three or four arguments. For many functions, the arguments are optional.

You can provide arguments in one of three ways:

- In a specific order.

- In any order, but proceeded by a *keyword* to indicate which argument the value is applied to.

- In a specific order with extra optional keywords that come after the ordered arguments. For example, a function could have two required arguments, which must come before the three optional arguments. These optional keywords can be in any order. This function type is the most complicated of the three.

The number of arguments along with their specific types and the order in which they are arranged is called a function signature.

The function signature of the color constructor is the function name, followed by three integers.

```
color <integer> <integer> <integer>
```

Function Parameters in Specific Order

The most important data type in a 3D program is a point in three dimensional space. In mathematics this point is usually described as a vector, which has three components: the X axis component, the Y axis component, and the Z axis component. In 3ds Max, this vector is described as a Point3 data type. This Point3 data type has three properties: a `.x` property to hold the X axis component, a `.y` property to hold the Y axis component, and a `.z` property to hold the Z axis component. In computer graphics as well as in mathematics, vectors and points are always described in the specific order: x, y, z. It is the same with the MAXScript Point3 data type. To create a Point3 data type, you type the following:

1. In the Listener, type the following and press SHIFT+ENTER:
   ```
   myPoint = point3 15 33 7
   ```

 The Listener responds with the following:
   ```
   [15,33,7]
   ```

 Hint: Another simpler way to create a Point3 variable is as follows:
   ```
   myPoint = [15,33,7]
   ```

This created a Point3 object with the `.x` property equal to 15.0, the `.y` property equal to 33.0 and the `.z` property equal to 7.0. The Listener printed these numbers to look like integers; however, internally 3ds Max stores all positional properties as decimal numbers, otherwise called floating point numbers or floats.

Function Parameters in Any Order

The box function has several optional parameters that can be presented in any order, and that require keywords. Let's see how they work.

1. Reset 3ds Max.

2. In the Listener, type the following and press SHIFT+ENTER:
   ```
   b1 = box length:20.5 width:15.0 height:5.6
   ```

3. Move the box aside.

4. Type the following and press SHIFT+ENTER:
```
b2 = box height:5.6 length:20.5 width:15.0
```

This creates a second box with the same property values as the first. Each statement contains three arguments. The results are the same even though the order of the arguments is different. The keyword tells the function whether the value pertains to the box's length, width, or height.

Function Parameters in Specific Order with Optional Keyword Parameters

MAXScript has a function to load a 3ds Max file. This is the `LoadMaxFile` function. This function signature consists of:

• A required string filename value that must come immediately after the function name.

• Two more optional arguments that must be accompanied by keywords.

If the function is successful it will return a true Boolean value; if it fails (for instance the file doesn't exist), the function will return a false Boolean value.

Below are four different but valid ways to call this function:

```
result = LoadMaxFile "c:/scenes/trucks.max"
result = LoadMaxFile "c:/scenes/trucks.max" useFileUnits:true
result = LoadMaxFile "c:/scenes/trucks.max" quiet:true useFileUnits:false
result = LoadMaxFile "c:/scenes/trucks.max" useFileUnits:false quiet:true
```

Notice the last two examples. Both pass in identical arguments to the function, only the order of the two optional arguments are switched.

Other Examples

Here are examples of the different ways you can call functions, depending upon how they are defined.

• `FunctionName()` —The function does not have any arguments. Either the function doesn't need any, or this is a function that can use default values. For example, sphere() creates a sphere with default values.

• `FunctionName value1 value2` —The function has arguments; you don't use the parentheses. This function takes one or more arguments, and you know from the function definition what order they should be in, so the values are passed in the correct order. For example, subtract var1 var2 subtracts the variable var2 from var1.

• `FunctionName keyword1:value1 keyword2:value2`—The function has arguments in arbitrary order; you use keywords to identify what they apply to. To specify values this way, use a colon (:). For example, box height:10 length:20 creates a box with a height of 10 and length of 20.

• `FunctionName value1 keyword2:value2`—The function is a mixed case of the previous examples. You don't see this combination very often. The first argument is required. The second argument is optional, and the default value is used if you do not specify the argument.

Creating Your Own Functions

MAXScript contains many powerful built-in functions. However, scripting normally entails going beyond the functions MAXScript provides. Creating your own functions is useful in several ways. You can continually call your function from a script rather than explicitly writing out all its statements each time you need them. You can also make functions that you write available to other scripters. Function parameters were discussed in the previous section. You should review that material, if necessary.

In order to create a function, you need to define what it does. This is done in the *function definition*.

The function definition contains the word `function` or `fn`, followed by the name you want to give your function, followed by the list of parameters (if the function requires any), and then an equal sign (=). The equal sign signifies the start of the *body* of the function. The body is the routine, or series of statements, that the function executes. The body of the function is usually wrapped in parentheses if it is large.

Creating a Simple Function

Here you create a function that changes the wireframe color of a geometric object to red.

To create a simple function:

1. Open a new MAXScript Editor window by doing one of the following:

 * In 3ds Max, choose MAXScript menu > New Script.

 * In the Listener, choose File menu > New Script.

2. Type the following:
    ```
    --Function definition "ChangeToRed"
    fn ChangeToRed obj =
    (
      if superclassof obj == geometryClass then
      (
        obj.wirecolor = [255, 0, 0]
      )
    )
    ```

3. Press CTRL+E to run the script.
 The Listener responds with `ChangeToRed()` to indicate that the function was successfully loaded. If there are objects in your scene, nothing will happen to them. The function is loaded, waiting to be called, but has not yet been called.

 In this function definition, `obj` represents the parameter that will be passed to the function when it is called. You will see this in the next step.

 If you place this definition at the beginning of a script, then 3ds Max will know what `ChangeToRed` means any time you want to use it.

4. In a new MAXScript Editor, type the following:

```
for i = 1 to 3 do
(
    sphere pos:[random -80 80, random -80 80, random -80 80]
    cone pos:[random -80 80, random -80 80, random -80 80]
    cylinder pos:[random -80 80, random -80 80, random -80 80]
)
```

You now have several objects in your scene.

5. Use the ChangeToRed function in a loop. In a new MAXScript Editor window, type:

```
for obj in objects do
(
    ChangeToRed obj
)
```

All the objects change color. (You might need to click in a viewport to activate it to see the objects change color).

The array `objects` is an array of all objects in the scene. This array is created automatically by 3ds Max. This loop goes through all the objects in the scene, and runs the function `ChangeToRed` on each one.

Function Return Values

A function returns a value after it executes. That value will be the result of the last statement executed in the function. Next, you learn how to return a value from a function.

To return a value from a function:

1. In a new MAXScript Editor window, type the following and run it:

```
function addnums x y =
(
  z = (x + y)
)
```

2. In the Listener, type:

```
a = addnums 1 3
```

The addnums function returns the sum.

Now, you will change the function by modifying the name of the function, and the last (and in this case, the only) statement.

3. Type the following in the MAXScript Editor and run it:

```
function addnums2 x y =
(
  x + y
)
```

The statement x + y still evaluates to the sum of x + y even though no assignment was made in the function body.

4. In the MAXScript Editor, type the following and press ENTER:

```
b = addnums2 4 9
```

You get the answer you expect.

Function Parameter Types

There are two types of function parameter arrangements, *positional* parameters and *keyword* parameters. In the previous section, you saw examples of how to call functions. In this section, you learn how to define functions that use these types of parameter arrangements.

Positional Parameters

You use positional parameters when the function call requires the arguments to be specified. In general, the order of arguments is important, although your particular function may not care. (The addnums function above works despite the order of the two numbers. If the function subtracted two numbers instead, then the order would matter).

Keyword Parameters

You have been using keyword parameters throughout this chapter in all of the object constructors. Now you will see how to define your own functions using keyword parameters. The function definition is the same, but you explicitly declare the keyword parameters.

Defining Functions with Keyword Parameters:

1. In a new MAXScript Editor window, type the following:

```
function putUpMessage text1:"File Not found." =
(
  messageBox text1 title: "Warning" beep: true
)
```

You created a function that takes one variable; however, you added a colon (:) and a default value to the definition.

2. Evaluate the script (press CTRL+E) to load the function.

3. In the Listener, type:

```
s = sphere()
msg1 = "The sphere's radius is "
```

```
    msg2 = s.radius as string
    putUpMessage text1:(msg1 + msg2)
```

The message is displayed.

You can also mix positional parameters with keyword parameters. The function definition in this case must use the positional parameters first, followed by the keyword parameters:

```
function mysphere rad position:[0, 0, 0] =
(
   sphere radius:rad pos:position
)
```

All this function does is place a "wrapper" around the standard 3ds Max sphere() function. The function mysphere requires the rad parameter, but the position parameter is optional.

Passing Arguments by Value

An important concept to learn about passing arguments to functions is that of passing an argument to a function by value. This means that a *copy* of the argument is actually passed to the body of the function, and the original value that exists outside the function is *unaffected* by the copied argument variable that exists inside the function body. This copy can be modified in any way inside the function, without affecting the original value that was passed to the function. The following exercise illustrates this concept.

To pass an argument to a function by value:

1. In a new MAXScript Editor window, type and evaluate:
```
    m = 30.4
    n = 23.0
    function addnums2 x y =
    (
      x = 10.0
      x + y
    )
    addnums2 m n
```

2. The Listener returns a value of 33.0.

3. Type m in the Listener and evaluate.

4. The result for the value of m is 30.4.
 Notice the sum of the numbers is 33.0. When the functions get the arguments, it assigns a copy of the values into the variables x and y. In this case, the variable x gets a *copy* of the value of m, which is 30.4, and the variable y gets a *copy* of the value of n which is 23.0. Once the function is executed, m is unaffected by anything done to the value of x, since x is only a copy of m. So when x is assigned the value of 10.0, the variable m is unaffected.

You will notice that this function can only return one value, i.e. the sum of the two numbers. From the outside, you can only get one variable out of a function when you pass arguments by value. For many situations this is fine. The LoadMaxFile function used earlier returned only one Boolean value that indicated success or failure.

In some situations, however, you want to obtain multiple return values. You will learn how to do this in the next section.

Passing Arguments by Reference

Passing arguments by reference is used to pass multiple argument values into a function, perform work on them, and get them out again. This means that the memory address of the argument is passed to the body of the function, and that the original value that exists outside the function is *affected* by the argument variable that exists inside the function body. Thus changing the argument inside the function will also change the variable outside the function.

To pass by reference, you must do the following:

- Pass the function the address of the argument, not its value. This is done by adding the '&' symbol to the beginning of the variable. For instance:

    ```
    addnums2 &m n
    ```

- Add another '&' symbol to the beginning of the corresponding parameter in the function signature. For instance:

    ```
    function addnums2 &x y =
    ```

The '&' symbol is called the *reference operator* in MAXScript (as well in other programming languages). The reference operator denotes the address of a variable. Further discussions on addresses and the related topics of pointers are beyond the scope of this book.

Note: The following exercise is identical to the pass by value exercise except for the modification to pass by reference.

To pass an argument to a function by reference:

1. Open a new MAXScript Editor window with MAXScript menu > New Script.

2. Type the following into the editor, and execute it with CTRL+E:

    ```
    m = 30.4
    n = 23.0
    function addnums2 &x y =
    (
      x = 10.0
      x + y
    )
    addnums2 &m n
    ```

3. The Listener returns a value of 33.0.

4. Type m in the Listener and evaluate.

5. The result is 10.0.
 Notice the returned value of the function is still 33.0 like last time, but the value for m is now 10.0 instead of 30.4. The value of m was changed inside the function.

 Note: When you create a function, you can define any of the parameters as "by reference." For example, in the addnums2 function both parameters could have been "by reference" rather than one (&x).

Exceptions to Pass by Value (Advanced Topic)

There is an exception to the pass by value rule in MAXScript functions. When a variable that has sub-properties is passed to a function, the pointer or variable of the object is passed by value. However, the sub-properties of the object are passed by reference. The following exercise illustrates this.

To demonstrate exceptions to pass by value:

1. Reset 3ds Max.

2. Open a new MAXScript Editor window with MAXScript menu > New Script.

3. Type the following into the Editor, and execute it with CTRL+E:

```
myPoint = point3 10 20 30

function modifyPoints pnt =
(
  pnt.x = 3
  pnt = point3 7 14 21
)
modifyPoints myPoint
```

4. The Listener returns a point3 literal of [7, 14, 21], which is the new point3 value created in the function.

5. Type myPoint in the Listener and evaluate.

6. The result is [3,20,30].
As you can see the value of myPoint was *unaffected* by the assignment of pnt inside the function, however the value of the .x property of myPoint was *affected* by the assignment of pnt.x inside the function.

The above exercises can be found in the script *pass_by_value_reference.ms* on the companion website.

Returning Values from Functions

When a function finishes a set of instructions a value is returned. If there is an variable assignment in the calling line of code, the value is assigned to the variable. Functions can be roughly categorized into two different types: those that return a value, and those that don't. Functions that return a value usually do so by returning a value at the end of the function. Functions that don't return a value are called void functions, because you don't expect

any information to be returned from the function when it finishes executing. The other way to return a value from a function is to pass in a value by reference, which was covered earlier.

Perhaps the easiest way to return a value from a function is to simply place it on the last line of the function body. For example:

```
function foo =
(
  g = 4
  h = 5
  g*h
)
```

Then if you type i = foo(), the Listener will return 20. This also means i gets the value of 20.

Leaving out the keyword 'return' can confuse others about what your function is returning. It is better to write:

```
function foo =
(
  g = 4
  h = 5
  return g*h
)
```

This example explicitly shows where the function returns the value of 20. Why then present the first example? First, because you are certain to see much old code written this way, and second, because it is faster. Using the return keyword is a little slower to use. If the function is called many times, omit the keyword return, thereby reducing execution time.

Local and Global Variables

The terms *local* and *global* refer to the *scope* of the variable. Scope determines where in the MAXScript code a variable can be accessed. After a variable is declared as *global*, the variable can be used anywhere in any script at any time. A *local* variable can be used only within the block in which it is defined, or in blocks nested inside the block in which it is defined. A *code block* is any portion of code enclosed in parentheses or brackets.

So it is correct to say a local variable, declared in a nested block in the middle of a script, is *'out of scope'* or cannot be accessed at the end of a script.

The variables that you have created so far are valid until you exit 3ds Max. When you type x = 5.0 in the MAXScript Editor or Listener, you declare a global variable called x. A global variable retains its value until you exit 3ds Max, even if you close the Listener or Editor, or reset the program.

Defining Variables

3ds Max does not look ahead when it processes your scripts. The following exercise shows that you cannot use a variable until it is defined.

To properly define a variable:

1. Reset 3ds Max.

2. Open a new MAXScript Editor window with MAXScript menu > New Script.

3. Type the following into the Editor, and execute it with CTRL+E:
   ```
   rad = 10
   sphere radius:rad
   cylinder radius:rad
   ```

 No errors are generated. The variables are declared in the correct order.

4. In this step, you will create code that declares variables in the wrong order. Replace the existing script with this text, and execute it:
   ```
   cylinder radius:new_rad
   new_rad = 10.0
   ```

 The variable new_rad does not exist until it is first defined. Here, an error was generated because the script doesn't know what new_rad is in the first line of code.

5. Execute the script again.
 This time, you don't get an error. The first line generated an error the first time the script was run, but the second line was executed anyway, and the new_rad variable was created and assigned the value of 10. The variable new_rad became available from that point on, and was a valid variable by the time you ran the script for the second time.

 This is a common scripting problem that many new scripters encounter. When you encounter errors, reexamine your script to ensure that variables are declared in the proper order.

Global Variables

A global variable is any variable declared or defined outside all blocks of code. In the previous exercise, all the variables you declared were global variables, because they were not declared inside a for loop, while loop, function statement, or other block.

Note: Loop structures are discussed later in this chapter.

You can also declare a global variable by explicitly declaring it. These are all valid ways to declare a global variable:
```
global a
global a = 2
a = 2 -- when defined in an area of the script not inside a block
```

In general, you should avoid using global variables. It is possible for you to declare in your script a global variable that is also used elsewhere in 3ds Max, and if you overwrite its value, other scripts or plug-ins might not work as expected. The short examples in this book use global variables, but the variables a, b, x, y, and other single-letter variables are unlikely to interfere with global variables in other scripts that you are running. However, for any

script you intend to use frequently or distribute to others, you should use local variables as much as possible to avoid conflicts.

Local Variables

The variables you declared (defined) in the previous exercise are global because they are not inside a block. You can declare a variable as local to limit its scope. Local variables are only valid within the block of code in which they are defined, or in nested blocks within that block. A block is sometimes referred to as a *scope context*. You studied examples of blocks of code when you worked with loops and conditional statements.

You can declare a local variable in a number of ways. For example, the following are all valid ways to declare the variable b as local (remember, they must be inside a block):

```
( local b )
( local b = 2 )
( b = 2 -- when defined within a block )
```

If a variable is declared as local when it is outside ALL blocks, the compiler will throw an error saying "No local declarations at top level:"

Once a local variable is declared, you can use it in the same block in which it is defined, and in any nested blocks beneath it. For example, consider the following script:

```
s = sphere()
for i = 1 to 5 do
(
    a = instance s pos:[i*50, 0, 0]
    if (s.pos.x > 150) then
    (
        s.pos.y = 50
        c = (30 + i)
    )
    b = c -- The variable c is undefined in this block.
    b = copy a -- The variable a is defined within this same block,
      -- so it is valid.
)
```

There are two blocks here, one embedded within another. The variable c is declared within the if-then block, so it is valid only within the parentheses that surround this block. The variable a is declared within the for loop block, so it can be used within the for loop block, and within the if-then block.

If you run this script and include the line print c after the line b = c, you will see that the value "undefined" is printed for c.

You can reuse local variables used in one block within another block in the script. In fact, many programmers like to use the variables i, j, and k to define loops whenever possible. This means these variables are used over and over again within a single program.

Conditional Statements

A conditional statement is easy to understand conceptually. It gives you a way of controlling program execution. There are several ways to implement conditional statements.

If-Then Statements

The first type of conditional statement is the *if-then* statement.

```
if s.pos.x == 10 then s.radius = 40
```

In the above example, the statement changes the sphere's radius to 40 only if the value of its x position is 10. The double equal sign (= =) indicates a logical comparison, whereas the single equal sign (=) signifies assignment.

The words if and then must appear in the conditional statement. If you forget to include them, MAXScript will return an error.

Logical Operators: Not, And, Or

You can assign multiple conditions to an if-then condition. To do this you use *logical operators*. The three logical operators you can use are *not*, *and*, and *or*. Here are some examples:

```
if (not s.radius == 10) then messagebox "Radius is not 10."
if (x == 5 and y == 6) then z = 0
if (x == 5 or y == 6) then z = 0
```

If you find that the not operator is awkward, there is another way you can test a "not equal to" condition. The syntax for "not equal to" is !=.

```
if s.radius != 10 then messagebox "Radius is not 10."
```

When testing multiple conditions, you generally need parentheses to group your conditions logically, especially when the if clause becomes complex. Expressions within parentheses are always evaluated first. In the following example, each statement produces different results:

```
if (x == 5 or y == 6) and z == 10 then w = 0
if x == 5 or (y == 6 and z == 10) then w = 0
```

If you leave the parentheses out of a complex clause completely, then you can determine how the clause will behave by considering the logical operator precedence rules. The rules specify that certain operators take precedence over others and are evaluated first. "Not" has highest precedence and is evaluated first. "And" and "or" are evaluated left to right, with "and" taking precedence.

```
x and y or z
```

According to the rules of precedence, having no parentheses is equivalent in the following example:

```
(x and y) or z
```

The same is true in this example:

```
not x or y and z
```

It is equivalent to:

```
(not x) or (y and z)
```

Recall that MAXScript uses line feeds to distinguish new script statements. You use the backslash (\) to indicate statement continuance. When using an if-then construct, this condition is relaxed—the if and then portions of the statement can be on separate lines. Since 3ds Max expects a then clause, you can legitimately place it on the next line.

```
b = box()
if b.height != 10.0
   then b.length = 40.0
```

The previous construction will yield the same result as the following:

```
b = box()
if b.height != 10.0 then
   b.length = 40.0
```

The b.length statement is indented to indicate that it is part of the if-then condition. This is for readability only.

If-Then-Else Statements

If you type the previous example in the Listener, nothing happens. To understand why, you need to know the if-then-else control structure. You can extend the simple if-then construct to include else. The if, then, and else portions of the statement can all be on separate lines. For example:

```
if b.pos == 10
   then b.height = 40
   else b.height = 80
```

The else clause gives you an alternative action when the condition inside the if clause is not met. Remember that the Listener executes your statements line by line as you type. Next, see how the Listener responds to if-then-else.

To use If-Then-Else in the Listener:

1. In the Listener, type the following:
```
b = box()
```

2. Type the following:
```
if b.pos.x == 0 then b.height = 40
```

The object has not changed; the Listener has not responded with any text and has not generated any error messages.

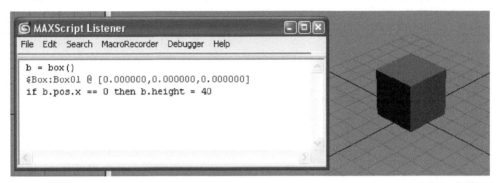

The Listener does not know if you will be typing an else statement next, and it needs to be aware of the complete if-then-else structure before MAXScript can act. If the next line you type contains an else clause, then the Listener knows what to do. If the next line does not contain an else clause, then the Listener assumes there won't be one.

3. Type the following in the Listener:
```
else b.height = 10.0
```

Now the Listener responds, and the box's height changes to 40.0.

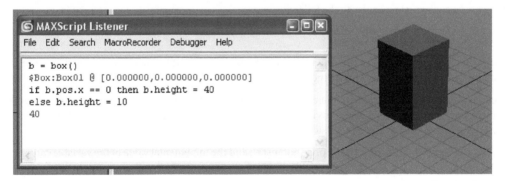

4. Type the following and press SHIFT+ENTER after each line:
```
if b.pos.x == 0 then b.height = 40
messagebox "Done"
```

Even though there is no else clause, the Listener knows you are finished, and the message box is displayed.

Note: If you are executing scripts from a script editor window using Evaluate All, then this If-Then-Else procedure does not apply since the whole script will simply execute.

List of Operators

There are other operators you can use besides == and ! =. Here is a complete list.

Operators:	Description:
==	Equal to
!=	Not equal to
>	Greater than
>=	Greater than or equal to
<	Less than
<=	Less than or equal to

Loop Structures

A loop is a repetitive, or iterative, operation. It indicates the execution of a group of statements again and again, stopping at some point. For example, if you had 20 spheres in your scene and you wanted to change their properties, then you could do so inside a loop structure that executes 20 times, once for each sphere. This is more efficient than typing the statement 20 separate times for each sphere. The two loop structures discussed here are the *for loop* and the *while loop*.

For Loop

A *for loop* uses a construction similar to the following:

```
for i = 1 to 5 do [an action]
```

This assigns the value 1 to the *index* variable i. An index variable is a variable that changes (it can increase or decrease) for each repetition of a for loop. Index variables are also referred to as loop index variables.

An index variable must be declared in the same line as the for loop. In this case, the for loop performs the action, then increments the value of i to 2, performs the action, and so forth. This continues until i reaches 5. The loop performs the action with i equal to 5, then stops.

You can use any variable to construct a for loop (not just i), and the incremental value of the variable can start or end with any integer. You can also use the variable within the action itself. You will see an example of this in the following exercise.

To create a simple for loop:

1. Reset 3ds Max.

2. In the Listener, type the following:
   ```
   for i = 1 to 5 do sphere pos:[i*50,0,0]
   ```

 This creates five spheres, each with a different position on the X axis. The x component of the position is set to i*50 for each new sphere.

 You can now put the spheres in an array, and do an operation on all of them.

 Note: Arrays are included in the next procedure for completeness. For information on arrays, see the "Collections" section of this chapter.

To use arrays with loops:

1. In the Listener, type the following, and press ENTER after each line:
   ```
   intArray = #()
   for i = 1 to 5 do append intArray (i*5)
   ```

 This appends the numbers 5, 10, 15, 20, and 25 to the array intArray.

2. Type the following, and press ENTER:
   ```
   for i in intArray do sphere pos:[i,i*2,i*3]
   ```

 This creates a series of five spheres with positions based on the intArray values.

In the for loop you just used, the equal sign was replaced with the word in. This is a common construction when performing operations over an array.

Loops with Multiple Statements

In order to execute a for loop with multiple statements in the loop body, the statements must be in parentheses, and the word "do" must appear before the parentheses. Just as in the if-then-else examples, if you are using the Listener, 3ds Max will not execute anything until the statements are complete. In the case of a loop, you must type the final parenthesis before anything happens. The statements inside the parentheses are indented for organization and readability. A good rule of thumb is to indent one tab for each new grouping of parentheses.

If the body of the for loop contains only one statement, then the parentheses are not required. The following two examples are equivalent:

```
for i = 1 to 5 do
(
  s = sphere()
)

for i = 1 to 5 do
  s = sphere()
```

Now that you are writing multiline scripts, you should start using the MAXScript Editor. This window allows you to enter numerous commands, then execute them all at once.

To create loops with multiple statements:

1. Reset 3ds Max.

2. Choose MAXScript menu > New Script to open the MAXScript Editor.

3. In the MAXScript Editor, type:
```
for i = 1 to 5 do
(
    a = sphere pos:[i*50,0,0]
    messagebox a.name
)
```

4. Press CTRL+E to evaluate and run the script. You will see a message box after each iteration displaying the name of each sphere as it is created.
 When you are asked to execute or run the script in the MAXScript Editor, you can press CTRL+E to run it, or choose File > Evaluate All from the MAXScript Editor menu bar. You will use the MAXScript Editor for many of the exercises in this book.

To combine loops and conditional statements:

1. Reset 3ds Max, or delete all objects from the scene.

2. From the MAXScript Editor menu bar, choose File > New to open a new editor with no text.

3. Type the following:
```
cylArray = #()
for i = -3 to 3 do
(
    if i != 0 then
    (
        a = cylinder height:50 pos:[i*40,0,0]
        append cylArray a
    )
    else
    (
        a = cone height:50 pos:[i*40,0,0]
        messagebox a.name
    )
)
```

4. Press CTRL+E, or choose File>Evaluate All from the Editor window menu bar.

You placed a conditional statement inside the for loop. As each cylinder is created, you check the value of i. If i is equal to 0, then you create a cone instead, and display the object name in a message box.

Note: The index i starts at -3 and ends at 3. A loop index does not have to be a positive number, and it does not have to start at 1.

Notice the use of the parentheses in the above example. The statements of the if...then...else structure are contained in parentheses, and the if...then structure is then contained within parentheses that define the body of the for loop. Improperly matching the open and close parentheses is a common error. You must always have as many open parentheses as closed ones, and you must be careful that they are properly placed. If not, your script will not run, or it will run but with unexpected results.

While Loops

While loops are similar to for loops in that they iterate over a group of statements. The difference is that in a while loop the number of iterations is not known or specified beforehand. Instead, you set a condition that stops the loop.

There are two types of while loop constructs, *do-while* and *while-do*.

To use Do-While and While-Do loops:

1. Reset 3ds Max.

2. In a blank MAXScript Editor window, type the following script and run it:

```
i = 0
t
do
(
    t = teapot pos:[i*20, 0, i*20]
    i = i+1
) while t.pos.x < 101
```

This code creates cascading teapots.

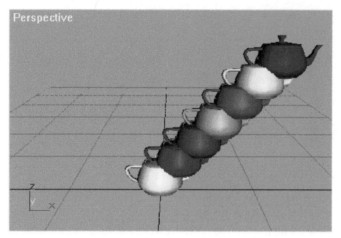

Notice that the variable t was declared before the body of the do code block so it would be available for the while conditional test at the end of the script. If t were removed, it would be undefined in the line:

```
while t.pos.x < 101
```

This would cause MAXScript to throw an error.

3. Reset 3ds Max again, clear your MAXScript Editor, type the following script, and run it:

```
i = 0
test = true
while test do
(
  t = teapot pos:[i*20, 0, i*20]
  i = i+1
  test = t.pos.x < 101
)
```

You get the same result as in step 2. However, the script statements are executed differently. If you look carefully, you will notice that in step 2, the statements in the do body are always executed at least once. The condition is not tested until you have executed the loop body. The teapot is created and the position is tested.

In the second example, you ask for the condition first, to see if the loop body is to be executed at all. Depending upon your circumstance, it could be that the condition is not met initially, so the loop may not even execute once.

Note: You have used expressions that evaluate to Boolean values in this script. The expression t.pos.x < 101 evaluates to either true or false. The expression is evaluated to a Boolean, and the result is assigned to the variable test. Also, the script statement while test do is equivalent to while test == true do.

Collections

The term *collection* describes any grouping of objects or values that 3ds Max keeps track of. Arrays are one type of collection.

An *ObjectSet* collection is a special type of collection maintained by MAXScript. Its contents automatically change with scene changes. For example, the objects collection holds the scene objects at any given time. If an object is added or deleted, the objects collection grows or shrinks accordingly.

On the other hand, if you add an object to an array with a script, then delete the object from the scene, the array will still hold a reference to the deleted object. This is not desirable, since attempting to access the array member will generate an error.

Arrays

An *array* is a sequence of items. A number, or *index*, is used to access each item or value in the array. The various items in the array are the *array elements*.

The elements in an array can be of any type, such as numbers, true/false values, 3D objects, strings, and so forth. You create array objects with an array constructor. The simplest way to create an array is to use the following command:

```
myArray = #()
```

The pound sign (#) followed by parentheses signifies an array. With the above statement you created the variable myArray and stored an empty array in it.

The array does not yet contain any elements. One way to assign elements to the array is to give it values when you create it:

```
myArray = #(1,2,4,8,16)
```

This array contains five integer elements. Each element corresponds to an index. The first value listed has index 1, the second index 2, and so forth. You access each element of the array using the index in square brackets.

The following line of code would return the third value in the array, the integer 4:

```
myArray[3]
```

The following line would replace the third value in the array with the integer 28. You can also use this method to populate an empty array with values.

```
myArray[3] = 28
```

You can append elements to an array with the append command:

```
append myArray 56
```

This would append a sixth element to the array, the integer 56. You can store any series of elements in an array, including 3D objects.

To store objects in an array:

1. Reset 3ds Max, or delete all objects from the scene.

2. In the Listener, type and evaluate the following:
    ```
    c = cylinder pos:[50,0,0]
    b = box()
    s = sphere pos:[-50,0,0]
    ```

 This creates three objects in the scene at different locations.

3. In the Listener, type and evaluate the following:
    ```
    objectArray = #(c,b,s)
    ```

 This creates an array that holds the three objects.

4. Type and evaluate the following:
    ```
    d = donut()
    append objectArray d
    ```

 This appends the donut object to the array.

Array Functions

Arrays are extremely useful for performing the same operation on several objects or values. If you want to iterate over an array, you can do so even if you do not know how many elements the array contains. Here is how that is done:

```
a = #("one", "word", "at", "a", "time")
for i = 1 to a.count do
(
   messagebox a[i]
)
```

The `.count` property of array objects always holds the total number of elements in the array.

There are a number of additional functions you can use with arrays. These are deleteItem, join, sort, and findItem. Here are examples of their syntax.

* `deleteItem`—DeleteItem deletes the entry denoted by the second argument. In the example below, arr[2] is removed from the array. The array count is automatically decreased by 1.

    ```
    arr = #(1.0, .55, .3, 2.6)
    deleteItem arr 2
    for i = 1 to arr.count do
    messagebox (arr[i] as string)
    ```

- join—Join combines two arrays. It can also combine a collection and an array:

```
for i = 1 to 3 do
(
  sphere()
  box()
)
arr = $sphere* as array
join arr $box*
for i = 1 to arr.count do
messagebox arr[i].name
```

- findItem—FindItem can be very useful in a variety of situations. You use it when you are trying to find a specific value. It returns the index of the value you are looking for. If the value is not in the array, then findItem returns a 0:

```
arr = #(2.4, 4, 3.2, 1.1)
index = findItem arr 3.2
-- The found index will be 3
messagebox (index as string)
-- 3.3 is not in the array, so the returned index is 0
index = findItem arr 3.3
messagebox (index as string)
```

- sort—Sort arranges an array into ascending order. If the array is a string, then the array ends up in alphabetical order. The syntax is:

```
sort arr
```

The sort function produces an error if the array elements are not all of the same data type. In most programming languages, an array can only contain data of a single type. In MAXScript, elements of a single array can be of many data types. Here is an example:

```
-- First create an empty array
arr = #()
-- Now add some elements
arr[1] = 4
arr[2] = "string stuff"
```

This is perfectly valid. However, it is up to you to keep track of what types of variables exist at what indices.

Printing Arrays

In MAXScript, prior to 3ds Max 7, attempting to print an array or convert (also called casting) an array to a string, would result in only the first 20 elements getting printed. Now, a new MAXScript global variable will enable entire arrays to be printed or cast, rather than limiting them to the first 20 elements. The global variable is:

```
options.PrintAllElements
```

When set to true, all elements of an array are printed, or converted to a string (see the *MAXScript Reference* Help for other data types that also support this). When set to false only the first 20 are printed.

Note: See the *MAXScript Reference* Help for additional syntax usages.

To use PrintAllElements:

1. In the Listener, type the following:
    ```
    options.PrintAllElements = false
    h = for i = 1 to 30 collect i
    ```

2. Notice that only the first 20 elements were printed:
    ```
    #(1, 2, 3, 4, 5, 6, 7, 8, 9, 10, 11, 12, 13, 14, 15, 16, 17, 18, 19,
    20, ...)
    ```

3. Type the following in the Listener:
    ```
    options.PrintAllElements = true
    h
    ```

4. Notice that all the elements were printed.
    ```
    #(1, 2, 3, 4, 5, 6, 7, 8, 9, 10, 11, 12, 13, 14, 15, 16, 17, 18, 19,
    20, 21, 22, 23, 24, 25, 26, 27, 28, 29, 30)
    ```

Multidimensional Arrays (Advanced Topic)

A multidimensional array is an array where each item contains another array—an array of arrays. Such an array is called a two dimensional array. It is possible to have arrays of higher dimensions. A two dimensional array would look like this:

```
#(#(1,2),#(3,4))
```

You can assign any variable to it like so:

```
h = #(#(1,2),#(3,4))
```

You create a two dimensional array in the following exercise.

To create a two dimensional array:

1. Reset 3ds Max.

2. Open a new MAXScript Editor window with MAXScript menu > New Script. Type the following into the editor, and execute it with CTRL+E:
    ```
    function array2D row column =
    (
        local data = #()
        for i = 1 to column do
        (
          data[i] = #(0)
          for j = 1 to row do
    ```

```
    (
        data[i][j] = random 1 10
    )
)
return data
)
myArray = array2D 2 4
```

3. The Listener responds with a new 2D array filled with random numbers that range between one and 10.
```
array2D()
#(#(10, 1), #(10, 9), #(4, 5), #(9, 4))
```

In the next example, you'll define an array that holds all of the information necessary to create an object. Then you will define an array of those arrays.

To use multidimensional arrays with mixed data types:

1. Type all the statements in this example into a MAXScript Editor window as they appear. You will execute the entire script at the end.

2. In a new MAXScript Editor window, create two arrays. These will become cylinder description arrays.
```
cylobj1 = #()
cylobj2 = #()
```

3. Create some modifiers to use later:
```
tap = taper amount:-1.0
bnd = bend angle:30
```

4. Fill in array elements for the cylinder objects. You define the first element to be the cylinder height, the second its x position, the third to be the cylinder's name, and the fourth to be the modifier you are applying.
```
cylobj1[1] = 30.0
cylobj1[2] = 0.0
cylobj1[3] = "first cylinder"
cylobj1[4] = tap
cylobj2[1] = 60.0
cylobj2[2] = 40.0
cylobj2[3] = "second cylinder"
cylobj2[4] = bnd
```

5. Build an array of cylinder description arrays.
```
my_cylinders = #(cylobj1, cylobj2)
```

To access an element from cylinders, you use cylinders[i][j], where the first index [i] refers to the cylinder description array, and the second index [j] indexes into the cylinder description array.

6. Build the two cylinders.

```
for i = 1 to my_cylinders.count do
(
  c = cylinder height:my_cylinders[i][1]  \
              pos:[my_cylinders[i][2], 0.0, 0.0] \
              name:my_cylinders[i][3] \
              heightsegs:10
addmodifier c my_cylinders[i][4]
  )
```

A version of this script can be found on the companion website and is called *2_D_Arrays.ms*. This is the result.

Wildcards

To add several objects to a collection at once, you can use the wildcard character, the asterisk (*). Earlier, you saw the asterisk used as the symbol for multiplication. The asterisk can also be used as a placeholder to signify one or more arbitrary alphanumeric characters. This is equivalent to doing a file search in Windows Explorer and using an asterisk, for example, searching for *.max locates all files with a .max extension. You can use the wildcard character in MAXScript loops in a variety of convenient ways, for example in combination with pathnames.

As you recall, each object created in 3ds Max is assigned a pathname in the object hierarchy. This is where the concept of a collection becomes convenient. You can consider all objects of a given type as a MAXScript collection of those objects. You can perform operations on each object in a collection by looping with a for loop, but there is an easier way—you can use wildcards. Keep in mind that it is not necessary to provide a name or reference for each object that is created.

To use collections versus arrays:

1. Reset 3ds Max, and clear the Listener.

2. Create two teapots by any means. Allow 3ds Max to assign the default names; do not rename them.

3. In the Listener, type the following:
   ```
   coll = $teapot*
   arr = coll as array
   ```

 The Listener shows you that the array consists of two teapots. The syntax as array is similar to as string, which you used earlier. The statement coll as array converts, or *casts*, the collection coll to an array.

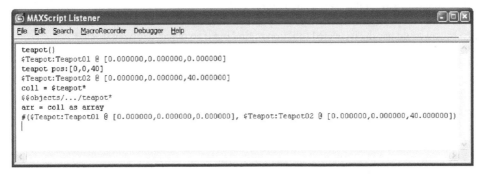

4. Select and delete one of the teapots in your scene.

5. In the Listener, type and evaluate the following:
   ```
   arr = coll
   ```

 The Listener returns $$objects/.../teapot*.

```
MAXScript Listener
File  Edit  Search  MacroRecorder  Debugger  Help

teapot()
$Teapot:Teapot01 @ [0.000000,0.000000,0.000000]
teapot pos:[0,0,40]
$Teapot:Teapot02 @ [0.000000,0.000000,40.000000]
coll = $teapot*
$$objects/.../teapot*
arr = coll as array
#($Teapot:Teapot01 @ [0.000000,0.000000,0.000000], $Teapot:Teapot02 @ [0.000000,0.000000,40.000000])
arr = coll as array
#($Teapot:Teapot01 @ [0.000000,0.000000,0.000000])
```

The collection variable coll was automatically updated when you deleted the teapot.
You did not have to do anything special in your script. Likewise, if you create another new teapot, coll is updated internally.

6. Reset 3ds Max, and create two teapots again. Type and evaluate the following in the Listener:

```
coll = $teapot*
arr = coll as array
```

7. Delete one of the teapots, and type and evaluate the following in the Listener:

```
for i = 1 to arr.count do
    messagebox arr[i].name
```

As you might expect, you get an error.

Once the array is created, it exists independently of the collection. If you delete a scene object, the array count does not change, nor do the values in the array. If you try to index through the array, you will be attempting to access properties of objects that no longer exist. If there is a possibility that objects in your array can be deleted, then simply construct the array again before using it.

8. Alternatively, you could use the isDeleted function to find out if an object has been deleted.

9. Type and evaluate the following into the Listener:

```
for i = 1 to arr.count do
(
    if not isDeleted arr[i] then
        messagebox arr[i].name
)
```

You do not get an error with this code.

Note: You can use the $ character to denote the currently selected object. For example:

```
$.name
```

This statement returns the name of whatever is currently selected.

Structures

You have been introduced to basic data types such as integers, floating point numbers, and strings. These data types are fundamental to MAXScript. However, these data types are basic, and therein is their weakness. The strength of object-oriented programming languages is that they allow abstraction of concepts into a high-level data type or class. You can readily see how the integer class is a good abstraction for numbers, but what if you want to generalize a higher level concept in a computer program? How would you describe a car? Or a job? Or

how would you describe a person? You could describe a person as having a name (String), age (Integer), height (Float), weight (Float) and other such things. For example, you could conceptualize a person like this:

- Person
 - Name: "Carol"
 - Age: 47 years
 - height: 5'8"
 - weight: 130 lbs

This same intellectual process is used to create a new data type in MAXScript using structure definitions.

First you create a definition of a structure. Then you create an instance of this structure. The process of making a new instance is called instantiation. Your new instance now has all the properties and methods of the structure. Once created, your object will behave just like other data types native to MAXScript. The rules for a structure are as follows.

Structure Syntax

Rules for structure creation:

- Must start with the `struct` keyword.
- Be followed by any name that you choose.
- Followed with an open parenthesis.
- Must contain one or more optional variables that describe the structure. These must be separated by a comma (,) symbol. These variables are called member variables because they belong to the structure, or they are a member of a group of data types and functions that together make a structure.
- Can contain zero or more member functions.
- The last member variable or function does not have a comma after it.
- Followed with a close parenthesis.

A structure created with the person example would look like this:

```
struct Person
(
    name,
    age,
    height,
    weight
)
```

Structure Constructor Function

You create a person object by creating a variable and assigning it to the result of a special constructor function that has the same name as your structure. These constructor functions act just like standard functions and can take positional and keyword arguments. For instance:

myPerson = Person()

Here myPerson is the variable or value, and it is created by the constructor function called Person that is used with a pair of parentheses.

Now you can use this myPerson value just like you used any other number or string value in MAXScript. For example, you can access its properties, you can pass it through functions, and you can print the results to the Listener.

Structure Initialization

Creating an object of the person data type however will not insert any data into it. For example, use the myPerson value from the previous example and type the following code into the Listener, and then evaluate it:

```
myPerson.name
```

The following result is displayed:

```
undefined
```

This result occurs because you have not input any data into your person value. Your myPerson value is said to be empty.

There are three principle ways to initialize an object with data:

1. Pass in variables to positional and/or optional keyword arguments to the constructor function. The positional arguments are in the same order as the individual member elements of the structure. The keyword names for the constructor function have the same name as each of the member variables. You cannot initialize a member function. Using our person example you would write:

    ```
    myPerson = Person "Carol" 47 68 130
    myPerson = Person name:"Carol" age:47 height:68 weight: 130
    myPerson = Person "Carol" weight:130
    ```

 If you then type myPerson.name into the Listener and evaluate, you would get "Carol" as the result.

2. Assign values to the member variables after the object has been created. Thus you create an empty value and then initialize or populate it with data. Using our person example you would write:

    ```
    myPerson = Person()
    myPerson.name = "Carol"
    myPerson.age = 47
    myPerson.height = 68
    myPerson.weight = 130
    ```

This approach is much longer and prone to more errors than the first approach. However, you use this approach when you do not currently have data for an object—you will input the data for the object at a later time.

3. Assign values to the member variables in the structure definition itself. Thus when your value gets created it will contain default values for its member data. Using our person example you would write:

```
struct Person
(
    name = "Carol",
    age = 47,
    height = 68,
    weight = 130
)
myPerson = Person()
```

Then if you type `myPerson.name` into the Listener and evaluate you would get `"Carol"` as the result.

You may also override the default values for the member data by passing in any data through optional keyword arguments. For example, using the latest Person definition you could write:

```
myPerson name:"Sue"
```

This myPerson value would have "Sue" for the name, but still have 47 for the age, 68 for the height, and 130 for the weight properties.

Structure Member Functions

Structures can be made very powerful by including member functions into a structure definition. These member functions act just like normal functions, except they have access to other struct data members. Using the person example, you add a function that returns the person's height in units of centimeters instead of inches. For example:

```
struct Person
(
    name,
    age,
    height,
    weight,
    function GetHeightCM =
    (
        cmheight = height * 2.54
    )
)
```

This function takes the height, multiplies it by a conversion factor, and returns the new value. You could use the new function by writing the following code:

myPerson = Person "Sue" height: 60

cmh = myPerson.GetHeightCM()

Then if you type cmh into the Listener and evaluate you get 152.4.

Calling Functions During Construction of a Structure (Advanced Topic)

So far all you have seen during structure creation is copies of arguments getting assigned to the member variables. No other code gets initialized with what you have seen so far. But what if you want to call other code to manipulate your data when your struct value is created? You can do this by assigning a function to a member variable in your struct definition. For instance:

```
struct Person
(
    name,
    age,
    height,
    weight,
    function GetHeightCM =
    (
        height * 2.54
    ),
    cmHeight = GetHeightCM()
)
```

Notice a new member variable was added to the struct called cmHeight. This variable will hold the height in units of centimeters. Any member function that gets assigned to a member variable will get called during construction. Continuing with our example you could write:

```
myPerson = Person "Carol" height:60
```

And then type the following into the Listener and evaluate:

```
myPerson.cmHeight
```

This would return a value of 152.4, just as expected. You can have more than one function that will be called during construction. For example, you could add a member variable that contains the converted weight in kilograms:

```
struct Person
(
  name,
  age,
  height,
```

```
weight,
function GetHeightCM =
(
  height * 2.54
),
function GetWeightKG =
(
weight * 2.2
),
cmHeight = GetHeightCM(),
kgWeight = GetWeightKG()
)
```

Calling functions during structure creation is a very powerful tool in MAXScript.

Strings

String variables are alphanumeric characters or text, such as "Hello", "MAX4U", or "Please enter your name." Strings are literal values that you might use in a pop-up message or for a file path. You assign strings to a string variable by using quotation marks. If you don't supply the quotation marks, you will get an error.

MAXScript provides several operations that you can perform on strings.

Concatenation

Concatenation combines two strings by using a plus sign (+). You can think of it as adding two or more strings to get a third:

```
text1 = "MAXScript is"
text2 = " fun!"
text3 = text1 + text2
```

In the example, text3 will have the value "MAXScript is fun!" Note that a space was placed at the beginning of the text2 string to make the string read correctly. A space is considered a character in a string.

You can use the messageBox method to view the string:

```
messagebox text3
```

The figure below shows the result of the script above. The Listener shows the results of the assignments after each line is executed.

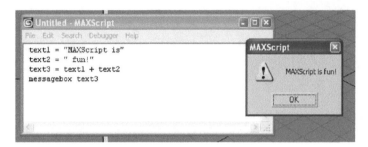

Findstring

Findstring finds the first instance of a substring inside a larger string. For example:

```
test = "String example"
location = findString test "ex"
```

The Listener returns with a value of 8, to indicate that the substring ex starts at the eighth character of test. If the substring is not present, the Listener will return undefined.

Replace

Replace replaces one string with another. This method is implemented as follows:

```
test = "This is a string"
test2 = "yet another"
test3 = replace test 9 1 test2
messagebox test3
```

The first argument is the string that contains the starting text. The second argument is where to start replacing. The third is how many characters to remove, and the fourth is the substring that is to be inserted. The string test3 will now be "This is yet another string."

Converting Between Numbers and Strings

If you are performing file input or output, often you will need to convert numeric data in your script to text that can be written to a text file. You may also want to read text from a file that has to be converted to numeric data to use in your script. In these cases, the numeric data must be converted back and forth from strings. MAXScript provides a simple way to do this.

If you try to add a number and a string with the plus sign (+), MAXScript will generate an error. Before you can append a number to a string, you must convert the number value to a string data type. You accomplish this by using the *as string* command.

Suppose you want to make the following string:

```
string1 = "Your customer number is 345"
```

If you have the customer number as an integer, you can construct this string in this manner:

```
custNum = 345 -- custNum is an integer
custString = custNum as string -- makes a string from custNum
string1 = "Your customer code is " + custString
```

You can also use `as integer` and `as float` to convert a string to an integer or float number, respectively.

To use string/numeric conversions:

1. Open a new Script Editor window and type in the Listener:
```
s = sphere()
val = s.radius as string
text1 = "The sphere's radius is "
text2 = text1 + val
messagebox text2
```

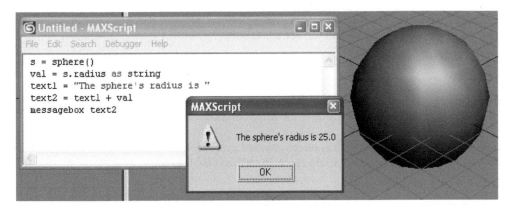

The variable `val` holds the value of the sphere's radius as a string.

2. Now you convert from strings to numbers. In the Listener, type the following:
```
val = "20.0"
s = sphere()
s.radius = val as float
```

You converted the string "20.0" to a float data type, and assigned it to the sphere's radius.

Creating and Running Scripts

Now that you've learned many of the aspects of building scripts, you will create a complete script that uses some of these tools. You'll also learn how to run the script from different parts of the 3ds Max user interface.

In the exercises that follow, you will create a script that piles objects on top of one another, and changes their wireframe colors to form a gradient from the bottom of the pile to the top.

The script will take this general form:

- Put all objects in the scene into a collection.
- Place the first object in the collection at [0,0,0].
- Get the height of this object, and place the second object at [0,0,height of first object].
- Get the height of the second object, and place it at [0,0,height of first + height of second].

And so on. You can see that the Z component of the position can be calculated from a loop.

To create the PileUp Script:

1. Open a new MAXScript Editor window.

2. In the window, type the following:
   ```
   -- MyPileUp.ms
   -- Script for piling up primitives that have a height parameter
   ```

 These lines are comments that define the script. In addition, you might want to add your name, the date you created the script, and any other details you deem necessary.

 The script will operate on objects already in the scene, so the first thing you need to do is make a collection of these objects.

3. In the Editor, add the following line:
   ```
   coll = $* -- Puts all objects in a collection named coll
   ```

 Before creating a loop to go through the objects, you need a variable to hold the Z position for the next object in the loop. The Z position for the first object is 0, so set this variable to 0.

 Add the following line to the script:
   ```
   zNextObject = 0 -- Variable to hold the next Z position
   ```

4. Create a loop that piles up the objects.
   ```
   for i in coll do
   (
       i.pos = [0,0,zNextObject] -- Sets the Z position for the object
       zNextObject = zNextObject + i.height -- Adds the object's height
   )
   ```

5. Using the 3ds Max interface, draw a number of primitives in your scene. Take care to use only primitives that have a Height parameter, such as boxes, cylinders, cones, capsules, and so forth. Make sure each Height value is a positive number.

6. Press CTRL+E to run the script.
 The objects pile on top of one another.

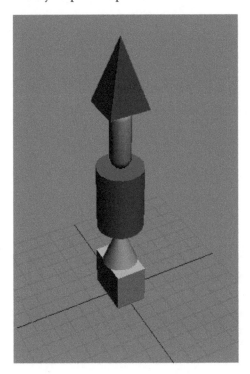

7. Save the script as MyPileUp.ms.

Working with Equations

The next addition you will make to the script requires some forethought, so work out the math ahead of time. When writing scripts, it is often helpful to get out a pencil and paper to work out what you're going to do before you do it. You won't need a pencil and paper for this exercise, but you might when you create your own scripts in the future.

Now you will add to the script to change the wireframe colors to form a gradient over the pile from bottom to top. Here, you will make the wireframe colors go from red at the bottom to yellow at the top.

Consider the RGB values needed to make red and yellow:

- Red: [255,0,0]

- Yellow: [255,255,0]

The second component, the green value, will have to go from 0 to 255 gradually over the course of the loop.

Suppose there are five objects in the scene. You could make the green component to progress as follows:

- Object 1: 1/5 * 255 = 51
- Object 2: 2/5 * 255 = 102
- Object 3: 3/5 * 255 = 153
- Object 4: 4/5 * 255 = 204
- Object 5: 5/5 * 255 = 255

However, the green component would be 51 for the first object. If you want it to be 0, you can make a progression of 0/4 to 4/4 instead of 1/5 to 5/5:

- Object 1: 0/4 * 255 = 0
- Object 2: 1/4 * 255 = 63.75
- Object 3: 2/4 * 255 = 127.5
- Object 4: 3/4 * 255 = 191.25
- Object 5: 4/4 * 255 = 255

In this case, the numerator of the fraction (the number you divide) is the object number decrease by one (-1), and the denominator (the number you divide by), is the same as the number of objects minus one.

Changing Wireframe Colors with a Loop

Next, add some code to the script to change the wireframe colors in this manner.

To change wireframe colors with a loop:

1. First, get the denominator for the fraction, which is equal to the number of objects in the scene minus one. After the line coll = $*, add the following line:

    ```
    bottomFraction = coll.count - 1 -- Get the denominator
    ```

 There is a problem. With the current loop construction, you cannot use the object's collection index to calculate the numerator. You can solve this by changing the way the loop is set up.

2. Change the for loop line to the following:

    ```
    for i = 1 to coll.count do
    ```

 This changes the variable i to the index of the object, rather than the object itself.

3. Change the next line to:

    ```
    coll[i].pos = [0,0,zNextObject]
    ```

 You also need to change the line that sets the next Z position:

    ```
    zNextObject = zNextObject + coll[i].height
    ```

 Now add the lines that set the wirecolor.

4. Just before the parenthesis that closes the for loop, add the following lines:

```
topFraction = i - 1
greenValue = (topFraction / bottomFraction) * 255
coll[i].wirecolor = [255,greenValue,0]
```

5. In the viewports, move the objects around a bit, then run the script.

The objects move into a pile, but the colors are not quite right. All objects except the top one are red.

6. Examine the code you used to calculate the green component of the RGB value to determine what happened:

```
greenValue = (topFraction / bottomFraction) * 255
```

Both topFraction and bottomFraction are integers. In MAXScript, when you divide one integer by the other, the result is always an integer. If the result has decimal places, they are removed.

As the result, when topFraction is 1, it gives this result:

$1/4 = 0$

The actual number should be 0.25; however, the decimal places are removed. Thus, the result is 0 until topFraction reaches 4 for the last object in the collection.

7. To fix this problem, you can turn either topFraction or bottomFraction into a floating point number. In the script, change the bottomFraction assignment to the following:

```
bottomFraction = coll.count - 1.0
```

By using 1.0 in the equation rather than the integer 1, you automatically turn the number stored in bottomFraction into a floating point number. When you divide topFraction by this number, the result will also be a floating point number.

Note: Alternatively, you could change the number in the equation `topFraction = i - 1` to 1.0 to achieve the same result.

8. Run the script.
The objects are assigned colors that form a gradient from red at the bottom to yellow at the top.

9. Save the script as MyPileUp.ms.
You can find a finished version of this script in the file *pile_up.ms* on the companion website.

Hint: A small shortcut you could have used is the objects array. This is a collection of all objects in the scene that is automatically generated by 3ds Max. Instead of creating the array `coll` and using it to control the for loop, you replace the for loop line with the following:

```
for i = 1 to objects.count do
```

Then you could replace all references to coll with objects, and remove the line coll = $*. This would produce the same result as the script in the previous exercise. You can find this version of the script in the file *pile_up_2.ms* on the companion website.

Conclusion

In this chapter you learned how to use MAXScript to create simple scripts. You used the MAXScript Listener to define variables and assign data to them, and to define and use functions. You also learned basic programming concepts such as conditional statements, loop structures, scope, and parameter passing. You learned about arrays, collections, and structures. You also learned how to create a working script that modifies object properties.

Constructing User Interfaces

In this chapter, you will learn how to

construct user interfaces. You will build a UI

interface by creating a rollout and

populating it with UI controls. You will then

add event handlers to invoke elements of

your script from the UI controls.

Objectives

After completing this chapter, you should be able to:

- Create a floating dialog or utility rollout.

- Add user interface controls to the rollout.

- Make the script respond to user input.

Introduction

MAXScript includes tools for creating custom user interfaces that are built when the script runs. You can get user input from rollouts and dialogs, and execute commands based on the input. This chapter describes how to create user interface elements that are "wired" to your script.

Building User Interfaces

So far, you have written scripts that operate without any user input. You can add a user interface (UI) to your script so users can enter data, which you can then utilize within the script.

Types of User Interfaces

A script can generate two types of interfaces:

- Rollouts on the Utilities panel

- A floating dialog

An exception is the *scripted plug-in*, which is a specialized script that can generate rollouts in other parts of the 3ds Max UI.

Script Types

There are several types of scripts. These categories roughly divide script types by the type of UIs they generate.

- Scripted function—A scripted function contains one or more functions, but does not generate a UI. After you run the script, you can call the functions from the Listener or another script.

- Scripted utility—A script that defines one or more rollouts on the Utilities panel for its UI.

- Scripted plug-in—This is a specialized type of script that creates new 3ds Max tools, or extends existing tools. In all other types of scripts, you use code to perform actions that you can already perform with the 3ds Max UI, such as creating boxes and spheres, assigning controllers, and configuring viewports. With a scripted plug-in, you can create new geometric objects, maps, modifiers, and so on. The UI for a new tool appears in the appropriate part of the 3ds Max UI. For example, a new map is listed in the Map Browser, while a new modifier appears on the Modifier List.

- General scripts—Any other scripts fall into the category of general scripts. With such a script, you could generate a floating dialog as a UI, or have no UI at all. For example, you could write a script that creates a series of spheres, similar to the scripts you created in Chapter 1. This script would not generate a UI.

MacroScripts

With the addition of a few lines of code at the start of a general script, you can cause the script to appear as an action item in the Customize User Interface dialog. This means you can add the item to a toolbar or other UI element so you can then call the script from there. This also means you can call or execute the script from a keyboard shortcut.

Such a script is called a *MacroScript*. It can generate a UI and define functions, but it does not have to. It is simply a general script with a command that causes it to appear as an action item.

The name MacroScript came from its intended use, which was to help users unfamiliar with MAXScript create scripts from code displayed in the Listener. For a repetitive sequence of commands, you can perform the sequence once manually, which would display the corresponding Macro Recorder output in the top (pink) pane of the Listener. Then you could copy and paste the Macro Recorder output to the MAXScript Editor, run the script, and work with its corresponding action item in the Customize User Interface dialog.

To turn any general script into a MacroScript, you can do either of the following:

* Add the necessary code at the beginning to designate the script as a MacroScript, and then run the script.

* Highlight the contents of the script in the MAXScript Editor (or any other place where 3ds Max displays code, such as the Listener), and drag it to a toolbar. This automatically generates an internal name for the MacroScript, such as Macro1, Macro2, and so on.

Script Files

In general, you save a script file name with the extension *.ms*. To keep your scripts organized, you should save MacroScripts with the extension *.mcr*. Technically, you could save either type of script with either extension, and the scripts will still run. However, using the appropriate extension tells you (and others) how you intend the script to be used.

You can cause a script to run automatically when 3ds Max is started. To do this, you place the script in any of the following folders:

* 3dsmax/stdplugs/stdscripts

* 3dsmax/plugins, or any subfolder under plugins

* 3dsmax/ui/macroscripts, or any subfolder

* 3dsmax/scripts/startup

When you start 3ds Max, the startup routine searches these folders in the order shown, looking for files with the extensions *.ms*, *.mcr*, and *.mse*. (The extension *.mse* is used for encrypted script files. For more information, see "Encrypting Script Files" in the *MAXScript Reference*.)

Rollouts

Rollouts are at the heart of any MAXScript-generated UI. Before you can create any user interface elements such as checkboxes and spinners, you must create at least one rollout to hold them. The term rollout in MAXScript refers to the kind of rollout you are familiar with, such as those on command panels and dialogs. With MAXScript, you can also display a rollout as a single dialog, if you like.

Fortunately, it is very easy to create a custom rollout with MAXScript and populate it with user interface elements.

To create a rollout, you use the following construction:

```
rollout <variable> "Rollout Name"

(

    <UI elements such as check boxes, buttons, and spinners>

)
```

The variable holds the rollout's internal name, which you will use within the script to reference the rollout. The string "Rollout Name" is the name that will appear at the top of the rollout.

The code between the open and close parentheses is called the *rollout clause*. You define all user interface elements, and what each one does, within the rollout clause.

To get started, create a very simple rollout.

To create and display a rollout:

1. Open a new MAXScript Editor, and type the following:
   ```
   rollout a "Something New"
   (
       spinner b "Enter a value: "
       button c "Click Me"
   )
   ```

 This defines the rollout labeled "Something New." The variable a contains the internal reference to the rollout, which you can use in other parts of the script to refer to the rollout.

 The `spinner` and `button` commands create a spinner and button with the labels you included between the quotation marks. The variables b and c hold the internal reference to the spinner and button, respectively.

2. Run the script.
 Nothing happens. You have to set the location and appearance of the rollout.

3. At the end of the script, type the following:
   ```
   createDialog a 200 50
   ```

4. Run the script.

This displays the rollout as a dialog named Something New, with a width of 200 and height of 50. It contains two UI elements, a spinner and a button.

The command createDialog creates a new floating dialog using the rollout commands. Because the rollout's internal name is a, the command `createDialog` a references the rollout definition you made earlier in the script.

If you change the spinner value and click the button, nothing happens. You must add *event handlers* to make something happen when you interact with the UI.

To add event handlers:

1. Close the Something New dialog.

In the MAXScript Editor, after the spinner line, enter the following:

```
on c pressed do
(
    d = b.value
    sphere pos:[d,0,0]
)
```

Run the script. The dialog appears as it did before.

2. Change the spinner value, and click the button. Each time you click, you create a sphere at the X position indicated by the spinner value.

Let's take a closer look at how this works. The line `on c pressed do` is an event handler for the button c. This tells the script to run the code between the parentheses when the button c is pressed.

The spinner is held in the variable b. The value in the spinner entry area can be accessed with the property .value. Thus, `b.value` is the value in the spinner entry area.

When the button c is pressed, the script puts the spinner value in the variable d, then creates a sphere with its X position equal to the spinner value.

To convert the script to a MacroScript:

To make this script accessible from a button on the toolbar, you can simply highlight the text and drag it there.

1. Close the SomethingNew dialog.

2. In the MAXScript Editor, select all the text with CTRL+A.

3. Drag from the selected text to a space between two buttons on the main toolbar. When the cursor changes to an array with a plus sign, release the mouse.

A new button appears on the toolbar. The buttons looks like a miniature MAXScript Editor or Listener.

4. Click the new button.

The Something New dialog appears, and you can create spheres with it as usual.

5. Close the Something New dialog.

6. Right-click the New button, and choose Edit Macro Script.
 A new MAXScript editor window appears with a version of your script. A few lines have been added at the start to make the script into a MacroScript. This new version of your script has been saved in the file *DragAndDrop-Macro#.mcr*, where # is an incremental number used to identify this particular script.

 Note: The creation of this new script has not affected your original script, which still exists in its own MAXScript Editor window.

7. Close the MAXScript Editor containing the drag-and-drop script.
 The script you have created here is a general script. You can quickly convert it to a utility by changing a few lines of code.

To convert to a scripted utility:

1. Close the Something New dialog.

2. In the first line of code, change the word rollout to utility.

3. Delete the last line of code, the createDialog line that displays the floater as a dialog.

4. Run the script.

5. On the Utilities panel, choose MAXScript. From the Utilities drop-down menu on the MAXScript rollout, choose Something New.
 The rollout Something New appears on the Utilities panel. You can use the spinner and button the same way you used them on the floating dialog.

Adding User Interface Elements

So far, you have seen how to add a few user interface elements to a rollout. There are many more controls you can use to add labels, checkboxes, radio buttons, and other elements. In addition, you can control whether the elements appear at the left, right, or center of the dialog, and how many elements appear across a single rollout line.

The following is a list of commonly used UI elements, as they are named and used within MAXScript.

- Label—Static control to display text. The user cannot change the text, but you can change it within the script.

- Checkbox—A box that the user can turn on or off.

- Button—A button that pops back up after it is pressed.

- Checkbutton—A button that stays depressed when pressed, then pops up when pressed again.

- Pickbutton—A button to select objects in the scene.

- Radiobuttons—A set of radio buttons on the rollout. You can choose only one at a time.

- Spinner—Used to place a numeric control on the rollout. The control consists of spinner arrows and an edit field. A spinner has a range and default value as its parameters.

- Slider—An alternative to a spinner. The user slides the pointer back and forth. A slider also accepts a range and default as parameters.

- Edittext—An editable text field where the user can enter and edit text.

- Listbox—A list of items presented to the user. The user can scroll the list to choose an item.

- Combobox—A combination of a list box and edit text box. The list is always fully displayed in the rollout (although scroll bars may be present for long lists). The edit box at the top displays the currently selected item.

- Dropdownlist – A list similar to the combo box, but the list drops down when the user presses the arrow. Note that, with a Dropdownlist, you cannot enter text.

- Colorpicker – A control for displaying the Color Selector dialog. A color swatch is displayed on the rollout. The user can click the swatch to display the Color Selector.

- Progressbar—A control to display progress of activity.

- Mapbutton and materialbutton—Button controls that display the Material/Map Browser dialog.

- Bitmap—A control to display a bitmap image on the rollout.

For each interface element you specify with a rollout clause, you are creating an interface element object with its own set of properties. You use the control name to get and set its properties. There are properties that are common to all interface elements such as a position property, and some properties that are specific to the particular element type.

When you create interface elements, 3ds Max places them on the panel with default layout parameters. If you want to specify a layout of your own, there are several parameters you can pass to each constructor:

- `align`—This parameter is specified as #left, #right, or #center. You must include the pound sign (#). This justifies the element to the left, right, or center of the panel.

- `pos`—Positions the element at a specific x and y location in pixel units; it is specified with a Point2 data type ([x, y]). These positions are with respect to the upper-left corner of the rollout.

- `width`—Sets the width of the element in pixels.

- `height`—Sets the height of the element in pixels. For listbox and combobox controls, the height is related to the number of items in the list. To display exactly N items in a list box, set the height to N. To display exactly N items in a combo box, set the height to N+2.

- `offset`—Offsets the element with respect to the default position for the element. The units are pixels and the data type is a Point2.

- `across`—Positions elements horizontally rather than vertically. It applies to the control and the (N - 1) controls that follow it (where N is the number typed after the word across). This is discussed in the section that follows.

It is usually best to let 3ds Max position the items with their default parameters, and then make corrections as needed. Keep text labels short so they don't run past the end of the rollout, and take care to prevent controls from overlapping.

Event Handlers

The general form for an event handler is:

```
on <name of interface element> <name of event> <arguments> do

(

    [commands to perform]

)
```

Following is a common list of events you can use:

- pressed—Called when a button is pressed.

- changed—Called when a control state changes, for example, a checkbox is turned on or a spinner value is edited by a user.

- picked—Called for pickbutton controls; a user selects an item in the scene.

- entered—Called when a user enters a number into a spinner edit field and then presses ENTER.

- selected—Called when an item in a list or combo box control is chosen.

In 3ds Max 8, the *RightClick* event has been added to the following button types:

- Button
- CheckButton
- MapButton
- MaterialButton
- PickButton
- ImgTag

Many UI controls were improved in 3ds Max 7. For a listing of what's new, see the heading "User Interface Controls" under the topic "What was New in MAXScript in 3ds Max 7" in the *MAXScript Reference* Help.

Rollout Groups

As your utilities grow in size and complexity, you will want to group items on the Utilities panel rollout. Using the group clause, you can group interface elements in a logical way. It is up to you how, or if, you group items, but the grouping should delimit the panel's functionality in a way that makes sense. A group appears graphically as an outline on the panel with a label in its upper-left corner. The syntax for a group is:

```
group "group description"

(

    <UI items>

)
```

Creating a Working Script

You are now at a point to write a script that creates a solar system based on user input.

Before you create the user interface, you must decide what you want the script to do. In this case, you will write a script that does the following:

- To start the solar system creation process, the user must create a sun. The sun will be a sphere created at [0,0,0]. The user can set the sun's radius.
- In 3ds Max 8, a new feature has been added—the ability to handle right-click user events for various buttons (see the list in the previous section). To introduce this feature, you will make a different type of sphere

depending on whether the user left- or right-clicks on the create sun button. If the user left-clicks, a sphere is created. If the user right-clicks, a geosphere is created.

- Once the sun is created, the user can create additional planets. The user can choose the number of planets to create.

- When the user presses the Create Planets button, planets will be created, each with a random radius. For each planet, a circle shape will be placed around the sun to represent the planet's orbit, and the planet will be constrained to that path with a Path constraint.

- Once the planets are created, the user can select each planet and change its radius and orbit path.

Based on this information, you could create a user interface like the one shown below.

Creating the User Interface

Let's start by creating and testing the user interface. Later, you'll add event handlers to make the UI perform tasks.

To create the user interface:

1. Open a new MAXScript Editor window.

2. At the top of the window, type the following:

```
-- SolarSystem.ms
```

You can also add more comments that include information such as your name and the date you created the script.

3. Enter the following:

```
rollout ssRoll "Solar System"
(
    spinner spn_sunRadius "Sun Radius"
    button but_createSun "Create Sun"
    spinner spn_numPlanets "Number of Planets"
    button but_createPlanets "Create Planets"
    pickbutton pbt_pickPlanet "Pick Planet"
```

```
    spinner spn_planetRadius "Planet Radius"
    spinner spn_orbitRadius "Orbit Radius"
)
createDialog ssRoll 200 200
```

Many programmers use a particular convention when specifying UI elements. Here, the following prefixes are used to specify variables by type of UI item:

Type of Item Prefix:	Specifies:
spn_	Spinner
but_	Button
pbt_	Pickbutton

After the type of item prefix, the variable name containing the text label for the UI item is specified, starting with lowercase for the first word and an uppercase initial capital for each subsequent word. Thus, Sun Radius spinner becomes spn_sunRadius.

It doesn't matter what convention you use in your own scripts, as long as you are consistent.

4. Evaluate the script.
 A dialog is displayed, showing your UI elements.

You can improve the look of the dialog by separating the UI elements that edit the planets into their own group.

5. Enter the following before the first pickbutton:
    ```
    group "Planets"
    (
    ```

6. Add a close parenthesis after the last spinner.
 The code for the last three UI items should look like the following:

   ```
   group "Planets"
   (
   pickbutton pbt_pickPlanet "Pick Planet"
   spinner spn_planetRadius "Planet Radius"
   spinner spn_orbitRadius "Orbit Radius"
   )
   ```

 This code separates the last three UI items into their own group.

7. Evaluate the script.
 The planet editing UI items are in their own group.

 You can also improve the look of the UI by putting a space after each UI item label, before the end quotation mark.

8. Change each spinner line to include a space after the spinner label:

   ```
   rollout ssRoll "Solar System"
   (
       spinner spn_sunRadius "Sun Radius "
       button but_createSun "Create Sun"
       spinner spn_numPlanets "Number of Planets "
       button but_createPlanets "Create Planets"
       pickbutton pbt_pickPlanet "Pick Planet"
       spinner spn_planetRadius "Planet Radius "
       spinner spn_orbitRadius "Orbit Radius "

       group "Planets"
       (
       pickbutton pbt_pickPlanet "Pick Planet"
       spinner spn_planetRadius "Planet Radius "
       spinner spn_orbitRadius "Orbit Radius "
       )
   )
   ```

9. Evaluate the script.

There is a space between each spinner label and its spinner.

10. Save the script as mySolarSystem.ms.

Note: You will not be instructed to save the script after each section although it is good programming practice to do so. However, since 3ds Max 8, if MAXScript should cause 3ds Max to crash, a dialog should appear that will allow you to save any open scripts.

Adding Event Handlers

Next, add event handlers to create the sun and planets.

To add event handlers:

1. Before the last close parenthesis in the rollout clause, add the following:

```
on but_createSun pressed do
(
)
on but_createSun rightclick do
(
)
```

This creates two event handlers for the Create Sun button. When this button is left-clicked (or pressed), you want the script to create a sphere with the radius set by the Sun Radius parameter. When the button is right-clicked, you want the script to create a geosphere instead.

2. Inside the pressed event handler, add the following line:

```
sun = sphere radius:spn_sunRadius.value
```

The event handler should now look like the following:

```
on but_createSun pressed do
(
sun = sphere radius:spn_sunRadius.value
)
```

The value of the spn_sunRadius parameter is held in its .value property. The expression spn_sunRadius.value will return whatever is in the Sun Radius spinner's entry area at the time the Create Sun button is pressed.

3. Inside the `rightclick` event handler, add the following line:

```
on but_createSun rightclick do
(
    sun = geosphere radius:spn_sunRadius.value
)
```

4. Evaluate the script.

5. On the dialog, change the Sun Radius value to a number greater than 0, and left-click the Create Sun button. This will create a sphere in the scene with the specified radius. Move the sphere and experiment by right-clicking to create a geosphere. If the script fails, look in the Listener to see if you can detect the error, and correct it before continuing.

6. Create an event handler to create the planets and their orbits. After the event handler you just entered, enter the following:

```
on but_createPlanets pressed do
(
    for i = 1 to spn_numPlanets.value do
    (
        -- Create the planet
        planet = sphere() -- Create the planet
        -- Set planet radius to a random number between 10 and 30
        planet.radius = random 10.0 30.0
        -- Create a circle for the planet's orbit
        orbit = circle radius:(i*100)
        -- Put the planet on a path
        planet.pos.controller = Path_Constraint()
        planet.pos.controller.path = orbit
        -- Rotate the path so its 0 position is random
        orbit.rotation.z_rotation = random 0.0 360.0
    )
)
```

This event handler creates the number of planets specified, each with a randomly generated radius. It also creates a circle for each planet, and constrains the planet to the circle with a Path constraint. Finally, it rotates the path by a random number so the orbits do not all start at the same point.

7. Evaluate the script.
Change the Number of Planets value to 3, and click Create Planets.

This creates two planets around the sun, each with its own orbit.

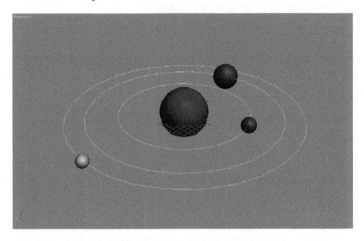

Fine-Tuning the UI

The Number of Planets spinner displays a float number that ranges from 0 to 100. This is the default setting for all spinners. A more appropriate setting for this particular spinner would be an integer ranging from 1 to 10.

1. Add the following to the end of the spinner spn_numPlanets line:

```
type:#integer range:[1,10,3]
```

The line should now look like the following:

```
spinner spn_numPlanets "Number of Planets" type:#integer range:[1,10,3]
```

This will force the spinner to display integers only. The integer can range from 1 to 10, and will have a default value of 3.

2. Evaulate the script.

3. Change the Number of Planets spinner.
The Number of Planets spinner has a default value of 3 and it contains integers from 1 to 10 only.

A new feature in 3ds Max 7 has pickButton control captions automatically display the name of the picked object. Previously users would have to do this task manually. To all the lines where a pickbutton is displayed, you will add the optional keyword parameter:

```
autoDisplay: true
```

79

Automatically Destroying Dialogs

At this point, you have several Solar System dialogs open. Each time you evaluate the script, a new one appears, but the old ones are not closed. To close any open versions of the dialog in the scene automatically every time you evaluate the script, you could add the following line to the beginning of the script:

```
destroyDialog ssRoll
```

However, this line will return an error if there is no ssRoll dialog in the scene. What you want the script to do is destroy the ssRoll dialog if one exists, but if it does not, you want the script to do nothing.

You can put the following line at the beginning of the script to accomplish this:

```
if ((ssRoll != undefined) and (ssRoll.isdisplayed)) do
    (destroyDialog ssRoll)
```

This line first checks if the rollout ssRoll is defined, and then if it finds an open dialog by this name, it destroys (closes) it. Notice both conditions must return true for the dialog to be destroyed. If either of the two conditions returns false then nothing happens.

Note: This conditional statement is new, and is made possible by a property that was introduced in 3ds Max 7—the property on rollouts called `.isdisplayed`. This property returns true if the rollout is displayed (or visible), and false if not. In previous versions of this book, this action used (and achieved the same result):

```
try (destroyDialog ssRoll) catch()
```

To automatically destroy dialogs:

1. Close all open versions of the dialog.

2. Add the following code to the script just before the start of the rollout clause:
   ```
   if ((ssRoll != undefined) and (ssRoll.isdisplayed)) do
       (destroyDialog ssRoll)
   ```

3. Evaluate the script.
 The dialog appears in the scene.

4. Move the dialog to another location so that you can see it close when you evaluate the script again.

5. Evaluate the script.
 Notice that there is only one version of the dialog in the scene.

 Your code should now look like this:
   ```
   -- SolarSystem.ms

   if ((ssRoll != undefined) and (ssRoll.isdisplayed)) do
       (destroyDialog ssRoll)

   rollout ssRoll "Solar System"
   ```

```
(
    spinner spn_sunRadius "Sun Radius"
    button but_createSun "Create Sun"
    spinner spn_NumPlanets "Number of Planets" type:#integer range:[1,10,3]
    button but_createPlanets "Create Planets"

    group "Planets"
    (
        pickbutton pbt_pickPlanet "Pick Planet" autoDisplay: true
        spinner spn_planetRadius "Planet Radius"
        spinner spn_orbitRadius "Orbit Radius"
    )

    on but_createSun pressed do
    (
        sun = sphere radius:spn_sunRadius.value
    )

    on but_createPlanets pressed do
    (
        for i = 1 to spn_numPlanets.value do
        (
        -- Create the planet
        planet = sphere() -- Create the planet
        -- Set planet radius to a random number between 10 and 30
        planet.radius = random 10.0 30.0
        -- Create a circle for the planet's orbit
        orbit = circle radius:(i*100)
        -- Put the planet on a path
        planet.pos.controller = Path_Constraint()
        planet.pos.controller.path = orbit
        -- Rotate the path so its 0 position is random
        orbit.rotation.z_rotation = random 0.0 360.0
        )
    )

)
createDialog ssRoll 200 200
```

Adding Pickbutton Events
Set up the event for the Pick Planets button.

To add a Pickbutton event:

1. Just before the last parenthesis in the rollout clause, enter the following:

```
on pbt_pickPlanet picked aPlanet do
(
-- Put the picked planet's radius in the Planet Radius spinner
spn_planetRadius.value = aPlanet.radius
-- Put the orbit's radius in the Orbit Radius spinner
pOrbit = aPlanet.pos.controller.path
spn_orbitRadius.value = pOrbit.radius
)
```

When you click Pick Planet, the object you choose is put in the local variable aPlanet. Also, the name of the picked object is now automatically given to the caption of the pick Planet pickbutton.

Note: MAXScript programmers often use the variable obj for this variable to indicate that an object was chosen. The variable obj is not a keyword or other special variable name. It is mentioned here only because you will often see it in scripts.

2. Evaluate the script.

3. Click Pick Planet, then click a planet.
 No matter which planet you click, the Orbit Radius appears as 100.0, even though the orbit radius can be as high as 1000. Recall that the spinner's range is limited to 100. You must change the limit for this spinner so it can display correctly.

4. Change the spn_orbitRadius line to the following:

```
spinner spn_orbitRadius "Orbit Radius" range:[0,1000,0]
```

5. Evaluate the script.

6. Click Pick Planet, and pick a planet. The correct orbit radius appears as the Orbit Radius value.

Using Local Variables

Set up the events that change the picked planet's radius and orbit when the Planet Radius and Orbit Radius spinners are changed.

To modify the radius and orbit:

1. After the last event handler you entered, enter the following:

```
on spn_planetRadius changed value do
(
)
```

This event will run any time the user changes the value in the spinner's .value property, by either entering a new value directly or adjusting the spinner with the mouse.

However, there is a problem. When this event is called, you want it to change the radius of the object you chose in the previous event handler, but that object's name is stored in the variable aPlanet, which is local to that event handler. You need to use it in this event handler, so a way to make it available outside the scope of the previous event handler is necessary.

To do this, declare a local variable pPlanet outside all event handlers, and use this variable to hold the name of the object. You can then use the variable in any event handler.

2. Before the pbt_pickPlanet event handler, add the following line:

```
local pPlanet
```

3. Within the pbt_pickPlanet event handler, add the following line at the beginning:

```
pPlanet = aPlanet
```

This sets the value of pPlanet to that of the chosen planet. Now you can use pPlanet in another event handler.

4. Within the spn_planetRadius event handler, enter the following:

```
pPlanet.radius = spn_planetRadius.value
```

This section of code should now look similar to the following:

```
local pPlanet
on pbt_pickPlanet picked aPlanet do
(
    pPlanet = aPlanet
    -- Put the picked planet's radius in the Planet Radius spinner
    spn_planetRadius.value = aPlanet.radius
    -- Put the orbit's radius in the Orbit Radius spinner
    pOrbit = aPlanet.pos.controller.path
    spn_orbitRadius.value = pOrbit.radius
)

on spn_planetRadius changed value do
(
    pPlanet.radius = spn_planetRadius.value
)
```

5. Evaluate the script.

6. Click Pick Planet, and click a planet.

7. Change the Planet Radius value. The planet's radius will change accordingly.
Next, do the same for the planet's orbit. You will run into a similar problem with the variables—the pOrbit variable is local to the pbt_pickPlanet event handler. Make it available by declaring it locally outside the events.

8. After the line local pPlanet, enter the following line:
```
local pOrbit
```

9. After the last event you entered, enter the following:
```
on spn_orbitRadius changed value do
(
    pOrbit.radius = spn_orbitRadius.value
)
```

10. Evaluate the script.

11. Click Pick Planet, and pick a planet.

12. Change the Orbit Radius value. The radius for the planet's path changes.

Disabling and Enabling UI Items

The script works, but it is not as error-proof as it could be. For example, the Create Planets button is available even if the user has not yet created a sun. Attempting to create planets before the sun has been created would generate an error.

To avoid user error, you can enable and disable UI elements based on what the user does with the UI. For example, when the dialog is opened, you can disable all buttons and spinners until the user creates a sun.

1. On the lines that define the spinners and buttons, add the following to each line except the first two:
```
enabled:false
```

Your code should look similar to the following:
```
(
  spinner spn_sunRadius "Sun Radius "
  button but_createSun "Create Sun"
  spinner spn_NumPlanets "Number of Planets " type:#integer \
                                range:[1,10,3] enabled:false
  button but_createPlanets "Create Planets" enabled:false

  group "Planets"
  (
  pickbutton pbt_pickPlanet "Pick Planet" autoDisplay:true \
    enabled:false
  spinner spn_planetRadius "Planet Radius " enabled:false
  spinner spn_orbitRadius "Orbit Radius " range:[0,1000,0] \
    enabled:false
  )
```

When you evaluate the script, only the first two UI elements in the dialog will be enabled. You will enable the others within the event handlers.

2. In the but_createSun pressed and rightclick event handler, enter the following lines to display the planet creation UI elements:

```
spn_numPlanets.enabled = true
but_createPlanets.enabled = true
```

This will cause these two UI elements to become available when the user creates either type of sun.

3. In the but_createPlanets event, add the following (be sure to add it outside the for loop, either before or after the loop):

```
pbt_pickPlanet.enabled = true
spn_planetRadius.enabled = true
spn_orbitRadius.enabled = true
```

4. Save the script.

5. Reset 3ds Max to clear the scene.

6. Evaluate the script.
 At first, only the first two UI items are available. After you create the sun, you can create planets. After you create planets, you can change each one's radius and orbit.

 One last change will make the script even more error-proof. When you first run the script, the Sun Radius parameter is set to 0. If you do not change this default, a sun is created with a radius of 0. You can easily imagine an inexperienced user clicking Create Sun over and over again to try to make the sun appear in the scene. The scene would become populated by dozens of invisible suns before he or she realized what the error was.

 To avoid this problem, you can set the Sun Radius parameter's default to 50 or another number larger than 0.

7. Add the following to the line that defines the Sun Radius spinner:

```
range:[1,1000,50]
```

The line should now look like the following:

```
spinner spn_sunRadius "Sun Radius " range:[1,1000,50]
```

8. Save your script.
 You can find a version of this script on the companion website in the file *Solar_System.ms*.

 You could make a number of additions to this script to improve it. For example:

 • Allow the user to enter the increment for creating the initial orbits, rather than using 100. If you do this, you will also need to expand the range for the Orbit Radius parameter to accommodate much larger numbers.

 • Allow the user to tilt each orbit, or make the orbit elliptical. This would require additional knowledge of transforms, which are covered in Chapter 5.

Conclusion

In this chapter, you learned how to construct user interfaces. You built a UI interface by creating a rollout and populating it with UI controls and adding event handlers to invoke elements of your script from the UI controls. You also learned the difference between a general script and a MacroScript, and how to create each.

The 3ds Max Interface

Chapter 3

The 3ds Max user interface is very large and complicated. Without MAXScript, tasks can easily become monotonous and boring. Moreover, artists, technical directors, and studios that do not have any custom scripts in their production pipeline are less efficient, slower, and less able to compete with those that do.

Objectives

After completing this chapter, you should be able to:

- Copy, instance, and reference scene geometry, and learn how to copy arrays.

- Use 3ds Max 'Max' commands.

- Invoke command panels via MAXScript.

- Access the main toolbar via MAXScript.

- Pick scene objects via a script.

- Pick scene points via a script.

- Use the mouse tracking tool.

- Use the painter interface.

Introduction

3ds Max contains many user interface items such as command panels, rollouts, dialogs, commands, and windows. The 3ds Max user interface also allows for many actions that are performed in the viewport, as well as commands to access external files. Because the 3ds Max user interface has such depth, many tasks that are complex or repetitive can quickly waste time. Such tasks can usually be scripted or aided by scripts.

MAXScript has many functions, and commands that operate on almost the entire user interface. It is in the best interest of an individual, studio or company to seriously look at these topics to find out how they can improve efficiency in their daily work.

The topic of MAXScript access to the user interface is too large to cover in one chapter of a book. Therefore this chapter will cover a few important topics only.

Copy, Instance, and Reference

One of the most basic tasks performed in the viewport is that of duplicating, or *cloning*, scene objects. Most of the tasks users can perform in the viewports can also be done via MAXScript.

It should be noted that copy and instance are supported by multiple data types and not just scene objects as they are represented in MAXScript. For instance, you can copy strings, colors, bitarrays, angleaxis values, and so on. This section will deal with copying primitive scene objects. You should consult the *MAXScript Reference* documentation for details on what other data types can be duplicated.

It is assumed that you know how to use copy, instance, and reference 3ds Max manually.

Copy

The syntax for the copy command is as follows:

```
copy <node>
```

To copy an object:

1. For this first example, reset 3ds Max, and open up the MAXScript Listener. In the Listener, type the following:
```
b = box heightsegs: 8
```

This will create a standard box with 8 height segments. The height segments will be used later in the tutorial.

2. Type the following:
```
c = copy b
```

This creates a copy of the box. It is located in the same position as the original box b.

3. Type the following:
```
move c [25,0,0]
```

Now, by inspecting the new box (variable c) you can see that the box is separate from the original. Any changes to box c have no effect on box b. The copied box has all of its own properties, modifiers, and so forth, and they can be changed without affecting the original or other copies.

In this example, you called the move function separately so you could visually see the different boxes. However it is possible to combine the two lines of code into one line with the following code:
```
d = copy c pos: [50,0,0]
```

This creates a copy of box c in a different location.

Instance

The syntax for the instance command is as follows:
```
instance <node>
```

Continue with the previous example. However, this time you create an instance of the box b.

To instance an object:

1. In the Listener, type the following:
```
i = instance b pos: [0,25,0]
```

This creates an instance of the original box (box i), which is located at the origin. The instance is located at the position you set in the Listener.

2. Type the following:
```
addmodifier i (bend())
```

3. Select the instanced box and switch to the Modify Command Panel. Change the parameters of the bend modifier and observe the results in the viewport.

 The changes you make to box i also update box b. Conversely, the changes you make to box b also update box i. This is classic behavior for an instanced scene object. Instances share properties, modifiers, materials and maps, and animation controllers with the original object, but not transforms, space warps, or pathnames.

4. To proceed to the next example, you must remove the bend modifier. In the Listener, type the following:
   ```
   deletemodifier i 1
   ```

 The deletemodifier function took the instanced value as the first argument. The second argument is the index of the modifier you want to delete. The index of the top modifier on the stack is the number one and increases towards the bottom of the modifier stack.

Reference

The syntax for the reference command is as follows:

reference <node>

Continue with the previous example.

To reference an object:

1. In the Listener, type the following:
   ```
   r = reference b pos: [0,-25,0]
   ```

 This creates an reference of the box, located apart from the original box at the origin.

2. Type the following:
   ```
   addmodifier r (bend())
   ```

 Notice that box r now has a bend modifier, but box b does not. You can think of the referenced box r as a child object and the original box b as a parent object. Changes made to the parent object will affect the child object, but any change to the child object will not affect the parent object.

3. Select the referenced box, and switch to the Modify Command Panel. Change the parameters of the bend modifier and observe the results in the viewport.

 Changes to the modifier on box r do not affect box b in any way (because box b has no modifier).

4. Type the following:
   ```
   b.height = 40.0
   ```

Notice that the change is propagated to both boxes. That is classic behavior for a referenced object.

Cloning Nodes Using MaxOps.CloneNodes

There is another, more complete method to clone nodes in MAXScript. The methods shown above are useful for simple objects, but you can get unexpected results when cloning objects with hierarchies, such as a light with a

target. You can use the MaxOps.CloneNodes method to maintain interdependencies such as parent child links between objects in the scene. The syntax for this method is:

```
maxOps.CloneNodes <array of nodes> clonetype: <enum> newNodes: <&array
of nodes> actualNodeList: <&array of nodes> offset: <point3> ...
```

This function will return true if successful or false if unsuccessful.

Note: There are more optional parameters than listed here. To keep things simple, only a few are covered.

Some of the MaxOps.CloneNodes parameters are:

- `<array of nodes>`—The array of nodes that you want to clone. However, if you pass in a single object, the function will detect this and automatically wrap it in an array.

- `clonetype: <enum>`—This parameter expects one of three values: `#copy`, `#instance`, or `#reference`. The default is `#copy`.

- `newNodes: <array of nodes>`—This node array will be filled with the new cloned nodes.

- `actualNodeList: <array of nodes>`—You will pass in an empty array for this optional parameter, which will be filled with the actual nodes that are cloned. The reason is that there can be dependencies between nodes that cause other nodes to be added to the list, for example, between light and camera targets, nodes parts of systems, part of groups, or expanded hierarchies.

- `offset: <point3>`—This moves the new node by the supplied point3 vector. This could be used to differentiate the new cloned nodes from the old nodes.

To demonstrate the difference between using the normal copy method versus the maxOps.CloneNodes method:

1. Reset the 3ds Max scene, and open the MAXScript Listener.

2. Create one targeted spot light in the 3ds Max scene.

3. Select the light. Do not select the target of the light.

4. In the Listener, type the following:
   ```
   a = $
   c = copy a
   move c [0,25,0]
   ```

 A duplicate light is created, but it shares the original target. MaxOps.CloneNodes must be used to clone the target too.

5. Type the following:
   ```
   maxops.cloneNodes a actualNodeList: &ANL clonetype: #copy \
        offset: [-25,-25, 0] newNodes: &NN
   ```

 A new light is created, with its own target.

6. Type the following:
```
print ANL
```

This prints two objects—the light and its target. In this example, you passed in one light object as the first argument. You passed in the address of an uninitialized array "&ANL" as the actualNodeList parameter. The function filled the array with the old light and the old light target. This ANL array is generally useful for inspection.

7. Type the following:
```
select NN
```

The new light and its target are selected in the scene. You also passed in the address of an uninitialized array "&NN" as the newNodes parameter. The function filled the array with the new light and the new light target. After calling this function, you can manipulate your new node in the array as usual.

For more information, see the following section in the *MAXScript Reference* Help:

MAXScript Language Reference > 3ds Max Objects > Interfaces > Core Interfaces > Core Interfaces Pages > Interface: MaxOps.

Copying Arrays

Arrays are very powerful and extremely useful in MAXScript. Arrays can contain just about everything that is scriptable. For example, you can have an array of numbers, strings, functions, structs, rollouts or even scene objects.

From time to time you will want to copy an array. In that case, you might think the following approach makes the most sense:
```
h = #(1,2,3)
m = copy h
```

However, it does not work. The value of m is not an array, it is simply a constant value of 'OK.' This is definitely not what you would expect. To get the expected results from copying an array, you need to add the optional argument of #noMap to the function call:
```
m = copy h #nomap
```

The Listener will then report:
```
#(1,2,3)
```

Adding the #noMap argument produces the expected results.

Included on the companion website is a script called *copy_instance_reference.ms* that demonstrates the material covered in this section.

Max Commands

MAXScript has some very general methods that control large parts of the user interface. Many of these are generated automatically in the top portion of the MAXScript Listener (called the macro pane) in response to

different scene events. For example, there is a command to save the scene file 'max file save' or a command to freeze the selection 'max freeze selection' or a command to maximize the scene viewport 'max tool maximize.'

For more information, see the following section in the *MAXScript Reference* Help:

MAXScript Tools and Interaction with 3ds Max > Interacting with the 3ds Max Interface >3ds Max Commands.

Command Panels

The command panels are one of the most important geographical areas in the 3ds Max program. By switching from one tabbed window to another, different commands then become available to the user. For example, mesh editing commands are only available from the Modify panel. MAXScript can be used to switch from one command panel to another. The syntax is as follows:

```
SetCommandPanelTaskMode [mode:] <panel name>
```

There is also a corresponding function to get the currently opened command panel:

```
GetCommandPanelTaskMode()
```

This returns one of the following panel names:

- #create
- #modify
- #hierarchy
- #motion
- #display
- #utility

To Set a Command Panel:

1. Reset the 3ds Max scene. The scene is opened to the create command panel. To change to the modify command panel, type one of the following:

 - `SetCommandPanelTaskMode #modify`
 - `SetCommandPanelTaskMode mode:#modify`

 After typing either of the above, the Modify command panel will be displayed.

Another way to alternate between command panels is to use Max Commands (discussed in the previous section). The Commands are:

- max create mode

- max modify mode

- max hierarchy mode

- max motion mode

- max display mode

- max utility mode

For more information, see the following section in the *MAXScript Reference* Help:

MAXScript Tools and Interaction with 3ds Max > Interacting with the 3ds Max User Interface > Command Panels.

Main Tool Bar

Many important basic commands are accessed from the main toolbar. MAXScript gives access to many of these commands. For instance, the undo button can be pressed programmatically, or the object selection dialog can be opened, or the move button can be pressed and activated.

For more information, see the following section in the *MAXScript Reference* Help:

MAXScript Tools and Interaction with 3ds Max > Interacting with the 3ds Max User Interface > Main Toolbar.

Picking Scene Objects

One of the most popular functions in advanced MAXScript is the function that allows you to pick a scene object using the standard scene selection tools. This is accomplished using the PickObject function. The syntax is as follows:

```
PickObject [message: <string>] [count: n | #multiple] [filter:
<function>] ...
```

Note: The PickObject function syntax is quite long, so to save space and to simplify this section, only three optional arguments will be explained.

When called, this function changes the cursor to a select object icon and waits for the user to select one or more objects in the 3ds Max scene. Some of the PickObject optional parameters are:

- [message: <string>]—This is a message that will be displayed in the status bar at the bottom of the 3ds Max UI.

- [count: n|#multiple]—This tells the function how many objects to collect. You either pass in an integer number (n) for a set amount of objects to let the user select, or you pass in #multiple to allow the user

to select as many objects as needed, before the ESCAPE key is pressed, or the right mouse button is clicked. See the *MAXScript Reference* Help for more information about selecting multiple objects.

- [filter: <function>]—This is a function that allows you to filter out different kinds of objects in the 3ds Max scene. This function can simplify the selection of objects if you only need to select a shape object in a scene full of boxes. The filter is called and is passed to the scene object that is under the hovering mouse cursor. For example:

```
function mySphereFilter obj = ( ClassOf obj == Sphere )
```

Here the body of the function returns true if the object is a sphere and false otherwise. This filter function is then passed to the PickObject function.

To use the PickObject Function:

1. Reset the 3ds Max scene, and open a new MAXScript file (Choose MAXScript > New MAXScript from the Menu).

2. Open the MAXScript Listener.

3. In the viewport, create five boxes and two sphere objects anywhere in your scene.

4. In the script file, type the following:
```
function mySphereFilter obj = ( ClassOf obj == Sphere )
sel = PickObject message: "Pick any sphere" filter: mySphereFilter
format "You selected: %\n" sel.name
```

5. Evaluate the script.
 When you move your mouse around the viewport, your mouse cursor changes to a mode for selecting objects when it is over a sphere, and reverts to a default pointer cursor when it is over a box. The prompt at the bottom of the 3ds Max window contains a directive to select spheres.

6. Try to select any of the boxes.
 Notice that you cannot do it. The filter function is preventing you from selecting anything but a sphere object.

7. Select any of the sphere objects.
 The script allows you to select a sphere, and executes the last line of the script. The Listener reports that you selected a certain sphere and prints the name of it. The function returned after picking only one sphere because the default behavior is to return after selecting one object. If the optional argument of count had been supplied an argument, the behavior would have been different.

For more information, see the following section in the *MAXScript Reference* Help:

MAXScript Tools and Interaction with 3ds Max > Interacting with the 3ds Max User Interface > Picking Scene Nodes.

Picking Points

MAXScript has many functions for working with the 3d viewports. There are functions for changing the layouts of the viewports, refreshing the viewports, setting snap modes, zooming, setting grids, and so on. Rather than cover all of the functions available for the viewports, this section concentrates on one important function that is extremely useful. This function is the PickPoint function, where a user selects a point or location in the viewport and the coordinates of that location is returned as a Point3 data type.

The syntax is as follows:

```
pickPoint [ snap:#2D|#3D ] [ rubberBand:<start_point3> ] ...
```

Some of the PickPoint parameters are:

• [snap:#2D|#3D] —This argument if supplied sets the snap type. If it is not supplied, the point selected will be in the current construction plane.

 Note: In order for this parameter to work, snaps must first be turned on in the 3ds Max user interface.

• [rubberBand:<point3>] —This argument draws a dashed line from the supplied point to wherever the mouse is located (while the function is still active). It is usually used to visually connect a series of points in the viewport.

To Use the PickPoints Function:

1. Reset the 3ds Max scene, and open a new MAXScript file (Choose MAXScript > New MAXScript from the Menu).

2. Open up the MAXScript Listener.

3. Create a few geometric objects in the viewport and turn on 3D snaps (not 2D or 2.5D snaps or any other type of snap.

4. In the script file, type the following:
```
pnt = point3 0 0 0
for i = 1 to 3 do
(
        pnt = pickPoint snap: #3D rubberband: pnt
)
```

5. Evaluate the script and pick three points in the viewport.
 As you pick points, notice that a line is drawn from the origin to your cursor for the first point, and then from point to point for the rest. A more sophisticated script would only start drawing the rubberband line after the first point click. Also note that in step 2, you are required to turn on snaps first, in order for the snap argument to work. This function does not turn on snaps for you.

For reference information, see the following section in the *MAXScript Reference* Help:

MAXScript Tools and Interaction with 3ds Max > Interacting with the 3ds Max User Interface > Viewports > Picking Points in the ViewPorts.

MouseTrack (Advanced)

The MouseTrack Function lets you track the mouse in the viewports. For instance it can monitor mouse clicks, mouse movement, and track the intersection of the mouse with scene geometry. You can respond to the mouse events by writing a function that will get called whenever a mouse event happens. This function is called a callback function. A callback function has a certain signature, and takes certain arguments that are supplied by MAXScript.

The syntax is as follows:

```
mouseTrack [on:<node>] [prompt:"msg"] [snap:#2D|#3D]
[trackCallback:fn|#(fn,arg)]
```

Some of the MouseTrack parameters are:

• [on:<node>]—This optional argument is a scene object that the function will respond to in your callback function. If you don't supply this, the MouseTrack function will operate on the active grid.

• [prompt:"msg"]—This is a text message that will be displayed in the status bar at the bottom of the 3ds Max window.

• [snap:#2D|#3D]—This enables snaps, and only works when an object is tracking on an object surface.

• [trackCallback:fn]—This is the function that gets called in response to mouse events and is the name of your callback function. This callback function should return a value of #continue to keep processing MouseTrack events. If the return value is anything else, the function will simply get called once and stop.

The callback function you implement should take seven arguments as follows:

```
function CallBack message intRay obj faceNumber shift ctrl alt = (...)
```

• message— This is a code that tells what the mouse is doing. It is one of four different enumerated messages:

#freemove—The mouse is moving and no mouse buttons are pressed.

#mousepoint—The left mouse button was pressed.

#mousemove—The mouse is being dragged with the left mouse button pressed.

#mouseabort—The right mouse button was pressed.

• intRay: The intersection from a ray starting at the mouse cursor and aiming towards the active grid or tracked object. A ray has a position property (.pos), and a direction vector (.dir).

• obj—This is the object that is getting tracked. It was assigned when the MouseTrack function was called in the optional [on:<node>] argument. If the optional [on:<node>] argument was unsupplied, then the obj parameter is undefined.

• faceNumber—The index number of the face the mouse is over. This only works if the object is an editable mesh. If not, this parameter is undefined.

• shift / ctrl / alt—These values tell whether these keys are depressed. Values are true or false.

To use the MouseTrack function:

1. Reset the 3ds Max scene, and open a new MAXScript file (Choose MAXScript > New MAXScript from the Menu). Also open the MAXScript Listener.

2. In the new Script window type the following:

```
function myFooFunction message intRay obj faceNumber shift ctrl alt =
(
    print message
    #continue
)

s = sphere()
mousetrack on: s prompt: "Tracking" trackCallback: myFooFunction
```

3. Save the file, and evaluate the script. Move the mouse around the viewport, and experiment with clicking and dragging. Be sure to watch the viewport as you perform your actions.

4. Press the 'ESC' key to exit the action.
As you move the mouse around the viewport, many #freemove messages are sent to the MAXScript Listener so that the Listener window starts scrolling very quickly. You have to be quick to observe a #mousepoint message when you press the mouse button. You should see all the mouse messages as you experiment with this tool.

Next, modify the script so you can interactively drag a teapot on the surface of the sphere. This code will be written in the myFooFunction callback function. When MouseTrack function is running, it is helpful to remember that when a mouse is over the tracked object, the intRay and obj parameters of the callback function are defined. To interactively drag the teapot on the sphere's surface, use the intRay parameter—a ray has a very handy position property that tells you where the ray hits the tracked object. You will assign this position to the teapot.

5. Delete any objects in the scene.

6. Modify your script to look like this:

```
pot = teapot radius: 5 wirecolor: (color 255 0 0)

function myFooFunction message intRay obj faceNumber shift ctrl alt =
(
    case message of
    (
        #freeMove:
        (
            if (obj != undefined) and (intRay != undefined) do
            (
                pot.pos = intRay.pos
            )
```

```
        )
    )
    #continue
)

s = sphere segments: 48 wirecolor: (color 0 255 255)
mousetrack on: s prompt: "Tracking" trackCallback: myFooFunction
```

Notice that you defined a small teapot (pot) at the top of the script. In the callback function, you now trap the #freemove message. You also test to make the sure the obj and intRay parameters are defined. When the two previously mentioned parameters are defined, you assign the position of the intersecting ray with mesh to the position property of the teapot.

7. Save and evaluate the script. Move your mouse over to the sphere, and notice the behavior as you continue to move your cursor over it. It may help to minimize your window so you can see four viewports at the same time.

8. Press the 'ESC' key to exit the action.
 The teapot moves and follows your mouse as it tracks over the sphere. When you move your mouse over empty screen space, nothing happens to the teapot. In a perspective viewport it may not look like much because the teapot is not rotating. However if you end the action and rotate the perspective view, you can see that the teapot is 'attached' to the surface of the sphere.

9. To make it apparent that the teapot is following the surface of the sphere, rotate the teapot to follow the normal vector at the intersection point. This data is precisely given in the callback function with the intRay parameter. The intersection ray (intRay) is from the point of intersection and is parallel to the normal vector of the face it intersects with. Now, it is a small matter to align the teapot with the surface of the sphere. Within the if statement, add a line of code after the position assignment:

```
...
if (obj != undefined) and (intRay != undefined) do
(
    pot.pos = intRay.pos
    pot.dir = intRay.dir
)
...
```

10. Save and evaulate the script. Move the mouse over the sphere.

11. Press the 'ESC' key to exit the action.
 The teapot is now aligned with the surface of the sphere.

To make this script more user friendly, it should abort the command when the user clicks a mouse button rather than when the user presses the escape key.

Currently, the function returns a #continue value, no matter what happens in the case statement. This is rather crude, but simple. Next, expand the case statement to handle the other messages, including the messages you will use to abort or cancel the script.

12. Modify your callback function to look like the following:

```
function myFooFunction message intRay obj faceNumber shift ctrl alt =
(
    returnValue = case message of
    (
        #freeMove:
        (
            if (obj != undefined) and (intRay != undefined) do
            (
                pot.pos = intRay.pos
                pot.dir = intRay.dir
            )
            #continue
        )
        #mouseAbort: ( undefined )
        #mousePoint: ( undefined )
        #mouseMove:  ( #continue )
    )
    returnValue
)
```

13. Save and evaluate the script. Move the mouse around and press any button to cancel the script. As you can see, the MouseTrack and callback function working together can make some very interesting scripts. The final version of this script called *mouse_track.ms* can be found on the companion website. For reference information, see the following section in the *MAXScript Reference* Help:

MAXScript Tools and Interaction with 3ds Max > Interacting with the 3ds Max User Interface > MouseTrack.

Painter Interface (Advanced)

The tools you looked at previously, such as the PickPoints function, the PickObjects function, and the MouseTrack function, are very powerful in their own right. This section deals with the pinnacle of interactive MAXScript tools, the painter interface.

3ds Max has some tools that use a paint-like interface, where a brush operates on an object to 'paint' geometry, push or pull vertices on the mesh, or do some other operation. The MAXScript painter interface exposes those underlying paint capabilities. There are many functions and properties for using the painter interface, and it can be complicated for new users. This section will serve as a short introduction only.

The painter interface, like other interfaces, uses a global variable called:

thePainterInterface

This variable is not just any value. It has properties and methods that govern and manage the paint process.

Note: For more information on interfaces, see the appendix topic on "Interfaces."

The painter interface operates by using *callback* functions. Now you will remember from the MouseTrack example that a *callback* function is defined by you, but called by the system. Hence the term '*callback*' because the system calls you back via the function you wrote. The previous section dealt with the MouseTrack function, which only used one callback function. The painter interface uses five. These five functions are called during different painter type events. They are:

- `StartStroke`—Called when the paint event begins.
- `PaintStroke`—Called during the paint event.
- `EndStroke`—Called when the paint event ends.
- `CancelStroke`—Called when the user cancels the paint event.
- `SystemEnd`—Called when the paint event is ending.

To register these functions with the painter interface, you call a member function (also called a method) of `thePainterInterface` and pass it the five callback functions in the order shown above. This should be done after the functions are defined in the script. The initialization method is:

```
thePainterInterface.ScriptFunctions startStroke paintStroke endStroke
cancelStroke systemEnd
```

Once you have initialized the functions you tell the painter interface which objects (nodes) to paint on. Think of these objects as a canvas. For example:

```
canvasNodes = $
thePainterInterface.initializeNodes 0 canvasNodes
```

The above example would select all the objects in the scene and make them paintable. The first argument is not used, and should be left as zero.

To start a paint session, call the function:

```
thePainterInterface.startPaintSession()
```

To end paint session call:

```
thePainterInterface.endPaintSession()
```

Next, write a script to demonstrate the painter interface. You will write a script that paints a pyramid over a teapot. It will have a small UI, where the user presses a check button to paint, and unchecks it to stop painting. Instead of a floating rollout, you will place the UI in a rollout in the utilities panel.

To use the painter interface:

1. Reset the 3ds Max scene, and open a new MAXScript file (Choose MAXScript > New MAXScript from the Menu).

2. Open the MAXScript Listener.

3. In the new script window, define the following script:

```
global scatteredObject

--callback functions
function StartStroke = (

)
function PaintStroke = (

)
function EndStroke = (

)
function CancelStroke = (

)
function SystemEnd = (

)
--utility definition
utility paintStuff "Paint Utility"
(
    checkbutton ckb_paint "Paint"

    on paintStuff open do
    (
        clearlistener()
        delete $*  --delete all prexisting objects

        s1 = sphere radius: 24 segments: 48
        scatteredObject = Pyramid width:2 depth:2 height:20 pos:[0,25,0]

        thePainterInterface.ScriptFunctions startStroke paintStroke \
            endStroke cancelStroke systemEnd

        thePainterInterface.initializeNodes 0 s1
    )
    on ckb_paint changed state do
    (
        if state then
        (
            thePainterInterface.startPaintSession()
        )
        else
```

```
        (
            thePainterInterface.endPaintSession()
        )
    )
)
OpenUtility paintStuff
```

Note: The entire script will work only if the callback functions are in the global scope.

4. Save and evaluate the script.
 The command panel will switch to the utility panel, and a new rollout will be displayed. Any previously existing geometry will be deleted, and two new objects will be created.

5. Press the 'Paint' button. Move your mouse over the sphere and notice the paint tool displayed over the sphere. Paint on the sphere. It may look something like this:

The painter interface automatically traced a red path on the surface of the object as you drew out a path. When you let go of the mouse button the path disappears, and you are left to paint again. Presently, the sharp needle-like pyramid has not been used.

6. Add the following code inside the PaintStroke function:
   ```
   function PaintStroke =
   (
     localHit = [0,0,0]
     localNormal = [0,0,0]
     worldHit = [0,0,0]
     worldNormal = [0,0,0]
     str = 0.0f
   ```

```
    radius = 0.0f

    thePainterInterface.getHitPointData &localHit &localNormal \
        &worldHit &worldNormal &radius &str 0

    --create an instance of the pyramid and move it
    obj = instance scatteredObject
    obj.pos = worldHit
    obj.dir = worldNormal
)
```

7. Save and evaluate the script. After the rollout opens, press the 'Paint' button and start painting on the sphere. Now it should look something like this:

You have successfully painted one object onto another. The final script *painter_interface.ms* can be found on the companion website. For reference information, see the following sections in the *MAXScript Reference* Help:

- MAXScript Language Reference > 3ds Max Objects > Interfaces > Other Interfaces > Other Interfaces > Interface: thePainterInterface.

- MAXScript Tools and Interaction with 3ds Max > Creating MAXScript Tools > Scripted Paint Tools.

Conclusion

You have now been exposed to many important concepts of MAXScript and the user interface. You have learned about cloning objects, including cloning arrays. You have learned about a number of MAXScript commands available for performing high-level user interface access. You have learned about command panels, the toolbar, picking scene nodes, and picking points. You have also learned how to use the MouseTrack function and the painter interface.

Understanding Objects and Classes

MAXScript is a very powerful scripting language that has many principles of object-oriented programming. By recognizing these principles, you can gain further insight and understanding into how MAXScript works, thus opening the door to advanced scripting.

In this chapter, the MAXScript Reference Help is also discussed.

Objectives

After completing this chapter, you should be able to:

* Understand objects in the MAXScript context.

* Identify an object's class.

* Use the *MAXScript Reference* to determine an object's properties and methods.

* Understand MAXScript grammar and syntax.

Introduction

Fundamental to writing scripts is an understanding of the class structure used within MAXScript. Rather than attempting to teach you every command you need to write a script, this chapter shows you how to work with the MAXScript class structure to find the information you need within the *MAXScript Reference* Help. Many of the commands shown in this chapter will be familiar to you from the previous chapters.

In this chapter, you will learn the underlying concepts for these commands so you can expand your use of them many times over.

The *MAXScript Reference* Help is included with 3ds Max, and is updated periodically. Before starting this chapter, you should obtain the latest version of the *MAXScript Reference* from the Autodesk website.

Go to the Autodesk website at *www.autodesk.com* and select 'Media & Entertainment' on the banner. On the page that opens, select 'Training' on the left sidebar. Then, select 'Autodesk 3ds Max' from the drop down list. On the next page, select 'Documentation, Online Tutorials, Sample Files'. At the bottom of the page that opens, you will find the link 'MAXScript 8 Help'.

If you cannot obtain this file, you can use the *MAXScript Reference* on the companion website for this book. The *MAXScript Reference* is contained in the file *maxscript.chm* on the companion website. You can view the reference from the companion website, or copy it to your *3dsmax9/help* folder to overwrite the existing version.

Object Oriented Programming

MAXScript uses an approach called *object-oriented programming* (OOP). The term object isn't limited to objects in a 3ds Max scene. In MAXScript, an object is any entity that can be manipulated. This includes geometry, modifiers, controllers, colors, and numbers.

You can think of an object as a holder for information. The information held by the object varies depending on the type of object. As an example, consider a sphere in a scene. In MAXScript, the sphere object is not the 3D sphere itself. Instead, consider a virtual container labeled sphere that holds the sphere's name, radius, position, rotation, and other information about the 3D sphere. The container labeled sphere is what MAXScript works with.

You could create many such containers with different information without actually creating any 3D spheres in the scene. Then, if you wanted to create a sphere in the scene, you could run a MAXScript command to take all the information in one of the containers and create the 3D object.

Objects in MAXScript can be containers for:

- Any object you can create on the Create panel, such as a box, circle, free spot light, dummy helper, or gravity space warp.

- Materials such as Standard, Blend, Double Sided. An object like this contains all the information about the material's maps and parameters.

- Constraints and controllers, such as Path constraint, Rotation List controller. An object like this contains all the parameter data for the controller.

- Render effects such as motion blur, film grain. An object like this contains all the parameter data for the effect.

- Colors.

- Number types, such as integer, float, and Point3. This type of object is usually a variable. For example, the code x = 3 assigns the value 3 to the variable x. In this case, x represents an object.

- Strings.

- True/false values (Boolean data types).

- Arrays and collections.

- Elements of a user interface, such as checkboxes, buttons, and spinners.

For clarity, these elements are referred to as *objects*, and 3ds Max objects are referred to as *scene objects*.

An object contains not only the properties, but also the methods. This is a fundamental distinction between OOP and traditional "procedural" programming. This integration of properties (data) and methods (functions) into an object is the power of *object-oriented programming*.

In the first part of this chapter, you will work with objects that are also scene objects to help familiarize you with the way MAXScript works. After reading this chapter, you will have a better understanding of how the term object-oriented programming applies to MAXScript.

Class Hierarchy

Object-oriented programming works with classes, where each object belongs to a certain class. The classes are organized into a hierarchy.

To illustrate how the hierarchy works, let's take a look at part of the MAXScript class hierarchy. The hierarchy for a box, capsule, and chamferbox is organized as follows:

Value

 MAXWrapper

 Node

 GeometryClass

 Box

 Capsule

 ChamferBox

These three geometry objects are chosen because they are the first three in alphabetical order, and they will provide you with a framework for investigating the significance of the class hierarchy.

There are no classes below the Box, Capsule, and ChamferBox classes. These classes at the bottom of the hierarchy are *object classes* from which you can create MAXScript objects. In other words, there is no such thing as a GeometryClass object, but there is a Box object, Capsule object, and ChamferBox object.

In the earlier chapters, these object classes are referred to as *data types*. In the *MAXScript Reference*, they are called *classes*.

Note: Class names such as MAXWrapper and Node do not have any special significance. They are simply names the MAXScript programmers invented for classes.

Next, you will use the *MAXScript Reference* to see how classes are organized in MAXScript.

To access information about the Node class:

1. Open the *MAXScript Reference* by doing one of the following:

 * In 3ds Max, choose Help menu > MAXScript Reference.

 * Open the file *maxscript.chm* from the companion website.

 * Open the file *maxscript.chm* from your *3dsmax9/help* folder.

 The *MAXScript Reference* consists of a collection of online "books." Each book is indicated by a plus sign (+) and a book icon in the Contents pane of the Help viewer. You open books to navigate to the topics in that book.

2. In the *MAXScript Reference*, navigate to the book MAXScript Language Reference > 3ds Max Objects > Node: MAXWrapper > Node Subclasses.

The Node Subclasses book contains books for all the subclasses below Node. Their names should look familiar; all are scene objects you can create from the Create panel in 3ds Max.

3. Expand the book GeometryClass : Node.
The name of this book tells you that GeometryClass is just below the Node class in the hierarchy.

4. Open the topic "GeometryClass : Node."
This topic shows you all the subclasses below GeometryClass.

5. Click and open "Geometry – Standard and Extended Objects."

6. Click Box to open the topic "Box : GeometryClass."
This topic shows you the *constructor* and *properties* for the box object class. You will learn more about these terms in the sections that follow.

Class Inheritance

While each object has properties specific to itself, it can also inherit properties from the classes above it. To know about all the properties you can use with an object, you must also learn the properties of the classes above it.

In MAXScript, the Node class has certain properties, and the GeometryClass inherits them. In turn, the Box, Capsule, and ChamferBox classes inherit these same properties.

To work with node properties:

1. Open the topic Node : MAXWrapper > Node Common Properties, Operators, and Methods > General Node Properties.
The first listing shown is:

```
<node>.name
```

This listing indicates that the name property is available for all objects in the Node class, which includes all geometry, shapes, lights, cameras, helpers, and space warps.

The listing shows a *rule* that tells you how you can use this property with MAXScript. You will learn more about how to read rules in later sections of this chapter. For now, all you need to know is that the designation <node> refers to any object class below the Node class.

Let's work with a box you will create in the scene.

2. In the Listener, type the following:

```
b = box()
b.name
```

The second line returns the name of the box. You can also use this property to change the name of the box.

3. Type the following:

```
b.name = "Newbox"
```

This renames the box Newbox.

4. In the General Node Properties topic, scroll about halfway down to the heading Viewport Related Properties. Here you will find some properties that are familiar. They are:

    ```
    <node>.isSelected
    <node>.isHidden
    ```

 These properties hold Boolean (true or false) values to indicate whether the object is selected or hidden.

 You will recognize these properties as parameters you can set on the Object Properties dialog. Not all Node properties correspond to 3ds Max properties, but many do.

5. In the Listener, type the following:

    ```
    b.isSelected = true
    ```

 You have just set the box property .isSelected to true. The box is now selected, and the Listener returns the value true.

6. Type the following:

    ```
    b.isHidden = true
    ```

 Now the box is hidden. Let's try the same properties with another type of object.

 Note: You may notice a that the box is hidden but still selected. This is an anomaly made possible by MAXScript.

7. Type the following:

    ```
    c = capsule()
    c.isSelected = true
    ```

 This creates a capsule, then selects it.

 Every class below the Node class in the hierarchy shares these properties.

Class inheritance is at the heart of object-oriented programming. It makes it possible for MAXScript to share properties and other information among classes.

It's helpful to think in terms of classes when working with MAXScript. When you want to get or set a certain object property, you will have to find out what's available and how to use the properties. This often means looking through the *MAXScript Reference* to find the classes above the object in the hierarchy so you can learn their properties.

Determining Class Types

MAXScript provides high-level tools that display information about the classes that are accessible in 3ds Max. This section will deal with two methods that identify which class and superclass any MAXScript value belongs to. Programmers familiar with C++ or C sometimes call this Run Time Type Identification (RTTI).

Since each class passes its properties to the classes below it, it's important for you to know how to find the classes above a particular object's class quickly.

To find an object's class and superclass:

1. In the Listener, type the following:
   ```
   classOf c
   ```

 Because the object c belongs to the Capsule class, this returns the class Capsule.

2. To find the class that a class belongs to, use the classOf method with the name of the class itself.
   ```
   classOf Capsule
   ```

 This returns the class GeometryClass, the class just above Capsule in the class hierarchy.

3. To find the next highest class, you can use the superClassOf method.
   ```
   superClassOf Capsule
   ```

 This returns the class Node.

You can use class queries in your scripts to help ensure the appropriate types of objects are being used. For example, suppose you write a script that allows the user to select a sphere and a line or spline. Later in the script, you will access the sphere's radius, and use the line as a path for a Path constraint. In order for the script to work properly, you would have to be sure the user is selecting the right kinds of objects. You could use class queries to test whether the user's selection is valid.

The following short script illustrates this usage of class queries in a script's UI definition.

```
If ((spherePath != undefined) and (spherePath.isDisplayed == true)) do
(destroyDialog spherePath)
rollout spherePath "Sphere and Path"
(
    pickbutton pick_sphere "Click to Pick Sphere"
    pickbutton pick_path "Click to Pick Path"
    on pick_sphere picked sphObject do
    (
    if classOf sphObject!=sphere then \
    messagebox "Please pick a sphere."
    )

    on pick_path picked pathObject do
    (
    if classOf pathObject!=line and classOf pathObject!=SplineShape
    then messagebox "Path must be a line or editable spline."
    )
)
createDialog spherePath
```

For more information, see the following sections in the *MAXScript Reference* Help:

- MAXScript Language Reference > Values > Working with Values.

- MAXScript Language Reference > 3ds Max Objects > Identifying and Accessing MAXScript Classes and Properties.

Instances

An object you create with MAXScript is called an *instance* of that MAXScript class. The objects b and c that you created earlier are instances of the Box and Capsule class, respectively. Do not confuse this type of instance with a clone of a scene object, which is a different thing altogether.

You always use properties with an instance of a class, rather than on the class itself. In MAXScript, you can use properties on the variable that holds the instance, or on the object specified by name.

To work with instances:

1. In the Listener, type the following:
   ```
   box.name
   ```

 The Listener returns an error. This is because you are trying to use the property with a class, rather than an instance of that class.

2. Now type the following:
   ```
   b.name
   ```

 The last command returns the name of the box, and does not return an error.

 Hint: Where Box01 is the actual name of an object in the scene, you can also use the following:
   ```
   $Box01.name
   ```

The concept of instances is very important in MAXScript. You can think of a *class* as a type of object, while an *instance* is a specific example of that type of object. A class is a conceptual grouping, while an instance is a specific object. MAXScript performs functions on instances, not on classes.

In the *MAXScript Reference*, a class name in brackets <> indicates an instance of the class shown inside the brackets. For example, <Capsule> refers to an instance of the Capsule class, while <node> refers to an instance of any object in the classes below the Node class.

Properties

While an object is a thing, a property is data about that thing. As a real-life example, consider a cup sitting on your desk. If the cup is an object, its color, size, texture, and temperature are properties of the cup.

In MAXScript, every object has properties. You have already seen some of these properties in the scripts you created in earlier chapters. For example, the box object has the properties listed in the *MAXScript Reference* topic "Box : GeometryClass." These are the same properties that appear when you use the method showProperties on a box.

More information on properties appears at the end of this section.

Querying Properties

In chapter 1, "MAXScript Basics," you were introduced to the showProperties method. This method is useful for printing objects' properties to the MAXScript Listener. This section will introduce further ways to access object properties.

A common task is to determine what properties an object contains, and most importantly accessing those properties: For instance, you may wanted to store all the values that describe a box in an array. For such a task, the first thought you could have is to use the showProperties method to print the properties to the Listener. However, this does not allow you to access the properties of the object, nor does it return a string. You need a method that will return an array of values. This is what the getPropNames method does. The syntax is as follows:

```
getPropNames <maxwrapper_object> [#dynamicOnly]
```

This method returns an array of property name values accessible on the object.

Note: This section will not discuss the optional argument #dynamicOnly. For more information, see the *MAXScript Reference* Help.

To get property names:

1. Reset 3ds Max, and open a new Script Editor Window.

2. Open the MAXScript Listener. Type in the script:
    ```
    b = box()
    boxProps = getPropNames b
    ```

 The Listener prints out an array containing the properties of the box:
    ```
    #(#height, #length, #lengthsegs, #width, #widthsegs, \
    #mapcoords, #heightsegs, #realWorldMapSize)
    ```

 These are the same properties that are displayed for the box in the Modify panel.

 Note: In 3ds Max 8, the getPropNames (along with showProperties) now works for Function Published interface properties.

Getting / Setting Properties

Now that you have an array of properties for the box you can use the getProperty and setProperty methods to get and set its properties. The syntax for each is:

```
getProperty <maxwrapper object> <property_name>
```

```
setProperty <maxwrapper object> <property_name> <value>
```

The <property_name> parameter can either be a name such as #height, or a string such as "height." The <value> parameter is a value that is being assigned to the property.

To get and set properties:

1. In the Listener, type the following:
   ```
   getProperty b #height
   ```

 The Listener prints the result of 25.0.

2. Select the box in the viewport and switch to the Modify panel. Verify that the height indeed is 25.0 (the default value).

3. Type the following:
   ```
   setProperty b #height 40
   ```

4. Notice that the height of the box changed in the viewport and is now 40.0. This last line of code could have been written like this:
   ```
   b.height = 40.
   ```

 This last usage is shorter and easier to read. So what is the advantage of using the get / setProperty methods? If you need to access just one property in your code, then b.height = 40 (for instance) is fine. But, if you need to access ALL of an object's properties, then using the getPropNames and setProperty methods are the best approach.

 Note: When setting a property, you should verify that the value in the last argument matches the property type being set. For instance, the following code will throw an error:

   ```
   setProperty b #height "foo" -throws an error
   ```

5. Continue with the current example. Print the properties of the box to the Listener along with their corresponding values by typing the following:
   ```
   boxProps = getPropNames b
   for prop in boxProps do format "% = %\n" prop (getProperty b prop)
   ```

 The Listener prints the properties and values of the box:
   ```
   #height = 25.0
   #length = 25.0
   #lengthsegs = 1
   #width = 25.0
   #widthsegs = 1
   #mapcoords = false
   #heightsegs = 1
   #realWorldMapSize = false
   ```

 For more information, see the following section in the *MAXScript Reference* Help:

 MAXScript Language Reference > 3ds Max Objects > Identifying and Accessing MAXScript Classes and Properties.

Nested Properties

Some properties have properties of their own. For example, you have seen that the .pos property has more properties .x, .y, and .z, indicating the object's position on the X, Y, and Z axes. These other properties are called *nested properties*.

The following command returns the object's position on the X axis, represented by a number:

```
<node>.pos.x
```

To use this property, you would replace <node> with the instance of an object, such as:

```
b.pos.x
```

This returns the box's position on the X axis.

The following command returns the object's Rotation controller:

```
<node>.rotation.controller
```

For more information, see the following sections in the *MAXScript Reference* Help:

* MAXScript Language Reference > 3ds Max Objects > MAXWrapper: Value > Nested Object Properties.

* MAXScript Language Reference > 3ds Max Objects > Node: MAXWrapper > Node Common Properties, Operators, and Methods > Node Transform Properties.

MAXWrapper Class

The MAXWrapper class includes all 3ds Max scene objects, plus modifiers, materials, and effects. Part of the MAXWrapper hierarchy is shown below.

Value

 MAXWrapper

 Node

 Modifier

 Atmospheric

Let's take a closer look at the Modifier class.

Each modifier is actually considered an object within MAXScript. To use a modifier object, you must create an instance of it. For example, if you want to apply a Bend modifier to an object, you must create an instance of the Bend modifier.

To add a modifier:

1. In the *MAXScript Reference*, go to MAXScript Language Reference > 3ds Max Objects > Modifier: MAXWrapper and SpacewarpModifier: MAXWrapper > Modifier and SpacewarpModifier Types > Modifiers.
 Here, you can see all the object classes under the Modifier class.

2. In the Listener, type the following:

```
cyl = cylinder heightsegs:5
```

You have just created an instance of a cylinder with five height segments.

3. In any viewport, move the cylinder away from the box so you can see it more clearly.

4. Type the following:

```
myMod = bend()
```

You have just created an instance of the Bend modifier.

5. Enter the following in the Listener:

```
addmodifier cyl myMod
```

This applies the Bend modifier to the cylinder instance, and the modifier appears on the cylinder's modifier stack. To add the Bend modifier to the cylinder, you created an instance of the modifier, and used the instance in the last line to apply the modifier to the object.

If you are an experienced 3ds Max user, this concept might be confusing at first. When working within the 3ds Max user interface, you don't have to create the modifier or controller as a separate object before you can apply it; you simply choose it from a menu or command panel. But with MAXScript, you'll need to create an instance of every aspect of your scene before you can do anything with it.

There are exceptions to this rule, but you'll grasp the exceptions only after you understand the MAXScript workflow of creating instances for all objects, even objects such as modifiers that are not scene objects.

To work with modifier properties:

1. Open the topic "Bend : Modifier."
 The properties for the Bend modifier match the parameters that appear when you apply a Bend modifier within the 3ds Max scene.

 The Bend modifier assigned to myMod retains its connection to the actual modifier in the 3ds Max scene. Thus, when you change the properties of myMod variable, you also change the parameters of the cylinder's Bend modifier in the scene.

2. In the Listener, type the following:

```
myMod.angle = 90
```

The Bend modifier's Angle parameter in the scene changes to 90, and the cylinder bends accordingly.

When you apply a modifier to an object, the modifier itself is treated as a property of the object. For example, the following sets the Bend modifier's angle:

```
c.bend.angle = 60
```

Methods

A *method* is a function that performs a task on a MAXScript object. Like properties, methods are inherited from one class to the next class down the hierarchy; in other words, methods available for a particular class are also available for its subclasses.

Some methods for the Node classes are:

- `hide <node>`

- `select <node>`

- `distance <node> <node>`

Because these methods are available for the Node class, they are also available for everything in the GeometryClass, such as boxes, cylinders, and capsules.

The hide and select methods perform the same function as the .isHidden and .isSelected properties. In many cases, MAXScript can perform an action with either a method or a property.

For more information, see the following section in the *MAXScript Reference* Help:

MAXScript Language Reference > 3ds Max Objects > Node: MAXWrapper > Node Common Operators, Properties, and Methods.

Constructors

A *constructor* is a special type of method that creates an instance of an object class. You have already used a few constructors in your scripts.

The following code uses the box constructor to create a box and assign it to the variable b:

```
b = box()
```

A constructor must be followed by parentheses () or by property settings of the class. For example, the following is also a valid way to use the box constructor:

```
box length:40 width:20
```

You also use constructors to create other types of objects, such as modifiers and controllers.

```
myMod = bend()
```

This line creates an instance of the Bend modifier class in the variable myMod.

A constructor is always specific to an object class. In other words, each object class has its own constructor. Compare it with other methods such as hide <node>, which is shared with all classes under the Node class.

To find out the constructors for an object class, find the object class topic in the hierarchy in the *MAXScript Reference*. If a class has constructors, they are listed at the beginning of the topic.

Constructing on the Fly

Earlier, you created an instance of a modifier before you applied it to an object. You can avoid having to do this by using a constructor within an expression. This will eliminate the need to create the modifier (or other object) before using it in the script.

For example, you can apply the Bend modifier to the object c with the following command:

```
addmodifier c (bend())
```

Here, you are using the constructor bend() on the fly to apply it to the object. In this case, the constructor must appear in parentheses. The disadvantage to this approach is that you don't have a separate variable (such as myMod) for which you can get and set properties.

Get and Set Methods

Methods often begin with the prefix *get* or *set*. A method with one of these prefixes is used to get or set specific object properties.

A large number of get and set methods are used with the Editable_Mesh class, which is under the GeometryClass.

To work with get and set methods:

1. In the *MAXScript Reference*, open the topic: MAXScript Language Reference > 3ds Max Objects > Editable Meshes, Splines, Patches, and Polys > Editable_Mesh and TriMesh > Editable_Mesh: GeometryClass and TriMesh: Value.
 This topic shows all the methods and properties common to editable meshes. Rather than create an editable mesh from scratch, convert the box to an editable mesh.

2. Scroll down to the end of the Constructors (Editable_Mesh) section, about half way through the topic. The last two methods convert any object in the Node class to an editable mesh.

3. In the Listener, type the following:
   ```
   m = convertToMesh b
   ```

 On the Modify panel, you can see that the box has been converted to an Editable Mesh.

4. In the *MAXScript Reference*, open the next topic, "Mesh Vertex Methods."
 The first method listed is getNumVerts. Let's try this one.

5. In the Listener, type the following:
   ```
   getNumVerts m
   ```

 The Listener returns the number 8, which is the number of vertices in the editable mesh.

 You could also use this method to assign the number of vertices to a variable:

   ```
   numVerts = getNumVerts m
   ```

 This would assign the number 8 to the variable numVerts.

Mapped Methods

Some methods can act on an entire set of objects with one command. When an operation is performed over a series of objects, it is said to be *mapped* over those objects.

To use a method on more than one object, you can use a wildcard character to specify the objects, or you can arrange the objects in a collection, such as an array, and use the method on the collection.

To work with a mapped method:

1. Open the topic "Editable_Mesh : GeometryClass and TriMesh : Value" again.

2. Scroll down to locate the rule for the method convertToMesh.

   ```
   convertToMesh <node>                              -- mapped
   ```

 The designation mapped shown after the rule indicates that you can use this method with several objects at once. Let's try it out with the objects in the scene.

3. Reset 3ds Max, or delete all objects from the scene.

4. In the Listener, type the following:

   ```
   c = cylinder pos:[50,0,0]
   b = box()
   s = sphere pos:[-50,0,0]
   ```

 This creates three objects in the scene at different locations.

5. In the Listener, type the following:

   ```
   convertToMesh $*
   ```

 This uses the wildcard * to convert all the objects in the scene to editable meshes. Next, you will create an array that holds these objects, and use a method on the array.

6. In the Listener, type the following:

   ```
   objectArray = #(c,b,s)
   ```

 This creates an array called objectArray that contains the three objects.

7. In the Listener, type the following:

   ```
   hide objectArray
   ```

 This hides the objects. The hide method, which can be used on all members of the Node class, is also a mapped method.

Working with the MAXScript Reference

Now that you have learned about objects, classes, properties, methods, and their relationships in MAXScript, let's take a look at a few tools that can help you use the *MAXScript Reference* Help more effectively.

MAXScript Grammar

When you look up a topic in the *MAXScript Reference* Help, the information is laid out with a certain grammar telling you how to use the method or property in a script.

You have already seen several examples of MAXScript grammar. For example:

```
<node>.name
hide <node>
convertToMesh <node> -- mapped
```

From these examples, you can infer the following rules:

- Bold—Indicates the exact text you should type in the script.
- <text>—Indicates an object class.

There are other rules that you will need to know when you read the *MAXScript Reference*. They are:

- […]—Items in square brackets are optional. You can specify them 0 or 1 time.
- {…}—Items in curly brackets alone are optional, and can be specified 0, 1, or many times.
- {…}+—Items in curly brackets with a plus sign are not optional. You can specify them 1 or many times.
- {…|…|…}—If items are separated by bars, you must enter one of the items shown if you use the option. Items separated by bars can be inside square or curly brackets, depending on the number of times you specify them.
- Items in angled brackets <> represent a syntax rule that has been defined elsewhere. Some examples are:
 - <node>—A member of the Node class.
 - <digit>—An integer.
 - <point3>—A series of 3 values.

Rule Definitions

Many rules are defined in the *MAXScript Reference* help topic "MAXScript Grammar," under MAXScript Language Reference. In this topic, and throughout the *MAXScript Reference*, the symbol : : = is used to show a definition of a rule. For example:

```
<point3>            ::=  [ <expr>, <expr>, <expr> ]
```

This defines the rule for specifying a point3 object. The square brackets are in bold, indicating that they are to be typed exactly as shown. In other words, they do not indicate an optional element.

The rule <expr> indicates an expression. There are many types of expressions in MAXScript, the simplest being an integer.

From this rule, you can determine that the following is a valid way to express a Point3 object in MAXScript:

```
x = [10, 20, 15]
```

Note: Another valid method to create a point3 object is to use the point3 constructor, which has been demonstrated earlier in the book.

```
x = point3 10 20 15
```

This creates a point3 value in the variable x. You could also use the following:

```
x = [j * 10, 8, myVar]
```

This line of code is valid as long as the variables j and myVar are defined elsewhere in the script, and the expressions evaluate to valid values for the components of a Point3 value.

Optional Parameters

Many MAXScript methods use optional parameters with keywords. This section shows you how to read these listings and use them with methods.

To use optional parameters:

1. Open the topic MAXScript Language Reference > 3ds Max Objects > Modifier: MAXWrapper and SpacewarpModifier: MAXWrapper > Modifier Common Properties, Operators, and Methods. Under Associated Methods, the second method shown is:

   ```
   addModifier <node> <modifier> [before:index]   -- mapped
   ```

 You have already used this method with the following syntax:

   ```
   addmodifier <node> <modifier>
   ```

 The text inside the brackets is optional. The text shown below the method listing in the *MAXScript Reference* tells you that you can use this argument to specify where the modifier should be put on the stack. An index of 2, for example, would put the modifier in the second position on the stack, counting from the top down.

 The text before is a keyword that you must put in the code to specify what you're doing.

2. Next, create two modifier instances:
   ```
   myMod1 = bend()
   myMod2 = twist()
   ```

3. Add one of the modifiers to an object:
   ```
   addmodifier c myMod1
   ```

4. To apply the Twist modifier below the Bend modifier on the stack, enter the following:
   ```
   addmodifier c myMod2 before:2
   ```

5. Now try the following:

```
addmodifier c myMod2 2
```

This returns an error. The keyword `before` must be included to make the command work.

Return Values

When looking at the *MAXScript Reference*, you sometimes see a method listing preceded by text in angled brackets. The text in brackets indicates the data type that is returned by the method. This syntax often appears with *get* and *set* types of methods.

To see an example of return values, open the topic MAXScript Tools and Interaction with 3ds Max > Interacting with the 3ds Max User Interface > Filters > Selection Filter. The first four listings are:

```
<int>GetSelectFilter
<void>SetSelectFilter <int_index>
<int>GetNumberSelectFilters
<BOOL>GetDisplayFilter <int_index)
```

A method preceded by angled brackets indicates the command returns a value in the specified class.

- <int>—Returns an integer.
- <void>—Does not return a value.
- <bool>—Returns a value of true or false.

When you know what type of value the command will give you, you can use the appropriate type of variable to store the return value. For example:

```
x = GetSelectFilter -- This stores an integer in x
y = GetDisplayFilter 3 -- This stores a true/false value in y
```

Reference Assignments

When you assign a value to a variable, it might seem like you are actually storing the value in the variable. In fact, you are storing a *reference* to the value in the variable.

For example, consider the following expressions:

```
a = [0,20,45]
```

This does not store the Point3 value [0,20,45] in the variable a. Instead, it stores the Point3 value somewhere in memory, then puts a pointer to that location in the variable a. In other words, a contains a reference to the Point3 value, not the value itself.

This might seem like an unimportant distinction, since you can use variables and their corresponding values without concerning yourself about what is stored where. However, this concept becomes relevant when you assign the same value to multiple variables.

Suppose you include the following line in your script:

```
a = b = c = [0,20,45]
```

The same Point3 value is referenced by the three variables a, b, and c.

If you change the entire Point3 value for one of the variables, that variable no longer points to the same location. For example, this line of code would change the Point3 value referenced by variable b, so it no longer points to the same place as a and c.

```
b = [0,0,30]
```

As for a and c, they still reference the original value of [0,20,45]. But if you change only one component of this value, a different situation occurs. For example, suppose you use the following line later in your script to change an object's position on the X axis:

```
a.x = 90
```

This changes the first value in the Point3 value to 90. The command also changes the value that is referenced by both a and c, so both now reference the value [90,20,45].

The same is true for referenced arrays. Suppose you create three referenced arrays as follows:

```
d = e = f = #(5,10,15,21)
```

Changing one component in the array will change it for all variables.

```
e[4] = 20
```

Now d, e, and f reference the array #(5,10,15,20).

Conclusion

In this chapter, you learned important principles of object-oriented programming, and how MAXScript implements those principles. You learned about the class hierarchy in MAXScript, and how properties defined in a parent class are also implemented in base classes. You learned about the MAXWrapper class and studied a modifier as an example. You also learned how to determine the class of scene objects and other data types when scripts are running so that your scripts can react accordingly. Last and perhaps most importantly, you learned how to use the *MAXScript Reference* Help.

Transforms and Animation

This chapter will discuss principles of

animation via MAXScript. All animation in

3ds Max is implemented using one of the

many controller classes accessible in the

Track View and Motion Panel, or assigned

automatically by 3ds Max when you use the

Animate button to do key framing. These

controller classes are fully accessible

through MAXScript.

Objectives

After completing this chapter, you should be able to:

- Work with the position, rotation and scale transforms in MAXScript.
- Calculate rotations accurately.
- Change an object's pivot point or axis of rotation.
- Create and delete animation keys.
- Work with controllers.
- Work with tangent types.

Introduction

In this chapter, you will learn to use transforms effectively in scripting. You will often want to transform objects based on user input, and set keys to create animation.

You will also learn how to set up and use controllers to customize animation.

Position and Scale Transform Properties

The following position and scale properties are available for all geometric objects, regardless of their type:

```
.pos
.position -- same as .pos
.scale
```

In this chapter, the position and scale transforms are covered first, as these work in a similar manner. The rotation transform has certain limitations that you must take into consideration when scripting rotations.

Position Transform

An object's position can be set in two ways:

- Directly using the .pos or .position property.
- Indirectly using the move method.

In Chapter 1, "MAXScript Basics," you learned how to set the position directly for any object with the .pos or .position properties:

```
s = sphere()
s.pos = [150, 10 , 0]
s.pos.x = 200
```

The move method is used this way:

```
move s [10.0, 10.0, 10.0]
```

The argument list for move is the reference of the object you are moving, followed by the amount by which you want the object to move, as a Point3 data type. Note that the move method is not moving the object to point [x, y, z], but is moving it by the amounts [x, y, z]. Therefore, if you apply move more than once, the object continues to move by the specified amounts.

Setting the position property sets the value explicitly, and does not increase the value each time.

To use pos and move:

1. Reset 3ds Max.

2. In the Listener, type the following:
```
s = sphere()
```

3. Type the following:
```
s.pos.x = 25
s.pos.x = 25
s.pos.x = 25
```

 Executing this line of code three times results in the sphere always positioned at x = 25.

4. Type the following sequence and press ENTER at the end of each line.
```
move s [25, 0, 0]
move s [25, 0, 0]
move s [25, 0, 0]
```

 This results in the sphere moving a total of 75 units in the X direction.

The Scale Transform

The scale property stretches or compresses an object along the designated axis. By default, the X, Y, and Z components of the scale property are equal to 1.0, corresponding to a 100% size along each component. Setting a component to 2.0 would double the original scale, while setting it to 0.5 would halve the original scale.

You could apply scale to all three coordinates like this:
```
s.scale = [2.0, 1.0, 0.5]
```

As with position, this is a Point3 designation. The statement above would stretch the object to twice its size along X, leave Y unchanged, and compress the object by half along Z. You could just stretch along X by typing:
```
s.scale.x = 2.0
```

A uniform scale can be done by simply multiplying the scale property:
```
s.scale = 3.0 * s.scale -- or
s.scale *= 3.0
```

This statement says "set the new scale property to 3.0 times the current scale property." All axes will be scaled.

Just as there is a pos property and a move method, there is a corresponding scale method for the scale property. The scale method is implemented as follows:

```
b = box()
scale b [1.0, 2.0, 3.0]
```

This scales the box by different amounts in each direction. The .scale property and the scale method parallel the .position property and move method, where the property sets the Point3 values explicitly, and the method increases them incrementally.

To scale an object:

1. In the Listener, type the following:
   ```
   b = box()
   ```

2. To set the scale property, type and evaluate the following:
   ```
   b.scale = [2, 2, 2]
   ```

 [2, 2, 2] is returned in the Listener.

3. Type the following to set the scale again:
   ```
   b.scale = [2, 2, 2]
   ```

 The Listener still returns [2, 2, 2].

4. Now apply the scale method by typing:
   ```
   scale b [2, 2, 2]
   ```

 The Listener returns [4, 4, 4].

Rotation Transform

Rotations are more complicated than position and scale transforms. The mathematics behind them is more involved.

As with position and scale, MAXScript provides two approaches to rotating objects:

- Set the object's .rotation property explicitly.
- Use the rotate method.

With the position and scale transforms, each of the X, Y, and Z values are always expressed as single numeric values, such as 1.0 or 34.5. With rotations, there are several ways to express the number of degrees and the axes around which to rotate. Each method interprets values differently. The methods are:

- EulerAngle
- Quaternion
- AngleAxis

EulerAngle

The eulerAngle approach is perhaps the most intuitive to use, as it most closely parallels the way you work visually in the 3ds Max interface.

An eulerAngle constructor takes three arguments, one for each axis, expressed in degrees. Using this value rotates the object by the specified number of degrees on each axis using the World coordinate system.

```
b.rotation = eulerAngles 0 45 0
```

The previous statement would rotate the object by 45 degrees on the Y axis in the World coordinate system. The eulerAngles' rotation value is the easiest to understand, as it corresponds to the way you see rotations occur in viewports.

You can also put the eulerAngles' result in a variable and use it on an object afterward:

```
ang = eulerAngles 0 45 0
b.rotation = ang
```

The variable ang is actually a MAXScript object, with a rotation data type.

You designate angles for more than one axis like this:

```
ang = eulerAngles 30 20 44
```

When setting keys using eulerAngles, rotation from one key to the next is limited to 180 degrees on any axis. This is because eulerAngle uses the shortest possible path from one key to the next.

To rotate with eulerAngle:

1. In the Listener, type the following to create a cylinder and an eulerAngle object:
   ```
   c = cylinder height:50
   euAngle = eulerAngles 0 45 0
   ```

 This puts the eulerAngle rotation value in the variable angle.

2. Type the following to rotate the cylinder:

```
rotate c euAngle
```

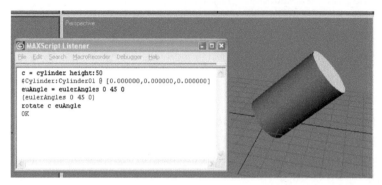

When you apply this to an object, the X rotation occurs first, followed by the Y rotation, followed by the Z rotation. It is important to keep this in mind especially since rotations are not commutative. In other words, a rotation around the X axis followed by a rotation around the Y axis does not produce the same orientation as a rotation around Y followed by X.

Rotation Property

You can use the components of an object's rotation property to set rotation along a specific axis. For example, the following statements can be replaced by statements that set the rotation property directly:

```
euAngle = eulerAngles 30 45 60
rotate b euAngle
```

These statements can be replaced with:

```
b.rotation.x_rotation = 30
b.rotation.y_rotation = 45
b.rotation.z_rotation = 60
```

Setting the rotation property in this manner limits the rotation angle to 360 degrees.

To test the 360-degree limitation:

1. Reset 3ds Max.

2. In the Listener, create a default box:

```
b = box()
```

3. Move the time slider to 100, turn the Auto Key button on, then type:

```
b.rotation.z_rotation = 720
```

4. Turn Auto Key off, and play the animation.
The object does not rotate.

5. Move the time slider to 100, turn the Auto Key button on, then type:
```
b.rotation.z_rotation = 450
```

6. Turn Auto Key off. Play the animation.
 The object will rotate only 90 degrees since the full 360-degree rotation is ignored (450 - 360 = 90).

EulerAngles Limitations

Euler rotations present a special challenge both internally in 3ds Max, and in MAXScript. The difficulty stems from the fact that as you rotate an object on one axis, the other axes change. A short exercise will illustrate how this works.

To test coordinate systems:

1. Reset 3ds Max.

2. Open the MAXScript Listener.

3. In the Top viewport, create a box that is somewhat flat and long by typing the following:
```
b1 = box length:100 width:75 height:25
```

4. Now create a copy of the box:
```
b2 = copy b1
```

5. Move the new box away from the original:
```
b2.pos.x = 100
```

The dimensions of the boxes will help you envision the rotations in this exercise.

6. In 3ds Max, open Graph Editors menu > Track View - Dope Sheet. Expand the Track View hierarchy until you see the Rotation tracks for Box01.
 You should be able to see the tracks for the X, Y, and Z Rotation. Currently, all rotations values are 0.

7. Set the Reference Coordinate System to Local by typing the following in the Listener:
```
set coordsys local
```

133

8. In the Listener, type the following:

```
b1.rotation = eulerAngles 45 0 0
```

This rotates the box by 45 degrees around the World X axis. In Track View, you see the X Rotation track value change to -45.

Next, you will rotate the box around its Y axis.

9. In the Listener, type the following:

```
b1.rotation = eulerAngles 0 45 0
```

In Track View, you would expect that the Y Rotation track to change to 45, but that is not the case. Instead, the X, Y, and Z Rotation tracks change to about -54.74, -30.00, and 35.26 respectively.

Gimbal Coordinate System

To understand what happened in the last exercise, let's use the Gimbal coordinate system. The Gimbal coordinate system shows the most accurate visual representation of euler XYZ rotation in the scene.

To use the Gimbal coordinate system:

1. Select the second box, Box02.

2. In Track View, expand the display to show the Rotation tracks for Box02.

3. In the 3ds Max UI, click Select and Rotate, and change the Reference Coordinate System to Gimbal. This coordinate system's gizmo resembles the Local coordinate system's gizmo, but only until you begin rotating the object.

4. In any viewport, rotate the second box by 45 degrees on its X axis.

5. Rotate the second box by 45 degrees on its Y axis.

The Track View tracks for this box read 45, 45, and 0. Note that the second box's rotation does not match the first box's rotation, which was performed with the Local coordinate system.

When you rotate with any coordinate system, 3ds Max converts the current coordinate system to Gimbal values for the X, Y, and Z Rotation tracks. It does this transparently so you might never realize it is happening. The only way you can tell is by looking at the track values in Track View.

6. Alternate between the two coordinate systems, Local and Gimbal, and rotate the boxes with each. You will see a difference in the way the transform gizmo operates.
 With Gimbal, the following occurs:

 • When you rotate on the Y axis, the X-axis gizmo rotates to follow it.

 • When you rotate on the Z axis, the X and Y gizmos rotate to follow it.

 This occurs because Euler XYZ rotations must evaluate rotations one axis at a time and in a specific order, and by default the Euler XYZ controller evaluates in the order X-Y-Z.

From this experiment, you can see that the only accurate way to calculate rotations on more than one axis is to use the actual values represented by the Gimbal coordinate system. Earlier, you did a rotation on one axis only (the box's local Z axis) and that worked fine in the Local coordinate system. However, for rotation on more than one axis, you need to use the Gimbal coordinate system to get an accurate representation for X, Y, and Z.

Gimbal Lock

From the previous experiment, you might conclude that you should use the Gimbal coordinate system to represent rotations in MAXScript. However, the Gimbal coordinate system has a problem, which is illustrated by the following exercise.

To experience Gimbal lock:

1. In the 3ds Max UI, change the Reference Coordinate System to Gimbal.

2. In any viewport, select an object and rotate it around its Y axis until the X-axis gizmo coincides with the Z axis.

You have just seen a fundamental problem with the Gimbal system. When you rotate by 90 degrees on the Y axis, the X- and Z-axis gizmos coincide, and subsequently represent the same axis of rotation. This situation, called gimbal lock, severely limits the types of rotations you can do.

You can get around this problem to some degree by changing the axis order for your rotations. For example, in this situation, if you knew the object would most likely rotate by 90 degrees about the Y axis, you could change the axis order to YZX or YXZ to put the Y rotation first. This would prevent gimbal lock when the object is rotated by 90 degrees about the Y axis. However, if you then rotated by 90 degrees about the Z or X axis, you would still get a case of gimbal lock.

For this reason, the Gimbal coordinate system is also limited in how it can represent rotations.

Local Rotations

All 3D software, including 3ds Max, has its own representation of *local rotation*, where you can rotate around an object's local axes. 3ds Max uses the local coordinate system to represent local rotation. However, you have just seen that rotation with the local coordinate system does not produce the actual values for the X, Y, and Z Rotation tracks in Track View. In this sense, local rotation is not an accurate representation of what is occurring.

On the other hand, the Gimbal coordinate system provides a more accurate picture of actual values stored for the X, Y, and Z rotations. However, it still calculates the axis rotations in a specific order. If you change the calculation order, the object's final orientation will often be different.

In short, there is no way to accurately represent a specific "local" rotation with euler XYZ values. Due to the nature of 3D rotation calculations, all 3D software suffers from this limitation.

Quaternions

When working with scene objects directly in the 3ds Max UI, the limitations of Euler XYZ representation will often have no effect on your ability to rotate objects and get the expected result. You can simply use the coordinate system that best suits the situation, and visually work toward the desired result.

When working with scripting, you do not have the option to work with the model visually. You must be able to represent rotation accurately with numbers and get a specific result.

This is where the quaternion method of representing rotation comes in handy. Quaternions represent each possible orientation explicitly, so you can set exact rotations around the world X, Y, and Z axes with no ambiguity.

A quaternion value is expressed as an angle and a Point3 value that describes a vector:

```
quat <angle> <vector>
```

The vector portion of the expression is a Point3 expression. The individual values in the Point3 expression are always between -1 and 1, inclusive. Some examples are:

```
quat 30 [1, 0, 0]
quat 30 [0.266917, 0.534798, 0.801715]
```

To understand quaternions, imagine a sphere with a vector inside it pointing from the sphere's center to its surface. The vector portion of the quaternion tells you the direction in which the vector points. The angle indicates by how many degrees the object should rotate around that vector.

When the vector values consist of a 1 and two 0's, the vector is easy to imagine as it points along one of the X, Y, or Z axes. The 1 value determines the axis along which the vector points. For example, a vector value of [1, 0, 0] causes the vector to point along the X axis.

For a more complex vector expression such as [0.266917, 0.534798, 0.801715], the vector points from the imaginary sphere's center to the location on the sphere's surface defined by this Point3 expression. The object would rotate around this vector by the number of degrees specified by the angle value. In the case of the example above, the angle is 30.

Usually, you will use vectors that point along the X, Y, or Z axis. If you do use vectors that point in other directions, you will need to know how to construct them.

Vector Values

The vector values in a quaternion must be calculated carefully. The square root of the sum of the squares of each component must equal 1. Using the example of quat 30 [0.266917, 0.534798, 0.801715], you can see that:

square root of $(0.266917)^2 + (0.534798)^2 + (0.801715)^2 = 1$

This limitation is due to the fact that the vector's length must always be equal to 1. The length of the vector is always equal to the square root of $x^2 + y^2 + z^2$.

Figuring out the correct quaternion vector values can be difficult and time-consuming. Let 3ds Max do it for you with the normalize method:

```
rot_vect = normalize [10, 14, 5]
q = quat 90 rot_vect
```

Predefined Rotation Variables

There are several predefined global variables in MAXScript. The x_axis, y_axis and z_axis are three of these variables. They represent Point3 values for the rotation axes.

```
x_axis represents [1, 0, 0]
y_axis represents [0, 1, 0]
z_axis represents [0, 0, 1]
```

In any rotation expression, you can substitute the Point3 expression with its corresponding variable. Knowing this, you could also use this expression to make the same statement shown earlier:

```
q = quat 45 x_axis
```

As with eulerAngles, you can assign the quaternion rotation object to any rotatable object:

```
b = box()
q = quat 45 x_axis
rotate b q
```

Expressions as Arguments

Often it is more convenient to compress two or more script statements into one. You can do this easily in MAXScript when calling functions. In all of our examples so far, variables or explicit numbers were provided as arguments. Instead, you can use expressions as arguments. An expression is a construct that evaluates to a value. For example, if you type quat 20 x_axis in the Listener and press ENTER, you see that the Listener indicates a successful command.

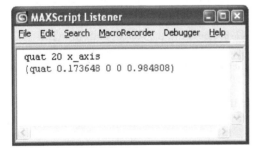

The expression you typed gets evaluated to a value, even though you did not assign the value to a variable. A quaternion object is created and the value is held in a variable internal to MAXScript that you don't see. The following two scripts do the same thing:

Create a quaternion object, then create a box and rotate it by that value:

```
rot = quat 30 y_axis
b = box rotation:rot
```

Alternatively, create the box and rotate it using an expression in the constructor:

```
b = box rotation:(quat 30 y_axis)
```

The expression `quat 30 y_axis` evaluates to a quaternion, so MAXScript allows you to just enter the whole expression directly for the function argument. Internally, 3ds Max calculates the expression first, and then assigns it to the rotation property. You must put the expression inside parentheses so 3ds Max can recognize where the expression begins and ends. How often you use expressions and where you do it is a matter of purpose and style.

Quaternions are limited in that you can only specify angles from -180 to 180 degrees. If you want to rotate more than this 360-degree span, you must use the angleaxis method.

AngleAxis

If you want to rotate more than 360 degrees, you can use angleaxis objects. These are similar to quaternions in their implementation. An angleaxis object looks just like its quaternion counterpart:

```
ang = angleaxis 30 [1, 0, 0]
ang = angleaxis 30 x_axis
```

The two statements shown are equivalent. Both create an object, ang, that produces a 30-degree rotation around the X axis.

To rotate with AngleAxis:

1. Reset 3ds Max.

2. In the Listener, create a default box by typing:
   ```
   b = box()
   ```

3. Turn on Auto Key, and move the time slider to frame 100. In the Listener, type:
   ```
   b.rotation.x_rotation = 720
   ```

4. Play the animation.
 The box does not rotate.

5. Move the time slider to frame 100. With Auto Key still turned on, type the following into the Listener:
   ```
   ang = angleaxis 720 [1, 0, 0]
   rotate b ang
   ```

6. Turn off Auto Key, and play the animation.
 The box performs two full revolutions.

Contexts

All geometric objects have a pivot point associated with them. The pivot point is the point about which movement, rotation, and scale take place. So far in this chapter, you have only considered transforms with respect to an object's default pivot point.

To transform the pivot point manually:

1. Create any object.

2. On the Command panel, choose the Hierarchy tab.

3. With the object selected, turn on Affect Pivot Only.
 The pivot point moves and rotates when you apply the move and rotate transforms. The following figure shows the pivot point for a box after it has been arbitrarily transformed.

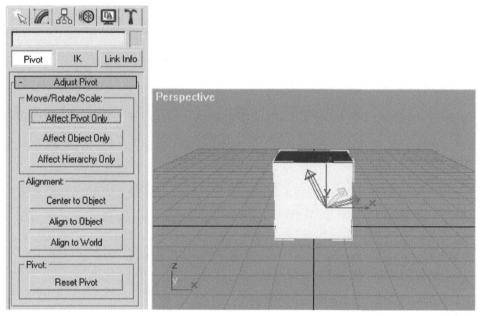

You can change the pivot point of an object in MAXScript by setting or moving its pivot property. For example:

```
object.pivot = [0, 0, 10.0]
```

or

```
object.pivot.z = 10.0
```

Any subsequent transforms of the object will be with respect to the new transformation center.

To transform a pivot point with MAXScript:

1. Create a box. Type the following and then press ENTER:
   ```
   b = box()
   ```

2. Move the pivot point. Type the following and then press ENTER:
   ```
   b.pivot.z = 40.0
   ```

3. On the Command panel, choose the Hierarchy tab. Turn on Affect Pivot Only. Make sure the box is selected. You see the pivot point of the box displaced along the Z axis.

4. Set the pivot point to the center of the box using the .center property. Type the following and press ENTER:

```
b.pivot = b.center
```

You see the pivot point move to the center of the box.

When you use the rotate method, 3ds Max assumes you mean with respect to the World Coordinate System and about the object's pivot point. You can transform an object with respect to points other than its own pivot point, or with respect to coordinate systems other than the World Coordinate System. This is done using

contexts. Contexts specify the reference for your operation. Two important contexts are `coordsys` and `about`.

- `coordsys`—Specifies the coordinate system of the operation.
- `about`—Specifies the pivot point (or transform center) for the operation. The `about` context applies to rotation and scaling.

To use the About context:

1. Create two cylinders in your scene. Type the following. Press ENTER at the end of each statement:
```
c1 = cylinder height:50
c2 = cylinder pos:[40, 0, 0]
```

Next, try two different rotations of c1.

2. Type the following and press ENTER:
```
rotate c1 (quat 45 y_axis)
```

The default coordinate system is World, and the default pivot point is the object's pivot point, which is at the base of the cylinder. Next you examine the `about` context and its usage.

3. Right-click any viewport, and press CTRL + Z to undo the rotation you just did.

4. In the Listener, type the following and press ENTER:

```
about c2 rotate c1 (quat 45 y_axis)
```

You get another rotation, but this time the transform center is the pivot point of c2.

The `about` context prefix comes at the beginning of the statement, not at the end as you might expect. 3ds Max interprets the statement from left to right, so you must apply the context before the rotation. If you place the `about` context prefix at the end, it will be applied for the next operation you type.

Here are other examples of using `about`:

- `about [x, y, z]` — Rotates about the defined point.

- `about selection` — Rotates about the center of the currently selected object(s).

Coordsys Context

You can also use the `coordsys` context to change the current working coordinate system. Again, statements must have the `coordsys` context prefix at the beginning. For example:

```
in coordsys local rotate c1 (quat 45 y_axis)
```

Here the reference coordinate system is set to local just for the lines of the code that follow in parentheses. To set a coordinate system for all commands until further notice, use this construction:

set coordsys local

`Coordsys` can be set to World, local, parent, grid, screen, or another object's local coordinate system.

Earlier, you learned that when you set the `.pos`, `.rotation`, and `.scale` properties with a statement, the values are set absolutely and do not increment when the statement is repeated. This is true for all coordinate systems except local. When the coordinate system is set to local, the coordinate system changes its position, rotation, or scale each time you set a property, so a subsequent repeat of the same statement will cause the transform to occur again in a relative fashion.

Animation

Animation in 3ds Max is accomplished through the use of animation controllers. Controllers calculate the values of objects' animatable properties by a variety of interpolation methods, depending on the controller you select. The most common animation controllers, those for position, rotation, and scale, are called transform controllers.

Animation of a scene is organized by tracks. A track holds information about how a single object, modifier, parameter, or other element, changes during the course of the animation. Each animatable element in your scene has a track associated with it, and each track can have a controller assigned to it.

A scene's tracks and their properties can be accessed and edited in 3ds Max using Track View. Transform controllers can be assigned and edited on the Motion panel as well. To get the most from this section, you should be familiar with the use of Track View for viewing and editing tracks, and with the process of assigning controllers using either Track View or the Motion panel.

Controllers

For each object you create, transform controllers are assigned automatically to the object. For other animatable parameters, a controller is assigned to the object as soon as you add a key for the parameter.

For all object properties that are animatable, you can access the .controller sub-property, which specifies the actual controller.

```
s = sphere()
s.pos.controller
```

This would return the value Controller:Position_XYZ, indicating that the controller for the sphere's position track is Postion_XYZ.

The .controller property has the sub-property .value. Once a controller is assigned to a parameter, you can set a controller value this way:

```
s.pos.controller.value = [20,0,50]
```

Some controllers, such as Position_XYZ, have three components. Each of those components also has its own controller. You can access these controllers by using the indices 1, 2, and 3:

```
s.pos.controller[1].controller
```

This returns the controller for the X component of the default Position_XYZ controller, which is Bezier_Float. You can also use the .value sub-property with this subcontroller:

```
s.pos.controller[1].controller.value
```

This would return the value of the X component of the Position_XYZ controller.

Each controller has sub-properties specific to it. For example, if the object has a Position_XYZ controller as its position controller, the following line is equivalent to the previous line of code:

```
s.pos.controller.X_Position.controller.value
```

For a controller that has subcontrollers, there is always more than one way to access a controller and its values. Many programmers find that they prefer the construction controller[1].controller over the more explicit controller.X_Position, as it allows them to work with whatever controller is assigned to the object (provided the controller has three components). If you use the former construction within a script, you can change the controller that the object uses without generating an error.

To assign a new controller to an animatable parameter, you can create an instance of the controller, then assign it.

```
c = linear_float()
s.radius.controller = c
```

Then you can use the instance to change the controller's properties.

```
c.value = 40
```

As with all instances, if you assign the controller in the variable c to other parameters in the scene, changing the value of c will change all instances of c.value.

In many situations, you can use the .track sub-property in place of .controller. However, it is recommended that you use .controller to ensure your scripts work in all situations.

Animation Keys

With MAXScript, you can create keys for tracks, and set their values.

- You can create animation keys with the animate context. This context is the equivalent of turning on Auto Key and performing the commands that follow it. However, 3ds Max will not actually turn on the Auto Key button in the user interface.

```
animate on
(
   [commands]
)
```

With this context, you can use at time to indicate where you want the keys to be set:

```
s = sphere()
animate on
(
   at time 50 s.radius = 10
   at time 100 s.radius = 60
)
```

This would create keys for the sphere's radius at frames 50 and 100, setting the sphere's radius to 10 and 60 on those keys, respectively.

When you use animate on to set keys, a key is automatically created at frame 0 regardless of whether you explicitly set a key there. This follows the way the Auto Key button works in 3ds Max; when you set a key at a

frame later than 0 and there is no key at frame 0, 3ds Max automatically creates a key at frame 0 with the track's original value.

When the sphere is first created, the radius track doesn't have a controller assigned to it. When you create keys with the animate on context, the default controller for a sphere's radius, Bezier_Float, is assigned to the radius track. After you create keys for the track, you can display the controller type by typing the following in the Listener:

```
s.radius.controller
```

- You can also create animation keys with AddNewKey. If the track already has a controller, you can use addNewKey to add a key directly to the controller:

```
c = s.radius.controller
addNewKey c 20
```

This adds a key for the sphere's radius controller at frame 20. Setting a key in this way does not change the controller's value at that frame; it simply sets a key.

When you add keys with addNewKey, a key at frame 0 is not created automatically.

To delete all keys for a specific controller, you can use the following:

```
deleteKeys s.radius.controller
```

Key Values

To change a key value at a specific frame, you can:

- Use the animate on context, and set key values either directly to the controller, or to the parameter itself. The following two lines of code are equivalent:

```
animate on ( at time 30 s.radius = 50 )
animate on ( at time 30 s.radius.controller.value = 50 )
```

You would most likely want to use the shorter version when writing scripts. However, when setting rotation keys, you can force a value greater than 360 without using angleAxis by assigning the value directly to the controller. For example, consider the following two lines of code:

```
at time 50 s.rotation.z_rotation = 720
at time 50 s.rotation.controller[3].controller.value = 720
```

Assume the rotation controller is the Euler XYZ controller. The first line would result in no rotation taking place, since the angle always evaluates to the remainder after dividing by 360. However, the second line would set a key that turns the object by two full rotations about its local Z axis.

- Use the .keys property, which contains an array of keys already set for a specific controller.

```
s.radius.keys[2].value = 40
```

This changes the value of the second key set for the radius controller.

When you change key values with the .keys array, you must be aware of the controller to which you are assigning values. The value you assign is evaluated to the controller's keys. If you created the controller as an instance and assigned it to more than one animatable parameter in a scene, changing its value with .keys will change it for all the parameters to which the controller is assigned.

To create a simple animation:

1. Reset 3ds Max.

2. In the Listener window, create a teapot:
   ```
   t = teapot()
   ```

 You will animate the radius of a teapot, starting at frame 0 and ending at frame 100, with keyframes at 0, 50, and 100. Do this in the Listener window so you can get feedback as you type each step.

 Although the default controller for the teapot radius is a Bezier Float controller, you want to change that.

3. Create a linear_float controller object:
   ```
   c = linear_float()
   ```

 The linear_float controller provides a smooth, linear change of a property's value between two keyframes. It can only be applied to properties, such as the teapot's radius, which is described by a single float data type.

4. Now that you have a teapot and a controller, assign the controller to the teapot's radius:
   ```
   t.radius.controller = c
   ```

 Now you will set keys with the `animate` on context. As each keyframe is added, the animatable property's controller (in this case, the controller for the radius) will have an array entry added to its .keys property.

5. Create three key using the `animate` on context:
   ```
   animate on
   (
       for i = 0 to 100 by 50 do
       (
           at time i t.radius = ((i * 0.5) + 10)
       )
   )
   ```

 This sets the radius to 10, 35, and 60 at frames 0, 50, and 100, respectively.

6. Play the animation, and watch the teapot's radius change.
 You can access the keys in several ways.

7. Type the following:
   ```
   print c.keys[2]
   ```

 The Listener responds with #Linear Float key(2 @ 50f). Since the controller was assigned to the teapot's radius, you can also access the key positions directly through the teapot's radius.

147

8. Type:

```
print t.radius.keys[2]
```

The Listener responds as in step 7.

9. Now play your animation, and watch the teapot's radius change.

Controller Types

The linear float controller is simple and straightforward. Other common controllers are:

- Linear controller group—Includes the linear_float, linear_position, linear_rotation, and linear_scale controllers.

- Bezier controller group—Includes the bezier_float, bezier_position, bezier_point3, bezier_rotation, bezier_scale, and bezier_color controllers.

- TCB controller group—Includes the tcb_float, tcb_position, tcb_point3, tcb_rotation, and tcb_scale controllers.

In the linear controller group, each type of controller provides for a simple linear interpolation between keys. Linear interpolation means that the property being animated changes in a steady, evenly graduated fashion. For example, halfway between keys, the property's value will have achieved half of its change, and so on. The difference in controller types within each group above is simply the type of variable being controlled.

The Bezier controller gives you more flexibility in defining an animation. The controller has the following properties:

- .inTangent—float or Point3

- .outTangent—float or Point3

- .inTangentType and .outTangentType—#smooth, #linear, #step, fast, #slow, #custom, or #auto

- .x_locked—Boolean

- .y_locked—Boolean

- .z_locked—Boolean

- .constantVelocity—Boolean

The .inTangent and .outTangent properties are used if you are creating a custom tangent type. In the case of position, they would be Point3 data types, and would define the tangent values for X, Y, and Z at the keyframe.

If you are not familiar with Bezier controllers, see the *MAXScript Reference* Help for more information.

To use the bezier controller:

1. Reset 3ds Max.

2. In a MAXScript window, type the following:
```
s = sphere showTrajectory:true
```

 This creates a sphere, and causes its trajectory display to turn on.

3. Continue the script with the following:
```
s.pos = [-100, -100, 0]

c = bezier_position()
s.pos.controller = c
```

4. Create motion for the sphere by setting keys:
```
animate on
(
    at time 0 s.pos = [-50, -60, 0]
    at time 35 s.pos = [-10, -50, 0]
    at time 70 s.pos = [20, 50, 0]
    at time 100 s.pos = [80, 10, 0]
)
```

5. Evaluate the script.
 You can see the interpolation between the keys by studying the trajectory displayed in the viewports.

6. Play the animation.
 The default tangent type for both the .inTangentType and .outTangentType properties is smooth. Leave the defaults for keyframes 0 and 100, but change the types for keyframes 35 and 70.

7. In 3ds Max, choose Graphic Editors menu > Track View - Curve Editor. When the Curve Editor appears, select the sphere's Position track to see the function curves.

8. In the Listener, type the following to change the key tangents:

```
c.keys[2].inTangentType = #fast
c.keys[2].outTangentType = #fast
c.keys[3].inTangentType = #slow
c.keys[3].outTangentType = #slow
```

In Track View, you can see the changes to the curves.

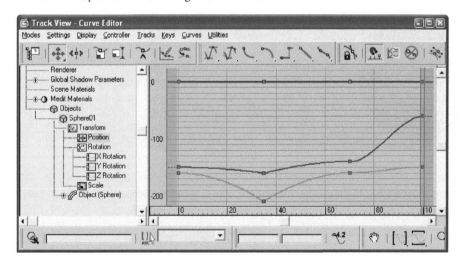

9. Play the animation.

To create a wheel rotation script:

1. With what you know about rotations and coordinate systems, you can write a script that sets rotation keys based on user input and scene information. Here, you will write a script that sets rotation keys for a wheel on a car. The amount by which the wheel rotates will be determined by how far the car travels. Load the file *Roadster_start.max* from the companion website.
 This scene contains a simple car with four wheels.

2. Play the animation.

The car is constrained to a path along the road, and travels at a constant velocity. The wheels, which are cylinder primitives, are linked to the car.

The scene contains two cameras. One follows the car as it travels, while the other is locked to the right front wheel. A small object is linked to the wheel. This object, along with the star-shaped hubcap, will enable you to see how the wheel turns.

Write a script that does the following:

- Allows the user to pick the wheel, and the path along which the car travels.

- Test that the wheel the user chooses is a cylinder, and the path is a line or editable spline.

- Determines the length of the path.

- Uses the wheel's circumference and the length of the path to calculate how many times the wheel should turn.

- Sets keys that cause the wheel to turn by the appropriate number of degrees on the Z axis.

3. Start with a script that already has the UI portion set up. Choose MAXScript menu > Open Script, and choose the script *WheelRollStarter.ms* from the companion website.
This script contains the UI items you will need for the completed script, and a few events. The last event, which will calculate the keys, is empty.

The first line tests to see if there is a dialog displayed. If so, it closes the dialog. This prevents the script from generating numerous copies of the dialog while you are testing the script.

```
try (closeRolloutFloater wheelFloater) catch()
```

The next series of lines sets up the UI for the script.

```
rollout setRoll "Wheel Roll"
(
    label lab_wheel "Pick Wheel: "
    pickbutton pbt_obj "Click to Pick Wheel" width:105 autoDisplay:true
    label lab_path "Pick Path: "
    pickbutton pbt_path "Click to Pick Path" width:105 autoDisplay:true
    spinner spn_startFrame "Start Frame: " type:#integer \
        range:[0,1000,0] fieldwidth:40
    spinner spn_endFrame "End Frame: " type:#integer \
        range:[1,1000,100] fieldwidth:40
    button but_setkeys "Set Wheel Keys" enabled:false
```

The remaining lines in the rollout clause determine what will happen when UI buttons are pressed. The last one, the event handler for the button that sets keys, is currently empty. You will fill it in with this exercise.

```
    local wheelObject, wheelPath

    on pbt_obj picked wheel do
    (
        -- Test that picked object is a cylinder
        if classOf wheel!=cylinder then \
            messagebox "Please pick a cylinder."
        -- If it is a cylinder:
        else
        (
            -- Put picked object in variable wheelObject for use outside
            -- block
            wheelObject = wheel
            -- If path has also been picked, enable "Set Wheel Keys"
            if wheelPath != undefined then but_setkeys.enabled = true
        )
    )

    on pbt_path picked pth do
    (
```

```
                -- Test if line is either line or editable spline
                if classOf pth != line and classOf pth != SplineShape then \
                    messagebox "Please pick a line or editable spline."
                -- If it is a line or editable spline:
                else
                (
                    -- Put picked path in variable wheelPath for use outside
                    -- block
                    wheelPath = pth
                    -- If wheel has also been picked, enable "Set Wheel Keys"
                    if wheelObject != undefined then but_setkeys.enabled = true
                )
            )

        on but_setkeys pressed do
        (
        )
    )

    wheelFloater = newRolloutFloater "Wheel Roll" 200 195
    addrollout setRoll wheelFloater
```

4. Run the script.

The script displays a dialog where you can pick the wheel, and path, and then click Set Wheel Keys.

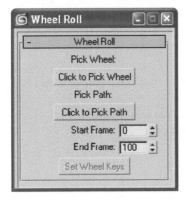

5. Try picking different objects in the scene to see which ones the script will accept.

When the script does accept an object, notice that the name on the pick button automatically updates with the name of the scene object. This feature is new as of 3ds Max 7. This feature is enabled by passing true to the autoDisplay in the pickButton control declaration in the rollout definition. Previously, you had to explicitly assign the name of the object to the caption of the pick button, (in the pickButton event handler) like so:

```
pbt_path.text = pth.name
```

The Set Wheel Keys button doesn't do anything. You will add it to the script to make it set the keys.

Note: If you don't want to type in the entire script but want to follow along with the steps, open the script *WheelRollFinished.ms* from the companion website.

6. In the script WheelRollStarter.ms, inside the parentheses for on but_setkeys pressed do, add the following lines of code:

```
local pathLength, numRotations, totalDegrees, startAngle, endAngle

-- Get the length of the path
pathLength = curveLength wheelPath
-- Get number of necessary rotations using 2piR
numRotations = pathLength / (2 * pi * wheelObject.radius)
-- Multiply by 360 to get total number of rotations
totalDegrees = numRotations * 360
print totalDegrees
```

7. Run the script to display the dialog. Pick Wheel101 and the path, then click Set Wheel Keys.

8. In the Listener, look for the totalDegrees value that was displayed by the last statement in the script. Now you know the number of degrees by which to rotate the wheel. What do you do with this value? Since the total number of degrees is greater than 360, you must set the rotation in either of two ways:

- Using angleAxis, or

- By setting the rotation controller's value explicitly.

You will use the second method for this exercise.

9. After print totalDegrees, enter the following lines of code:

```
with animate on
(
    at time spn_startFrame.value wheelObject.rotation.controller. \
        z_rotation.controller.value = 0
    at time spn_endFrame.value wheelObject.rotation.controller. \
        z_rotation.controller.value = totalDegrees
)
```

10. Run the script, pick Wheel101 and path, and click Set Wheel Keys.

11. Play the animation.
As the car moves, the wheel rolls by the appropriate number of degrees.

The script is very simple, but it can be changed or improved in a number of ways. The script *WheelRollComplete.ms* on the companion website contains many of these elements.

Rotation Axis

You could make the script more flexible by allowing the user to choose the wheel's rotation axis with radio buttons in the UI definition. Add the following lines after `button but_setkeys`:

```
label lab_rotAxis "Local Rotation Axis: "
radiobuttons rbt_rotAxis labels:#("X","Y","Z") default:3
```

If you add these UI elements, you will need to change the height of the dialog to accommodate them (do this in the second to last line of the script). Then, in the code that sets the angle keys, you could use the rotAxis.state to set the actual rotation axis. So, replace the code in the body of the `with animate on` context in the `on but_setKeys pressed` event with:

```
rAxis = rbt_rotAxis.state
at time spn_startFrame.value wheelObject.rotation.controller[rAxis] \
    .controller.value =0
at time spn_endFrame.value wheelObject.rotation.controller[rAxis] \
    .controller.value = totalDegrees
```

Steps

The script you created works fine for a car traveling along a path from 0 to 100 percent at a uniform speed. However, if the car should change speed or reverse at any time, you would need to set keys at intervals, and calculate the rotation for each key.

You could allow the user to set the interval by providing a Time Step spinner. Add the following line before the `button but_setkeys` UI control item:

```
spinner spn_timeStep "Time Step: " range:[1,10,5]
```

If you add this UI element, you will need to change the height of the dialog to accommodate it.

To get the path percent at any given time, you will need to know which object is following the path. You could either provide a pick button for choosing this object, or you could assume it is the parent object of the chosen wheel. The wheel's parent object can be accessed with the following statement:

```
wheelObject.parent
```

You can get the current path percentage for the car object with the following:

```
wheelObject.parent.controller.percent / 100
```

Instead of using the `with animate on` clause to set just two keys, you would use a loop to set a key at each step interval. Then you would step through the animation by the Time Step value to set a key at each interval. Replace the entire with animate on section with:

```
local rAxis = rbt_rotAxis.state
local curDeg, curPerc, distTraveled, numRotations

for t = spn_startFrame.value to spn_endFrame.value \
    by spn_timeStep.value do
(
    at time t
    (
        curPerc = wheelObject.parent.position.controller.percent / 100
        distTraveled = curPerc * pathLength
        numRotations = distTraveled / (2 * pi * wheelObject.radius)
        curDeg = numRotations * 360.0
        animate on wheelObject.rotation.controller[rAxis]. \
            controller.value = curDeg
    )
)
```

For an interesting visualization of the rotation, turn on Show Trajectory for Wheel01-MotionIndicator.

You can use the scene Roadster_reverse.max to test this technique. In this scene, the roadster's percent goes to 100 then back to 50, with the camera following accordingly.

Delete Keys

If you are using steps to set keys, you can use the following to delete any pre-existing keys:

```
deleteKeys wheelObject.rotation.controller
```

Key Tangents

When you set keys, their tangents (as shown in Track View - Curve Editor) might not be linear. You can set access to the key tangent types with a loop by using the following properties (shown here for the object b for demonstration purposes):

```
b.rotation.controller[1].controller.keys -- All keys on X rotation track
b.rotation.controller[2].controller.keys -- All keys on Y rotation track
b.rotation.controller[3].controller.keys -- All keys on Z rotation track
```

For example, you can access the In tangent type for a given key, i, on the X Rotation track with the following:

```
b.rotation.controller[1].controller.keys[i].inTangentType
```

To set the tangent type to linear:

```
b.rotation.controller[1].controller.keys[i].inTangentType = #linear
```

For the wheel roll script, you can set all key tangents to linear at the end of the on but_setkeys pressed event. The default tangent type of #auto is probably better in this case, but the linear tangent type presents a good place to show how to access and set the tangent types.

```
for i = 1 to 3 do
(
    for k in wheelObject.rotation.controller[i].controller.keys do
    (
        k.inTangentType = k.outTangentType = #linear
    )
)
```

Conclusion

In this chapter, you learned how to work with transforms in MAXScript. You learned about the different types of rotation, and how to use them. You also learned how to set animation keys and work with controllers. Lastly, you created a working script to set object rotation, based on user input and scene elements.

Working with MAXScript Objects

MAXScript can manipulate many different

types of scene objects. This chapter shows

how to work with a few basic scene objects

such as modifiers, lights, and cameras. Also,

two important topics on rendering,

callbacks, and random values are covered.

Objectives

After completing this chapter, you should be able to:

- Work with Modifiers.

- Create lights and cameras.

- Work with materials.

- Control the renderer.

- Work with callbacks.

- Work with random numbers.

Introduction

So far, you have learned how to create geometry with MAXScript. In this chapter, you will learn how to create and modify lights, cameras, and materials.

When you work in the 3ds Max UI, you set up the renderer and use those settings as you work. This chapter explains how to set up the renderer in MAXScript to automate the rendering process.

You will also learn about callbacks, a method for calling a script whenever a particular event occurs in your scene. Finally you will be introduced to random value generation in MAXScript.

Applying Modifiers

With MAXScript, anything you create can be considered some type of object or entity, even if it has no physical manifestation. Modifiers are also considered objects, although they are not 3D objects. They are entities that possess properties that you can set and change, just as you do with 3D scene objects. You learned about this distinction in Chapter 4.

First you create a modifier object, and set properties for it.

To create and apply a modifier:

1. Reset 3ds Max.

2. Create a Bend modifier using the bend constructor, and specify the bend angle. In the Listener, type the following:

   ```
   b = bend angle:90
   ```

 The variable b is the reference to the Bend modifier, while angle is one of its properties. The Bend modifier can now be applied to any 3D object.

3. Create a cylinder and set the number of height segments to 20 so you can see the modifier work. Type the following:

   ```
   c = cylinder height:50 heightsegs:20
   ```

4. Apply the Bend modifier b to the cylinder. Type the following:

```
addmodifier c b
```

The modifier has been applied to the cylinder with the `addmodifier` method, followed by the cylinder's reference and the modifier's reference. Since you did not specify an axis, 3ds Max uses the default axis, the Z axis.

5. You can also write this script in a shorthand fashion. Type the following:

```
cc = cylinder pos:[100,0,0] height:50 heightsegs:20
addmodifier cc (bend angle:90)
```

In the last step of the previous exercise, you put the modifier's constructor inside the parentheses. This is another case of supplying an expression for a function argument. The expression creates a modifier object, which is then applied to the cylinder.

There are three ways to change the properties of the modifier:

- Assign an explicit reference to the modifier. Above, you assigned the variable b to the modifier's reference. You can then set b properties with expressions such as:

```
b.angle = 80
```

The object updates in the viewport automatically when the property is set. Notice that the original cylinder was affected, since the bend modifier referenced by b was applied to it, not the new cylinder.

- Change the modifier's properties through the object it is applied to. When you use the `addmodifier` command, the modifier appears as a property of the geometric object. Changes to the modifier can be done like this:

```
cc.bend.angle = 75
```

You accessed the bend property of the cylinder cc, then the angle property of bend. This is useful when you don't have an explicit reference to the modifier, as in the shorthand example in step 5.

- Access a property array of modifiers on the object. Each object has a `.modifiers` property that returns an array of modifiers that is applied. The first item in the array is the modifier on the top of the stack as viewed in the modify command panel. The second item in the array is the next modifier and so on until the last item in the array is the bottom modifier on the stack. Using our cylinder example:

```
c.modifiers[1].angle
```

This will access the angle property on the bend modifier. Accessing the modifier in this way is useful for performing operations on all object modifiers.

Lights and Cameras

Lights and cameras are subclasses of the Node class. All the discussions in Chapter 4 regarding class inheritance apply to lights and cameras as well as to geometry objects.

Lights

With MAXScript, you can create any type of light as those in the 3ds Max UI. Each type of light has its own constructor. For example, the free directional light constructor is:

```
directionalLight()
```

If you type this in the Listener window, text is displayed similar to that generated for a geometry object:

```
$Free_Directional_Light:FDirect01 @ [0.000000, 0.000000, 0.000000]
```

The object's class is `Free_Directional_Light` (also identified as `Directionallight`); the object's pathname is `$FDirect01`. The light has been placed at [0,0,0] in World space.

For a full list of the light types you can create with MAXScript, see the following section in the *MAXScript Reference* Help:

- MAXScript Language Reference > 3ds Max Objects > Node: MAXWrapper > Node Subclasses > Light: Node.

All available light types are listed in the Standard and Photometric books.

Many light properties are common to all lights. Some of them are:

```
<light>.rgb -- RGB color
<light>.excludeList -- Array of nodes to exclude from the light's effects
<light>.projectorMap -- A map stored in a textureMap object
```

For the complete list of properties common to all lights, see the topic "Light Common Properties, Operators, and Methods" in the *MAXScript Reference* Help.

To exclude objects from a light's influence:

1. Reset 3ds Max.

2. In a new MAXScript Editor window, type the following to create several objects in a scene:
```
for i = -1 to 1 do
(
    box pos:[i*40, 0, 0]
    sphere pos:[i*40, 0, 60]
)
myPlane = plane length:150 width:150
```

3. Create an omni light with default properties, and set its position:
```
myLight = omnilight pos:[0, -100, 100] castshadows:on
```

The `excludeList` property accepts an array of nodes. You will exclude the spheres from illumination.

4. Create an array of sphere nodes:
```
sphereArray = for obj in objects \
        where (classof obj == sphere) collect obj
```

This for loop will return an array of objects that are spheres. It also uses a special form of the for loop syntax where instead of using the keyword 'do' to specify the body of the for loop, you specify 'collect' to tell it to collect the object that passes a conditional test. In this case, the conditional test is also a special form of the for loop where it is part of the for loop declaration. And here it is easy to see what the test is: if the object is a sphere, return true. This form of the for loop is highly compact and readable.

5. Set the `excludeList` property of the light:
```
myLight.excludeList = sphereArray
```

6. Evaluate your script.

7. Render the scene.
Now, you see the boxes only.

Previously, you saw that each light had a `.projectorMap` property. Next, assign a texture map to that `.projectorMap` property. A texture map is another object you can create using MAXScript. There are over 30 types of texture maps, such as planet, marble, and checker. Once you have created a textureMap object, you can assign it to the `.projectorMap` property of the light.

Note: You can specify bitmaps as well, but due to the large number of properties of the BitmapTexture object, they are not as easy to work with. See the topic "BitmapTexture: TextureMap" in the *MAXScript Reference* Help.

To work with the .projectorMap property:

1. Continue with the previous example. Delete all the objects in the scene. Type the following two lines of code at the end of your previous script to create a marble texture map and add it to the light:
```
marbleMap = marble Vein_Width:0.1 size:12
myLight.projectorMap = marbleMap
```

The width and size properties have been changed to achieve a better marble effect. All the textureMap object's properties can be set individually. Here you only set two of them, and used the defaults for the others.

You won't see the texture map in the viewport, but when you render your scene, it should look similar to the image below.

You will work more with textureMap objects later in this chapter, in the *Materials* section.

Cameras

Cameras are quite simple to control using MAXScript. Some of the constructors for cameras are:

```
targetCamera()
freeCamera()
```

To create a target camera:

1. Continue from the previous example. Instead of manually deleting all the objects in the scene every time you run the script, you will have MAXScript delete the objects for you. Type the following line at the very beginning of your script:

```
delete $*
```

2. Type the following lines at the end of your script:

```
tobj = targetObject pos:[7,15,31]
```

This creates the target object that the target camera will use. There are no inherent properties associated with a target.

3. Create the target camera and specify the target:

```
tc = targetCamera pos:[0, 0, 40.0] target:tobj
```

4. When you move the camera, it stays fixed on the target. In the Listener window, type:
   ```
   move tc [-121,-166,60]
   ```

 The camera always points toward the target.

To assign the current viewport to the camera:

1. Activate the perspective viewport by selecting any scene object in the scene through the perspective viewport. Type the following in your script:
   ```
   viewport.setcamera tc
   ```

2. Turn on the safe frames in that viewport by typing:
   ```
   max safeframe toggle
   ```

 You should now save this file because you will revisit this script.

Materials

You can use MAXScript to access both the Material Editor and materials applied to objects. To access a material that has been assigned to an object, you can use the `.material` or `.mat` property:

```
<node>.material
<node>.mat
```

To access a material in the Material Editor, you can use the `meditMaterials` virtual array. This array is created automatically by 3ds Max, and is indexed by numbers corresponding to Material Editor slots. For example:

```
meditmaterials[3]
```

This would return the material in the Material Editor's third slot.

Warning: The `meditMaterials` array only has 24 items, so be careful not to pass an index outside the array, such as 25. Calling meditMaterials[25] will return an error.

You can also create your own materials as objects, and assign them to scene objects. Each material type has its own constructor. For example, the constructor for the Standard material is:

```
standard()
```

Once you create a standard material, you can access its maps as properties:

```
sm = standard()
sm.diffusemap
```

You can also create different kinds of maps as objects, and assign them to map channels:

```
ch = checker()
sm.diffusemap = ch
```

To turn on the map in a viewport, use the `showTextureMap` method:

```
showTextureMap sm ch on
```

This would turn on the display of the checker map ch in the material sm.

Controlling the Renderer

MAXScript provides several parameters you can set to control the renderer automatically. The easiest way to render is to use the render method. The syntax is:

render **[camera: <camera_node>] [frame: <number> | #current] ...**

Note: The render method has about 45 optional parameters. This section will list some of the more important options.

Some of the default parameters are as follows:

- The active viewport is rendered.
- The current render settings are used.
- Rendering is to the virtual frame buffer.

You can override the defaults. Some optional parameters are as follows:

- `camera: <camera>`—After creating a camera, you can render from the camera's perspective by using the camera object.

- `frame: <number> or #current`—To render a specific frame such as frame 10, you type:

 render frame:10

 You could also use the #current designator to specify that the renderer use the current frame number:

 render frame:#current

- `framerange: <interval> or #active`—This parameter sets the frame range of the animation by using the following:

 frameRange:(interval 0 100)

 You could also designate #active to specify that the renderer use the current active time range:

 render frameRange:#active

- `fromframe: <number>` and `toframe: <number>`—If you use the fromframe property only, the renderer starts at that frame and renders to the last frame. If you use the toframe property only, the renderer starts at its current frame, and stops at the toframe number.

- `nthframe: <number>`—Sets rendering to every nth frame.

- `outputfile: <string>`—You can specify the output file by typing a file path.

- `outputwidth: <number>`—Sets the width of the output.

- `outputheight: <number>`—Sets the height of the output.

- `pixelaspect: <number>`—Sets the pixel aspect ratio of the output.

In 3ds Max 8, you can specify optional render elements parameters:

- `renderElements:<bool>`—If this parameter is passed a true or unsupplied value, any render elements in the scene will be rendered.

- `renderMultiPassEffects:<bool>`—If this parameter is passed a true or unsupplied value, and a multipass effect is enabled for the current camera, then a multipass effect will be rendered.

- `renderElementBitmaps:<&var>`—If render elements are rendered, the render element output bitmaps are placed in an array, and this array is returned through the specified variable by reference.

For more information on the renderer, see the following section in the *MAXScript Reference* Help:

MAXScript Tools and Interaction with 3ds Max > Miscellaneous Functions > Controlling the Renderer.

In the next exercise, create a simple scene and render some frames. This exercise will continue from the previous script example. First you will animate the boxes so you can see some movement in the animation.

To use the render method:

1. Type the following to the end of the script you were working on previously:

```
boxArray = for obj in objects where (classof obj == box) collect obj
with animate on
(
    at time 10 move tc [50,0,0]
    for i = 1 to 3 do
        at time 10 ( rotate boxArray[i] (quat (i * 98) z_axis))
)
```

 If you move the time slider from frame 1 to frame 10, you see the camera moves and the boxes rotating.

2. Render the scene to an AVI file. Type in the Script Editor:

```
render camera:tc \
        outputwidth:320 \
        outputheight:240 \
        fromframe:0 \
        toframe:10 \
        outputfile:"c:\\teapot.avi"
```

 If you prefer to render to a different drive or folder, replace the drive name or add a folder on the last line, before the AVI file name.

3. Put up a message:

```
messagebox "Finished Rendering!"
```

 When the rendering starts, you only see the video frame buffer, so give it some time to complete. You can also check the AVI file of your animation on your computer to verify that your animation worked.

 Note: You can find the script *animate_boxes.ms* for this tutorial on the companion website.

Callbacks

A *callback* is a script that you designate to run every time a certain scene event occurs. For example, you can set up a callback to call a specific function any time one of the following events occurs:

- The scene is rendered.
- The time slider is moved, or the animation is played.
- A file is saved, imported, or merged.
- A modifier is added or deleted from the stack.
- An object is hidden, frozen, or deleted.

These are just a few of the events for which you can create callback functions. For all possible events, see the following section in the *MAXScript Reference* Help:

MAXScript Tools and Interaction with 3ds Max > Change Handlers and Callbacks.

In the next exercise, you will set up a callback script that will be called every time the time slider changes.

To create a callback:

1. Load the file *obstacles.max* from the companion website.

2. Play the animation.
 This scene contains a camera, which follows a path that weaves between several primitives. Each primitive has been assigned a different material.

You will set up a callback script that checks the distance between the camera and each object, and changes the object's opacity based on its distance from the camera. The objects will gradually appear (become opaque) as the camera gets closer to them, as if they're becoming visible through fog.

3. Choose MAXScript menu > New Script.

4. At the top of the script, enter a comment to name the script:
    ```
    -- Revealer.ms
    ```

 You can also add your name, the date, and any other comments you want.

 Create a function to test the distance between the objects and the camera:
    ```
    -- Calculate opacity
    fn calcOpacity =
    (
        for i in objects do
        (
            if superclassof i == geometryClass then
            (
            closeness = distance i $Camera01
            -- If camera is far from object, make it transparent
    ```

```
        if closeness > 900 then i.material.opacity = 0
        -- As camera gets closer, change opacity based on distance
        -- Full opacity when distance < 100
        else
        (
            if closeness > 400 then
                    i.material.opacity = (900 - closeness)/5.0
                else
                    i.material.opacity = 100
        )
        )
    )
)
```

This code makes objects that are close to the camera (less than 400 units away) have an opacity of 100. Objects far away from the camera (more than 900 units away) have an opacity of 0. Objects in between become more opaque the closer they get to the camera.

Now you need to add a callback to cause this function to be called each time the time slider is moved.

5. Type the following line at the end of the script:
```
registerTimeCallback calcOpacity
```

6. Evaluate the script.

7. Scrub the time slider.
As you move the time slider and the camera passes by objects, each one becomes more solid as the camera approaches.

After you have finished using a script that contains a callback, you will want to *unregister* the callback. Otherwise, the function will be called every time the specified scene event occurs. For example, with the script you just entered, the function calcOpacity will be called every time you change the time slider unless you unregister the function.

8. When you have finished using the function, type the following in the Listener:

```
unRegisterTimeCallback calcOpacity
```

This unregisters the `calcOpacity` callback function.

Note: You can find the script *revealer.ms* for this tutorial on the companion website.

Randomizing

You can use the random method in MAXScript to generate random values for the following data types: integer, float, color, quat, eulerAngles, angleAxis, time, Point2, and Point3. These random values can be used to change any property that takes the given data type. Here's a simple example of the random method:

```
for i = 0 to 5 do
(
    s = sphere pos:[i*40, 0, 0]
    s.radius = random 10.0 30.0
)
```

The random method produces random values. The syntax is:

random (lowest possible value) (highest possible value)

The value returned will be a random value between the minimum and maximum values. In the example, the radius of each sphere was assigned a number between 10.0 and 30.0. If you use float data types as the arguments, then the random value returned will also be a float. If you specify integers:

```
s.radius = random 10 30
```

then the return value of random will be an integer (i.e., values such as 25, 27, 35, et cetera).

The random method is quite flexible and when used with Point3 data types can be useful for randomizing positions, colors, and so forth. Suppose you want to randomize the positions of the spheres in the above example:

```
for i = 0 to 5 do
(
    s = sphere()
    s.pos = random [0.0, 0.0, 10.0] [25.0, 30.0, 100.0]
)
```

The random method can take the entire Point3 data type as an argument. The X position will be a random number between 0.0 and 25.0, Y will be between 0.0 and 30.0, and Z between 10.0 and 100.0.

Suppose the first line in your script is `s.pos.x = random 0.0 10.0`. You will get a random number between 0.0 and 10.0. However, each time you restart 3ds Max and immediately run the script without performing any other 3ds Max function, you get the same "random" number from this statement. However, you do not get the same value if the script is run over and over without closing 3ds Max.

The random method works internally with a seed. The seed is the starting point for the software's internal randomization routine. When you start 3ds Max, it always starts with the same seed. Therefore, the random method always generates the same "random" sequence each time it is called. For this reason, the random method is called *pseudo-random*. If you do not want this behavior, then you can change the seed using the seed method:

```
seed <number> -- where <number> is any float or integer
```

This method can be likened to the New Seed function in certain features of 3ds Max, such as the SphereGizmo helper.

Conclusion

In this chapter, you learned how to do a variety of things with MAXScript. First, you learned how to manipulate strings. Then you learned how to add modifiers, create and manipulate lights and cameras, and create materials and assign them to scene objects. Finally, you learned how to control the renderer with scripting, use a callback within a script, and generate using random values.

With the tools you've learned in these chapters, and your knowledge of the class hierarchy and its relationship to the *MAXScript Reference*, you can start creating your own scripts.

Appendix

This Appendix presents several advanced
topics in MAXScript. As you gain experience
with MAXScript and write more complex
scripts, you will find the need for the tools
shown here. If you are new to MAXScript,
these concepts will be more useful after you
have gained some experience with the
language.

Debugging and Error Trapping and Handling

When you write a script with more than a few lines of code, it's not unusual for the script to have one or more errors. This section covers the process of finding and fixing errors in scripts.

Debugging is the general process of locating and correcting errors in your script. *Error trapping* is the catching of errors within the script, and *error handling* is the means by which these errors are managed. For example, as part of your debugging process, you could include a few lines of code that test for a particular condition (error trapping), and instruct MAXScript to display a dialog if an error occurs (error handling).

Debugging and error handling are important parts of writing scripts. In addition to the newly introduced MAXScript Debugger (more on this later) there are a number of techniques to help you debug your code. These techniques include color-coding the script, bracket balance checking, in-process output statements (using print or format), and interpreting the error messages and stack trace.

Error Types

There are several types of errors a script can generate. Common errors are:

- Syntax—You have spelled a function or variable name incorrectly, or have attempted to use a function in a way that it can't be used.

- Logic—A portion of the script doesn't do what you intended it to do because you constructed it incorrectly.

- User error—This type of error occurs while the user is interacting with the script. For example, if the script calls for the user to select an object that has a .radius property, the script can check whether the selected object fits the criteria. If it does not, the script can display a message that asks the user to select another object.

If an error generates an error message, it is usually displayed in the Listener, even if you run the code from the MAXScript Editor or another location.

A *syntax* error occurs when you attempt to use functions, symbols, reserved words, variables, and other MAXScript language elements incorrectly. Here is an expression that does not conform to the rules of MAXScript and generates a syntax error:

```
for i = 1 to 10 print i
```

The error message in the Listener would be:

```
-- Syntax error: at end, expected "do" or "collect"
```

This expression is missing the reserved word "do" after the number 10.

A *run-time* error results when a statement attempts an invalid operation while the script is executing. Here is an example:

```
arr = #(1);arr[0]
```

The error message in the Listener would be:

```
-- Runtime error: array index must be +ve number, got: 0
```

This expression attempts to access the array member at index 0, but since array indexing starts at 1, an error is generated.

A *logic* error results when syntax rules are followed correctly, but the intended result does not occur. Here is an example:

```
y = if x<0 then 0
```

This expression evaluates without an error message, assigning 0 to y if x is less than 0. However, suppose you had actually wanted to assign 0 to y if x were greater than 0, rather than less than 0. This error occurred because your logic was flawed. These kinds of errors can be very difficult to find, since they do not generate an error message and the consequences may occur elsewhere in the script. A common solution is to write code that prints the variable value at different parts of the script so you can see where it has gone wrong.

A *compile-time* error results when an error occurs before the code is actually executed. Here is an example:

```
(
y = (1/(x as float)
)
-- Compile error: Unexpected end-of-script
```

This expression is missing a close parenthesis. Although technically this is a syntax error, it occurs at compile-time and therefore is distinguished as such.

Here is another example of a compile-time error. This one is not a syntax error:

```
local x=0
```

The error message in the Listener would be:

```
-- Compile error: no local declarations at top level x
```

This looks so simple and correct, how can it be an error? This expression attempts to declare x as a local variable at the top level of the script, rather than in a block. A variable can be declared as local only in a block. All top-level variables are global in scope, whether declared as such or not.

A *user* error results when the user performs an action that is inappropriate for the current state of the script. Here is an example:

The user clicks a button whose event handler processes some objects, but the objects have not been selected. To prevent an error and possible crash, you should include code to check for this situation (error trapping) and take appropriate action (error handling). You may want to pop up a message box that informs the user to select some objects first. See the section *Error Trapping and Handling*, later in this chapter.

Compile-Time and Run-Time

Generally speaking, MAXScript is an interpreted language. This simply means that the code is read line by line, and the necessary underlying instructions are constructed and executed (interpreted). This is in contrast to a compiled language, like C++, that compiles the code into an executable file, such as an EXE file. In a compiled file, the code is scanned first in a compile phase and converted so that the necessary underlying instructions do

not have to be reconstructed each time the program is run. This allows the program to run faster, but makes development more complicated.

Although MAXScript is interpreted, it does involve an initial compile phase. At this time, certain checks are made and the code is converted into a form that can be interpreted, but the necessary underlying instructions still have not been constructed. This is a compile-time process. Run-time, then, is the time after the compile phase when the instructions are actually being constructed and executed.

Debugging Techniques

There are a number of tools you can use to help you with debugging.

Color-Coding

The MAXScript Editor can color-code your script to help you distinguish among comments, keywords, and so on.

In general, color-coding is automatic. An exception is when you copy and paste text. To force color-coding to update, press CTRL+D. The color-coding is as follows:

- Green: comments
- Blue: keywords (for, do, if, then, etc.)
- Red: text within quotation marks (string literals)

An example of when this will help is if you have missed a close quotation mark for a string literal, the color-coding will reveal the error.

Bracket Balance Checking

The bracket balancer helps you check whether brackets such as (), [], and {} are balanced in your code. In large blocks of code, it can sometimes be difficult to tell whether each open bracket is matched by an appropriate close bracket.

To check your brackets, you can position the cursor within a bracketed block of code, and press CTRL+B to select (and highlight) all text within the current brackets. Pressing CTRL+B again will highlight the next outer block of text. You can keep pressing CTRL+B to move out through bracket nestings. If there is a bracket mismatch, the balancer will signal a beep, and will not select any text.

In-Process Output Statements

You can include output statements in your code to inspect the value of variables and other aspects of your script. This can be done using the print or format functions.

Print

The print function displays text in the Listener. You have already used this method in several of the practice scripts in this book.

You can use the print method to display a string, or to display the contents of a variable:

```
b = box()
print "Box position"
print $Box01.pos
```

The print function can be mapped across collections. For example:

```
arr=#(1, "two", (sqrt 9))
print arr
```

This statement prints the following to the Listener:

```
1
"two"
3.0
```

The print function is limited in that it can display only one string or variable for each print statement. To display both descriptive text and variable contents, you can use the format statement.

Format

The format function prints both text and variable contents to the Listener or to a file, in a format you specify.

```
a = 5
format "The variable a is equal to %\n" a
```

The statement above would print the following to the Listener:

```
The variable a is equal to 5
```

The first parameter of the format function is a string. In addition to text, you can place a percent sign (%) in the string wherever you want the contents of a specific variable to appear. After the string, you list the values in the same order in which they appear in the string. For example:

```
a = 2
b = 3
format "% times % equals %" a b (a*b)
```

Notice that the last parameter is a mathematical expression. Remember that every expression evaluates to a value, and can be used wherever that value is valid.

This call to the format function would output the following to the Listener:

```
2 times 3 equals 6
```

You can also use escape-character sequences within a format statement. Common escape-character sequences are \t for tab and \n for new line.

```
format "\t% times % equals %\n" a b (a*b) to:theFile
```

The previous statement would put a tab at the beginning. It would also force a new line at the end of the statement, so subsequent format statements would appear on the next line. The "to keyword" parameter directs the output to a file instead of the Listener.

Unlike the print function, the format function does not map across collections. Again you have:

```
arr=#(1, "two", (sqrt 9))
format "arr = %\n" arr
```

But this time, the statement outputs the following to the Listener:

```
arr = #(1, "two", 3.0)
```

Interpreting Error Messages

MAXScript returns error messages to help you identify what error occurred, and where. You have seen such error messages in the previous section on error types:

```
for i=1 to 10 print i
-- Syntax error: at end, expected "do" or "collect"
```

This message indicates that a syntax error occurred; it occurred at the end of the script, where MAXScript expected the reserved word "do" or "collect".

Let's look at a run-time error message:

```
arr=#(1);arr[0]
-- Runtime error: array index must be +ve number, got: 0
```

This message indicates that a run-time error occurred that the array index must be a positive, non-zero integer, but got 0.

Next, a compile-time error:

```
(
y=(1/(x as float)
)
-- Compile error: Unexpected end-of-script
```

This message indicates that a compile-time error occurred. Specifically, an unexpected end-of-script was detected. This is due to a missing parenthesis in the line y=(1/(x as float).

An Unknown system exception indicates a serious error and may lead to 3ds Max becoming unstable.

Error messages are not always helpful, and can even be misleading. An error message is MAXScript's attempt to identify and locate an error. This task is hindered by inherent limitations in the process. Sometimes it's just not

possible for MAXScript to identify and locate an error correctly. The error message may be vague, or the flagged location may be incorrect. Despite these limitations, error messages are an important part of debugging.

Stack Trace-Back

Error messages appear in the Listener, and sometimes in an Alert Box floating dialog. The Listener text includes the Alert Box information, plus a stack trace-back. This shows a history of the functions called, event handlers called, and loops executed leading up to, and including, the error. These are listed in reverse order of occurrence, with the most recent at the top of the trace. Also displayed are the local variables, function parameters, and their values. Close inspection of this information may allow you to identify suspect variables, and determine where the error occurred.

Here is a sample script that generates an error and displays an Alert Box, plus a stack trace-back. The script creates a simple dialog with a single button. The button event calls a simple function that takes one parameter. The function contains a loop that multiplies the loop index with the function parameter with an undefined local variable. This variable will generate the error.

Open the Listener, then run this script from a MAXScript Editor window. Press the button called 'Click Me!':

```
fn testFunction n =
(
    for i = 1 to 10 do x = i * n * undefinedLocalVariable
)

try destroyDialog rol_test catch()
rollout rol_test "Test"
(
    button but_test "Click Me!"
    on but_test pressed do
    (
        clearListener()
        testFunction 123
    )
)
createDialog rol_test
```

After you click the Click Me button, the following Alert Box is displayed, indicating the error Incompatible types.

This error occurs because the button event called the function and passed 123 as the parameter. Then, in the loop, the function attempted to multiply an undefined local variable 123 times.

The following is the stack trace-back that appears in the Listener. In the Listener window, red text indicates where the error occurred, and the error message itself. Blue text lists the parameter and local variables and their respective values.

```
-- Error occurred in i loop
--    Frame:
--      x: undefined
--      undefinedLocalVariable: undefined
--      i: 1
--      called in testFunction()
--    Frame:
--      n: 123
--      called in but_test.pressed()
--    Frame:
>> MAXScript Rollout Handler Exception: -- Incompatible types: 123, and
 undefined <<
```

The script execution history is displayed in reverse order. The first line indicates that the error occurred in the loop. The lines following "Frame" list the loop's local variables and their values (note: the loop index, i, is a local variable). Since i = 1, the error occurred in the first iteration of the loop. Then the trace indicates that the error occurred in the function. The Frame information also lists the function parameter and its value. Finally, notice that the error started in the event handler for the button. The last line contains the Alert Box title and error message.

Also, the cursor is positioned near the offending line of code. In this case, the cursor is at the close parenthesis of the function, just after the loop where the error occurred. Sometimes MAXScript is not able to identify the exact line, but usually it is close enough to allow you to debug your code.

The stack trace-back may appear a bit confusing at first, but it's not really that complicated, and it provides important debugging information. Taking the time to learn how to read it will make the process of debugging easier for you.

Error Trapping and Handling

Error trapping and handling is the means by which errors are detected and managed. A common user error situation occurs when the user attempts to process objects when none are selected. Here's how this error can be trapped and handled. Consider the following code:

```
if selection.count==0
then messagebox "Please select one or more objects."
else (/*Process objects*/; for obj in selection do obj.pos.x+=10)
```

The if statement checks whether zero objects are selected. If true, the then branch displays a dialog instructing the user to select some objects. Otherwise, the selected objects are processed in the else branch.

Note that processing an empty selection will not generate an error. The collection has zero members, so the loop won't iterate at all. This code successfully traps the error of no objects being selected, and handles it by asking the user to select objects.

Attempting to process a deleted object will generate an error. For example:

```
obj=box()
delete obj
print obj.name
-- Runtime error: Attempt to access deleted scene object
```

To trap and handle this error, replace the last line with:

```
if NOT isDeleted obj then print obj.name else messagebox "Deleted object!"
```

The isDeleted function can be used on modifiers, controllers, and other objects.

A general way of trapping and handling errors is to use the try/catch pair. This will try a block of code, and if an error occurs, it will execute a catch block. For example:

```
try (print obj.name) catch (messagebox "Deleted object!")
```

This line of code will try to print the object name. If it is unsuccessful, it will display a message box. Even if the operation in the try block fails, this line of code will not generate a run-time error.

The parentheses around the try and catch expressions are not required, but have been included for clarity.

The try/catch operation is relatively slow, so you should avoid using it in loops or functions that are called multiple times. Speed of script execution is the determining factor, however. If the code runs fast enough using try/catch, then you should use it.

MAXScript Debugger

The MAXScript Debugger is a new feature in 3ds Max 8 that helps you solve defects (bugs) in scripts. The Debugger itself has a few tools that help analyze your scripts.

This section on the Debugger is an introduction only. Debugging in general is a complicated process and it takes experience to fully understand.

Previously, when your script crashed, you had to rely on the stack trace-back dump to determine the state of your variables, and the sequence of function and event calls. Sometimes the stack trace-back did not work very well. For instance, you might get an "Unknown property: "<property name> in undefined" error. Finding the undefined variable could be very difficult, particularly if the function had many undefined variables. To solve these problems and track down bugs, you might have tried using several print or format statements in your script. This could really clutter up your code.

The new Debugger has tools that allow you to solve these problems. But first, let's learn how to access the Debugger.

Accessing the Debugger

The Debugger window can be accessed from the following menus:

- 3ds Max MAXScript > Debugger Dialog menu.

- Debugger menu of the Listener.

- Debugger menu of any Script Editor Window.

The Debugger dialog is small the first time you open it. However, you can resize it, and it will retain the size and position you set on future uses. The Debugger runs in stand-alone, outside 3ds Max.

Configuration Parameters

To access parameters for the Debugger dialog, press the 'Config…' button at the bottom of the Debugger dialog. The MAXScript Debugger Parameters dialog is displayed:

The options in this dialog govern when the Debugger will open, as well as other settings. You should check the box labeled 'Stay On Top', as it is possible to inadvertently send the Debugger dialog behind the 3ds Max window. For more information, see the MAXScript Debugger section in the *MAXScript Reference* Help.

Break Command

A script normally stops when it hits an error, exception, or throw statement. For instance, attempting to access a property on an undefined variable causes an error. Attempting to divide by zero causes an exception and halts a script. The throw method also causes a script to halt execution. The Debugger introduces a new method that

allows you to stop or break execution of your script manually. This function is called the *break function*, or *breakpoint*, and its syntax is simple:

```
<ok> Break()
```

This function returns the constant value "ok", and takes no parameters but simply halts the script at that point. If the Debugger window is set to open on a break command, it will then open.

Debugger Output Window

When a script is halted by an error or a breakpoint, the debugger window prints information about the script into an output window. The Debugger also shuts out access to the 3ds Max user interface, the Listener, and any MAXScript Editor windows that may be open.

To use the Debugger:

1. Reset 3ds Max.

2. Open the Debugger, and then open the Debugger Parameters dialog.

3. Check the 'Stay On Top' option.

4. Open a new Script Editor window and type the following:

```
(
    a = 0
    for i = 1 to 10 do
    (
        a += 1.5
        ss = i * 2
        if ss == 18 do break()
    )
)
```

5. Save the file as *debugger.ms*.

6. Evaluate the script.
 When the for loop index i is equal to 9, ss will be equal to 18 and the break command is called. The following information is printed in the Debugger output window:

```
#
**thread data: threadID:2848
**[stack level: 0]
**In i loop; filename: C:\Program Files\3DSMax8\Scripts\debugger.ms;
position: 89
**member of: anonymous codeblock
--Parameters:
--i: 9
--Locals:
```

```
--ss: 18
--i: 9
--Externals:
--owner: <CodeBlock:anonymous>
--a: 13.5
--Owner:
--Locals:
--a: 13.5
--Externals:
**[stack level: 1]
**called from anonymous codeblock; filename: C:\Program
Files\3DSMax8\Scripts\debugger.ms; position: 93
--Locals:
--a: 13.5
--Externals:
**[stack level: 2]
**called from top-level
```

The first line contains the thread ID you are in: 2848. (Your thread ID number will vary). Most of the time, thread IDs are not important, thus threads will not be discussed here. What follows is a dump of all the stack levels or stack frames, also called code blocks (code within parentheses). For each code block, MAXScript creates a stack frame and orders them according to when they were called. Each stack is numbered, starting from zero for the top (or most recent). Thus, the output shows the break occurring on the following line:

```
**[stack level: 0]
```

This is the stack associated with the for loop. The for loop is then identified on the second line:

```
**In i loop; filename: C:\Program Files\3DSMax8\Scripts\debugger.ms;
position: 89
```

The above line also lists the filename of the script, and the character position, starting from the beginning of the file where the break occurred.

The rest of the indented information lists various variables that are used inside the for loop.

- The Parameters heading lists any parameters for the code block. In this case, the index i is considered a parameter for the code block and its value of 9 is listed.

- The Locals heading lists any local variables that are defined inside the code block. In this case, the variable i is listed along with the variable ss and its value of 18.

- The Externals heading lists any variables from a larger scope that is used inside this for loop. In this case, the variable a has a local scope, and increments for each iteration of the for loop (value of 13.5).

- The Owner heading lists what owns the code block. In this case, the script was run inside a pair of parentheses. This code block is called anonymous because it doesn't have a name. If it were a

MacroScript it would have a name of the MacroScript category and MacroScript name joined by an underscore.

After the listing for the level zero stack frame is the listing of the previously executed stack frame (stack level 1), or the frame that called the for loop:

```
**[stack level: 1]
```

This is identified on the next line:

```
**called from anonymous codeblock; filename: C:\Program
Files\3DSMax8\Scripts\debugger.ms; position: 93
```

Stack level 2 is then identified, which is in the global scope, also known as the top level:

```
**[stack level: 2]
**called from top-level
```

Debugger Command Line

Now that you have seen an explanation of the output, you need to know what the command line does. This is a command line where you can input Debugger commands to navigate the code frames, query variables, change variables, and execute MAXScript commands. You can only do this when a script is halted, or in Break mode. At first glance, you might think that you could just type anything into the command line that you could type into the MAXScript Listener. However, the command line only takes certain commands. These commands are:

- `threads`—Lists all threads.
- `setThread <integer literal>`—Sets the specified thread as the active thread. This command also dumps the stack for the active thread.
- `setFrame <integer literal>`—Sets the specified frame as the active frame.
- `locals {<string literal>}`—Dumps variables for the current active thread and frame, or for a specified variable.
- `getVar <string literal>`—Gets a value for a specified variable in the active or global frame.
- `setVar <string literal> <expr>`—Sets a value for the specified variable in the active or global frame. The expression is evaluated in the active frame's scope.
- `eval <expr>`—Evaluates the expression. The expression is evaluated in the active frame's scope.
- `?`—Displays the list of Debugger commands.

Once a script is in Break mode you can change variables by using the above commands. These commands are demonstrated in the next section.

Watch Manager Window

The button called "Watch…" at the bottom of the Debugger window will open the Watch Manager window. It lists the current value of any variable you input in the 'Variable' column.

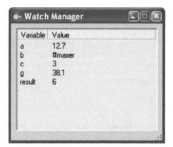

When a script enters Break mode, the variables you entered will be listed. The Break button at the bottom of the Debugger will be disabled, and the Run and Stop buttons will be enabled. Click the Run button to resume execution of the script. Click the Stop button to end the script. The 'Clear' button is always enabled and simply clears the output window.

The watch window enables you to query and change variables rather than using the command line. Also, only the variables you want to look at are displayed, so you don't have to search through the output window to find the variable you are looking for.

Note that your script sometimes has logic branches that seldom or never execute. For instance, a long if-then-else list or case statement may have code branches that execute rarely. (A case statement is another method used to control program flow that can be used instead of long if-then-else lists.) The result could be code that is poorly tested. Such a problem could be solved by simply changing the conditional variable immediately before it reaches a long if-then-else list or case statement, and then testing every logical branch the code could follow. This could simplify debugging dramatically, especially if the conditional clause is buried deep in function calls.

Like the Debugger Command Line, the Watch Manager window can also be used to change variables during Break mode. This is done by double clicking a cell where the value is displayed, and then manually changing the value.

The next exercise will demonstrate using the watch window to change a variable value during runtime, so you can test all execution paths in a case statement.

To Use the Watch Window:

1. Reset 3ds Max. Open the Debugger window and press the 'Watch' button to open the Watch Manager window. Open a new Script Editor Window and type the following script:

```
h = 1
r = undefined
break()

r = case h of
(
    1:    (h * 2)
    5:    (h * 3)
```

```
        "a":  (h + "pple")
        "b":  (h + "at")
    )
    break()
```

2. In the Watch Manager, enter h and r in the Variable column.

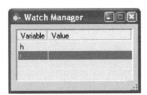

3. Save the script and evaluate. The Watch Manager reports the value of h as 1 and r as undefined.

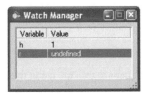

The script paused right before the case statement and is ready for your input—you could change the value of h immediately. However, first observe the default result of the script.

4. Click Run in the Debugger window.
 Notice that the script paused again. This was from the last break statement at the end of the script. This allows you to see the value of r (2) displayed in the watch window.

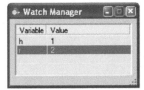

5. Click Run to end the script.

 Note: If you had left off the last break statement at the end of the script, when the Listener finished, the value of r would still have been shown as undefined. In that case, you could simply have pressed the 'Break' button to update the Watch Manager.

6. Evaluate the script.

7. When the script pauses, use the command line to change the value h, instead of using the Watch Manager. First, query the value of h. In the command line, type the following and press ENTER:

   ```
   getVar h
   ```

 The Debugger Output Window shows the typed command, and prints the value of 1 on the next line.

8. Set the value of h to 5. In the command line type the following and press ENTER:

   ```
   setVar h 5
   ```

 Notice that the value for h is updated automatically in the Watch Manager.

9. Click Run.
 The value of r is now 15.

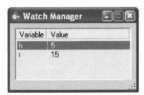

 You have succeeded in altering program flow by causing the second case statement to execute using the Debugger.

10. Click Run to end the script.

11. Evaluate the script. In the Watch Manager, change the value of h to the string "a." Be sure to include the quotation marks when assigning a string literal to the variable.

12. Click Run.
 The value of r is now "apple."

13. Click Run to end the script.

14. Evaluate the script. This time, change the value of h to the string "b."

15. Click Run.
 The value of r is now "bat."

Scope of Watch Manager

The Watch window can only display variables that are valid in the scope where the script is in Break mode. For instance, look at the following script:

```
function foo x =
(
    y = x * x
)
function start =
```

```
(
    y = foo 5
)
r = start()

break()
```

If you try to query the variable y, at the break point, the Watch Manager will show "** Undeclared variable: y." That is because both y variables have gone in and out of scope.

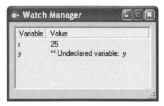

To query any of the y variables, you have to modify the script as follows:

```
function foo x =
(
    y = x * x
    break()
    y
)
function start =
(
    y = foo 5
    break()
    y
)

r = start()
break()
```

The break statement returns a value of OK. Thus, you have to explicitly put y at the end of each function to return the correct value. Otherwise, the function will return an incorrect value.

Fixing Errors with the Debugger

So far, you have halted scripts manually using the break method. You have also seen how to query variables with the break method instead of using print and format commands. Now look at using the Debugger for solving a real error in MAXScript—the 'Unknown property: <insert property name here> in undefined' error. Every experienced scripter has seen this error. It usually raises the question: "Unknown property of what?"

To catch the errors that will be demonstrated, open the Debugger, and then open the Debugger Parameters dialog and check the 'Break On Error' and 'Break On Exception' options. Open a new MAXScript Editor window and type and evaluate the following code:

```
function bazz a b = a.x * b
bazz undefined 5
```

The above code generates the following error in the Debugger output window:

```
#
-- Unknown property: "x" in undefined
**thread data: threadID:1812
**[stack level: 0]
**In bazz();
--Parameters:
--a: undefined
--b: 5
--Locals:
--a: undefined
--b: 5
--Externals:
--owner: undefined
**[stack level: 1]
**called from top-level
```

Note: The Listener stack trace-back dump has been improved as well. It now mirrors some of the information in the Debugger output window. (Remember that the Listener stack trace-back can not be accessed during Break mode.)

Here the error is reported on the second line, and then the output window displays the stack trace. By inspecting the output window, you can see that parameter a is undefined. The Watch Manager could also easily display the same information about the variables. One advantage of using the Debugger over the Listener stack trace-back is that variables can be entered into the Watch Manager after the crash during Break mode. Now instead of searching through a long stack trace-back dump, you can just enter the variable you are looking for:

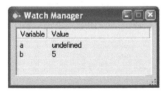

Setting the Active Frame

During execution of your script, the script may call many functions, or pass execution to different code blocks. These calls add up and are (as previously explained) tracked on a stack. When the script halts execution, the

Debugger dumps the stack information into the output window. Stack level 0 is the top frame and increments for each call that has already occurred, until you return to the beginning of your script.

The Debugger has a very powerful command that allows you to 'go backwards' in your script, when it is in Break mode. The command is setFrame:

```
setFrame <integer>
```

This sets the specified frame as the active frame. Typing this command in the Debugger command line moves the execution point in your script backwards to an earlier place in your code. When you set the active frame, you will notice variables from a lower numbered stack frame going out of scope, and variables from the new stack frame going into scope.

Thus, if your script halted at a point that was three function calls deep and you needed to query a local variable that was set in the first function, you can you go back to that function and look at the variable and resume running the script in the Debugger.

Following is an example.

To set active frames:

1. Reset 3ds Max, and open a new MAXScript Editor window.

2. Type and save the following script:
```
function terrier c =
(
d = 2 * c
break()
return d
)
function dog b =
(
tr = 2 * terrier b
)
function quadroPed a =
(
dg = 2 * dog a
)
function mammal =
(
h = [1,2,3]
qp = quadroPed h
)
mammal()
```

3. Evaluate the script.
 The Debugger opens and prints information to the output window.

4. Open the Watch Manager and enter all the variables and parameters used in the script:

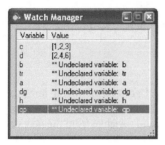

Currently, only the variables c and d are defined.

5. In the Debugger command line, type the following:

```
setFrame 1
```

The Watch Manager updates the display of variables b and tr, and variables c and d go out of scope and are now shown as 'Undeclared.'

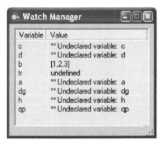

If you want to change parameter b in the Watch Manager you can, but in a limited way. For instance, you can assign an integer or a float to the variable.

point3 values cannot be modified in the Watch Manager . If you changed variable b in the Watch Manager, and then resumed running the script, the new value of b would not get passed to the terrier function. Rather, the old value of b (i.e., [1,2,3]) would be used.

To modify the point3 value of variable b, you must use the eval command in the Debugger command line:

eval <MAXScript expression>

6. In the Debugger command line, type the following and press ENTER:

```
eval b = [1,1,3]
```

Notice the Watch Manager and output window updated with the new value of b (i.e., [1,1,3]). If you resumed the script by pressing the Run button, the old value of b will still be passed to the terrier function, because that function still has the old value for parameter c. However, you can evaluate portions of the script using the evaluate command.

7. Type the following in the command line, and then press ENTER:

```
eval tr = 2 * terrier b
```

Notice the Watch Manager and Output Window updated with the new value of `tr` (i.e. [4,4,12]).

This value of `tr` is still somewhat temporary. If you click the Run button to finish the script, the mammal function will still return the default value of [8,16,24].

For more information on the Debugger, see the following sections in the *MAXScript Reference* Help:

- MAXScript Debugger > The MAXScript Debugger
- MAXScript Debugger > Using the MAXScript Debugger

Debugger Interface

You can control all of the properties of the Debugger *programmatically* (using code) through the MAXScript MXSDebugger Interface. This interface allows you to set options that are found in the Debugger Parameters Dialog. The interface is:

MXSDebugger

This interface has many properties that you can set. For instance you can call:

```
mxsdebugger.stayOnTop = true
```

Or

```
Mxsdebugger.breakOnException = false
```

Note: For a complete list of properties, see the *MAXScript Reference* Help.

This interface also has four methods that can be used to control the Debugger. These are `openDialog`, `closeDialog`, `writeString`, and `writeLine`.

Note: The four methods are fully documented in the *MAXScript Reference* Help.

The openDialog method is shown below. Open the Debugger programmatically by calling:

```
Mxsdebugger.openDialog break:true message:"Welcome to the \
    MAXScript Debugger" setfocus:true
```

- The optional parameter `break` determines whether the Debugger will break execution of a script or not.
- The optional parameter `message` displays a message to the Debugger output window before halting script execution.
- The optional parameter `setFocus` determines whether the Debugger is the top selected window or not.

For complete information on the MAXScript Debugger interface, see the *MAXScript Reference* Help at:

MAXScript Language Reference > 3ds Max Objects > Core Interfaces > Core Interfaces Documentation > Interface: MXSDebugger.

File Input and Output

There may be times you need to read or write data to a text file. Possible applications for file input and output are:

- Writing data that will be read by a game engine.

- Accessing data outside 3ds Max to create a scene.

File input/output (I/O) is straightforward in MAXScript, and there are many functions that allow you to work with and manipulate files.

When reading or writing data, you work with a *filestream*, a text file that has been opened or created for this purpose. The term *stream* means a conduit for data, whether it is coming in or going out. MAXScript can read and write text files and binary files. Each text character is one byte, so you read and write *bytestreams* from files.

In order to perform any file I/O, you must first open the conduit to the file. This can be done in two ways, depending on whether the file already exists or not. If the file exists, you can call the openFile function. If the file does not exist, you call the createFile function to create it:

```
fs = openFile "c:\\temp\\myfile.txt" or,
fs = createFile "c:\\temp\\myfile.txt"
```

Both functions return a reference to a filestream object in the variable fs. Then you can use the filestream object to read from, write to, and get information about the file.

To open and read from a file:

1. Open Windows Notepad and write a few lines of text:
   ```
   this is the first line
   now a second
   finally, the last line
   ```

2. Save this file into any convenient directory, and call it *test.txt*. For the purpose of this exercise, assume the directory is *c:\3dsmax8\scripts*.

3. In the Listener window, type the following:
   ```
   fs = openFile "c:\\3dsmax8\\scripts\\test.txt"
   ```

 A filestream has been created and assigned to the variable fs. The Listener has responded with `<File:c:\3dsmax6\maxscriptest.txt>` to indicate success.

4. Now type the following in the Listener:
   ```
   readLine fs
   readLine fs
   readLine fs
   ```

 Each time you execute the readline function, a new line is read from the file. If you type readLine fs one more time, the Listener responds with `-Runtime error: Read past end of file` to indicate that you attempted to read beyond the limits of the file.

5. When you are done using the file, call the close function:

```
close fs
```

If you have a large file containing many lines of text, you can use a while loop.

6. Type the following:

```
fs = openFile "c:\\3dsmax8\\scripts\\test.txt"
while NOT eof fs do readLine fs
close fs
```

The eof function tells you whether you are at the end of the file. It returns true if you are at the end of the file, otherwise it returns false. In code that reads a file, use the eof function to avoid an error condition.

File Pointer and Offset

Each time the readline function is called, the *file pointer* is placed automatically at the start of the next line. The file-pointer *offset* is a number that specifies where the pointer is with respect to the beginning of the file. When you open a file, the file pointer is positioned at the beginning of the file, where it has an offset of 0.

Although the file pointer is positioned for you automatically as you read characters, you can control it if you need to. This is done with the seek function. You can also retrieve the offset by calling the filePos function.

To use Seek and FilePos:

1. From the companion website, copy the file *seek.txt* to a convenient directory on your hard disk. This file contains a series of two-digit numbers, each separated by a space.

2. Type the following into the Listener, using the appropriate directory path for *seek.txt*:

```
fs = openFile "c:\\3dsmax8\\scripts\\seek.txt"
seek fs 6
readChars fs 2
```

The Listener returns with 53, indicating that the 2 characters it read at position 6 were 5 and 3.

3. Type the following into the Listener:

```
filePos fs
```

The Listener returns with 8. After the two characters are read, the file pointer is moved to the end of those characters, and is now at an offset of 8.

4. Type the following to close the file:

```
close fs
```

You have used the readChars function to get the characters. If you had used readline, then 3ds Max would have returned the entire line (starting from the offset of 6). There is also a readChars function that returns only one character.

Two more file functions that you can use to navigate through the file are skipToNextLine and skipToString. The skipToNextLine command jumps to the next line, and skipToString looks at a specific string of characters and positions the offset just after that string. SkipToString is useful when your file contains tags, text delimiters that you define to make it easy to locate items in a file.

To use skiptoString with tagged files:

1. Reset 3ds Max.

2. Copy the file *skiptostring.txt* from the companion website to a convenient directory.

3. Using Windows Notepad, open the file *skiptostring.txt*. It contains the following:
   ```
   $$hsegs 10
   $$height 50
   $$radius
   20
   ```

 The first three lines contain dollars signs followed by a text description and a number. The dollars signs serve to ensure that you will find the correct text in the file. This file is very short, but in a longer file with numerous values, text, and so forth, delimiters such as $$ will help ensure that you are seeking and finding the correct text.

4. Close Notepad.

5. Type the following in a MAXScript Editor window and make sure you type the correct path where *skiptostring*.txt resides:
   ```
   fs = openFile "c:\\3dsmax8\\scripts\\skiptostring.txt"
   ```

 This opens the file.

6. You perform a series of `skiptostring`, `readValue`, and `seek` functions:
   ```
   skipToString fs "$$height"
   h = readValue fs
   seek fs 0
   skipToString fs "$$hsegs"
   hs = readValue fs
   seek fs 0
   skipToString fs "$$radius"
   r = readValue fs
   ```

 The `skipTosting` function finds the file tag. However, the `skipTostring` function always begins looking from the current offset, so you reset the offset to the beginning of the file before each search using the seek function. You can look for the tags in any order.

7. Close the file, and create the cylinder from the data:

```
close fs
c = cylinder radius:r height:h heightsegs:hs
```

8. Run the script.
 The script reads the file, and creates a cylinder with the parameters specified in the file. Even though the radius value 20 in *skiptostring.txt* is on the line after the text $$radius, the script still read the value correctly.

Writing to Files

Next, learn how to write to files.

To create and write to files:

1. Create a cylinder in your scene:

```
c = cylinder()
```

2. In a new MAXScript Editor, type the following, and run it:

```
fs = createFile "c:\\3dsmax8\\scripts\\cylinderData.txt"
format "radius %" c.radius to:fs
close fs
```

 This produces the text radius 15.0 and writes it to the file.

3. Using Windows Notepad, open the file *cylinderdata.txt* to verify its contents, and then close the file in Notepad.

4. In the MAXScript Editor, change the format line to format two items on one line, and run the script:

```
format "radius % heightsegs %" c.radius c.heightsegs to:fs
```

5. Using Windows Notepad, open the file *cylinderdata.txt* to verify its contents, and then close the file in Notepad.
 This produces the text radius 15.0 heightsegs 1 and writes it to the file. The text created is all on one line. You change that in the next step.

6. In the MAXScript Editor, change the format line to the following:

```
format "radius = %\nheightsegs = %" c.radius c.heightsegs to:fs
```

 This is what is written to the file:

```
radius = 15.0
heightsegs = 1
```

The newline character is denoted by \n, a backslash character followed by the character n. Do *not* put a space after the n and the beginning of the next line's text; if you do so, the space will become part of the string.

7. Using Windows Notepad, open the file *cylinderdata.txt* to verify its contents, and then close the file in Notepad.

If you have a very long list of data to be written, you might not want to write it all in one format string. You can always write the newline character by itself. The following script will generate the same text as the previous example:

```
fs = createFile "c:\\3dsmax8\\scripts\\cylinderData.txt"
format "radius = %" c.radius to:fs
format "\n" to:fs
format "segments = %" c.heightsegs to:fs
close fs
```

To write numbers without text attached, just omit the text:

```
format "%" c.radius to:fs
```

File Access at the System Level

Sometimes, you will want to control files or directories at the system level. For example, you might want to create a new directory, get a list of all the files in a given directory, or copy files. MAXScript has a number of functions to do these tasks.

Following is a list of these functions and information about how they are implemented. You can type each in the Listener to see the results.

* getFiles—Returns an array of file name strings that match the filename or wildcard designation. In this example, you search for all files in the *c:\temp* directory that end with the extension *.max*:

```
fileList = getFiles "c:\\temp\\*.max"
```

In the example, fileList is an array of file name strings matching the criteria you set. You can find the number of files in the list by using the .count property of the array:

```
numFiles = fileList.count
```

Note: The array count can be used to determine if a file exists. If no files match the criteria, the count will be 0.

* getDirectories—Returns an array of directories; equivalent to getFiles. The statement below returns a list of all directories at the root level of your C:\ drive:

```
directories = getDirectories "c:\\*"
```

* makeDir—Creates a directory. The syntax is:

```
makeDir "c:\\newDir"
```

* deleteFile—Deletes the specified file from the system. The syntax is:

```
deleteFile "c:\\temp\\dontneedit.max"
```

* renameFile—Replaces the file name. The first argument is the existing name. The second is the new name:

```
renameFile "c:\\nameidontlike.max" "c:\\bettername.max"
```

- copyFile—Copies a file. The syntax is equivalent to the `renameFile` function:

```
copyFile "c:\\oldfile.max" "c:\\newfile.max"
```

For information on how to use these functions, see the *MAXScript Reference* at:

MAXScript Tools and Interaction with 3ds Max > File Access > External File Access > External File Methods.

Open and Save Dialogs

To accept user input for files, you need to access the open and save dialogs.

To use the Open File dialog:

1. In the Listener, type the following:

```
getOpenFileName()
```

The dialog shown below is displayed. The directory displayed is the *working* directory, which is the last directory 3ds Max accessed through a previous open or save action. If no open or save actions have taken place, the working directory is the directory that contains *3dsmax.exe*.

There is nothing displayed in the File name box, and Files Of type defaults to All Files (*.*). Also, the dialog title is the word Open.

2. Select a file, or type a file name in the File name box. Click Open at the lower right of the dialog. The Listener returns the path for the file.

3. In the Listener, type `getOpenFileName()`. In the dialog, click Cancel. The Listener responds with undefined to tell you that the open operation has been cancelled.

When used in a script, call the function this way:

```
fileName = getOpenFileName()
```

The variable `fileName` will be assigned the path of the selected file. The `getOpenFileName` function does not open the file. It only returns the name of file path selected by the user. If you actually need to open the file, you use the `openFile` function discussed earlier.

The dialog title (also called its *caption*) is one of your optional parameters.

4. Type the following:
```
fileName = getOpenFileName caption:"Select a File"
```

This text will appear in the title bar of the dialog.

5. Close the dialog.
 The next optional parameter specifies a string for the File name box.

6. Type the following in the Listener:
```
fileName = getOpenFileName filename:"test.txt"
```

7. Close the dialog.
 The third optional parameter is also a string, and specifies the text displayed in the Files of type drop-down list along with the associated file type. You can list as many file types as you want.

8. Type this in the Listener:
```
fileName = getOpenFileName \
caption:"Select a File" \
filename:"test.txt" \
```

```
types:"Text(*.txt)|*.txt|Script(*.ms)|*.ms|All(*.*)|*.*|"
```

In the types property, each sequence starts with the text that will appear in the drop-down list, followed by the file type that is to be displayed when that selection is made.

Opening the Save Dialog

You can open a Save dialog with the getSaveFileName function.

```
fileName = getSaveFileName \
caption:"Select a File Name" \
types:" Text(*.txt)|(*.txt)|"
```

The function getSaveFileName returns the name of the selected file. If the file already exists, the user is prompted to verify that the action should continue. As with getOpenFileName, getSaveFileName does not actually save the file. It only retrieves the selected name. Your script will have to open the file, write to it, and close it using the functions discussed previously.

Binary File I/O

Your computer stores numbers in a compact *binary* format. When you store numeric data inside files with binary format, you gain several advantages.

First, the file size will be small. A float value is stored in your computer using four bytes. Using the file functions that you used earlier, the number 1.4565, for example, requires six bytes (the decimal point takes up one byte on its own).

Bear in mind that not all numeric values will use a small file size when stored in binary format. Any integer stored in binary format uses at least four bytes, so for small integers between 0 and 100, a string representation is smaller than binary.

Another advantage of binary storage is that the script does not have to convert the strings to numbers when it reads the file. Previously, when you used the function readValue, MAXScript read and evaluated the string data internally, then converted the string to a numeric value that the computer could use in numeric operations. By reading binary information from files, this process is unnecessary.

Writing a Binary File

To open a file for binary reading or writing, you use the `fopen` function. This function returns a BinStream value that you use for further file access.

In the following example, you will create a sphere and write the coordinates of the sphere's vertices to a file. Then you will reset 3ds Max and read the vertices.

To write a binary file:

1. Reset 3ds Max.

1. In any viewport, create a sphere with a radius of about 50. Make sure the sphere is named Sphere01.

1. Convert the sphere to an editable mesh.

1. In a MAXScript Editor window, type the following script. If you do not have a *temp* directory on your C drive, choose any directory you like, and modify the script accordingly.

```
stream = fopen "c:\\temp\\bintest.bin" "wb"
```

The parameter wb stands for *write-only binary*, and indicates the mode that the script will use to write the data.

2. Now continue with the script:

```
--Get the number of vertices in the sphere
num = getNumVerts $Sphere01
for i = 1 to num do
(
  --Get the vertex positions
  pos = getVert $Sphere01 i
  --Write the x, y, z coordinates to the file
  writeFloat stream pos.x
  writeFloat stream pos.y
  writeFloat stream pos.z
)
```

The getNumVerts method returns the number of vertices in the editable mesh. The getVert method takes a mesh object as its first parameter and the vertex number as the second parameter. A Point3 value is returned that represents the x, y, and z coordinate values of the vertex.

3. Close the file by adding this final statement:

```
fclose stream
```

4. Execute the script.
 The file is created.

5. Using a text editor such as Notepad or Wordpad, open the file *bintest.bin*.
 The data is in binary format. MAXScript could read the file, but you cannot. Let's change the output so you can read it.

6. Change the script to the following using string data instead. You still specify wb since string bytes are still bytes. You must also change the file name:

```
stream = fopen "c:\\temp\\bintest2.bin" "wb"
num = getNumVerts $Sphere01
for i = 1 to num do
(
  pos = getVert $Sphere01 i
  writeString stream (pos.x as string)
  writeString stream (pos.y as string)
  writeString stream (pos.z as string)
)
fclose stream
```

7. Open *bintest2.bin* with Wordpad or Notepad. You will see the data written out in standard text. Note that in Explorer this file is larger than the previous binary version. If you had added a line-feed character after each entry, it would have been larger still.

There are many representations of numbers that you can use when writing binary data. You can read and write large integer values if you choose storage with more bytes. A *short* integer, which you write with the `writeShort` function, is stored with two bytes, while a *long* integer (writeLong) uses four bytes. You can also store integers as *signed* (with a plus or minus sign) or *unsigned* (always positive).

The following are the ranges of numbers you can store with writeByte, writeShort, and writeLong. The values shown are approximate.

With writeByte:
1-Byte integer, signed: +/-127
1-Byte integer, unsigned: 0-255

With writeShort:
2-Byte integer, signed: +/-32,000
2-Byte integer, unsigned: 0-65,000

With writeLong:
4-Byte integer, signed: +/-2,000,000,000
4-Byte integer, unsigned: 0-4,000,000,000

You can find a complete list of number representations you can use with MAXScript in the *MAXScript Reference* at:

MAXScript Tools and Interaction with 3ds Max > File Access > Text and Binary File Input and Output > BinStream for Binary Reading and Writing.

Reading a Binary File

The procedure for reading a binary file is similar to writing one. Since MAXScript knows what type of data you are reading, you can simply read the data sequentially. In the following example, you will create a sphere, then modify its vertices from data in a file.

To read a binary file:

1. Reset 3ds Max.

2. In any viewport, create a sphere with a radius of about 100. Make sure the sphere is named Sphere01.

3. Convert the sphere to an editable mesh.

4. Start your script by opening the file for reading:
```
stream = fopen "c:\\temp\\bintest.txt" "rb"
```

5. Read the data, and apply it to the sphere as you go:
```
num = getnumVerts $Sphere01
pos = [0, 0, 0]
for i = 1 to num do
(
  pos.x = readFloat stream
  pos.y = readFloat stream
  pos.z = readFloat stream
  setVert $sphere01 i pos
)
fclose stream
--Update the sphere so we can see the change
update $sphere01
```

6. Execute the script.
 You will see the sphere move to the location of the sphere you created in the last exercise. The sphere's size will also change to match the sphere in the last exercise.

 If you are interested in the topic of meshes (including vertex manipulation) for writing MAXScript importers and exporters, see the *MAXScript Reference* Help at:

 MAXScript Language Reference > 3ds Max Objects > Editable Meshes, Splines, Patches, and Polys > Editable_Mesh: GeometryClass and TriMesh : Value

Additional Binary I/O Functions

- There are functions that act on binstream values that are equivalent to the pointer positioning functions:

- fTell— Returns the current file pointer position.

- fSeek—Moves the file pointer to a specified position. Arguments are the amount to move the pointer, followed by the start position, which can be #seek_set (start of the file), #seek_cur (from the current

position) or #seek_end (from the end, in which case the amount to move should be a negative number). Do not confuse this with the seek function for ASCII file I/O.

Visual MAXScript

MAXScript gives you a convenient means to construct user interfaces. Visual MAXScript (VMS) is a forms-based editor that allows you to construct panels in an intuitive way. You see exactly how the rollout will look as you construct it, and you do not have to worry about positioning your user interface elements programmatically. VMS also writes some code for you by setting up the event handlers you want to include. Of course, it is still your responsibility to write the bodies of the handlers.

With Visual MAXScript, you create a panel that works the same way a rollout does. Later, you can display the panel as a dialog if you want.

To access Visual MAXScript:

1. On the Utilities panel, click More, and then choose Visual MAXScript.
 The Visual MAXScript Editor (VMS Editor) appears.

 A default panel appears on the left side of the Visual MAXScript Editor. The panel has black handles that allow you to resize it. The panel, at its default size, is the correct size to fit on the command panel.

 The second way to access the Visual MAXScript Editor is through the MAXScript Editor.

2. Close the Visual MAXScript Editor.

3. Open a new MAXScript Editor window, and then choose Edit > New Rollout.

The New Rollout command allows you to create a rollout from scratch, while the Edit Rollout command opens a previously created panel. You use this method to create a rollout while you are writing a script.

The VMS Editor has a row of icons along the bottom that represent all possible elements. When you place the cursor over an icon, a tooltip appears identifying the element. A text description also appears in the status bar at the bottom of the dialog.

To build UI elements on a rollout:

1. Click the button icon, the third button from the left.

When you click an element as above, the cursor changes to a pair of crosshairs when the mouse is positioned over the panel layout area.

2. Drag the panel, and a button element will be created.

The handles around the button allow you to graphically edit the button element size and position. The Value and Event Handler tabs appear alongside the panel layout.

3. Click the Value tab.

You can set any value by selecting the appropriate row and entering the value, or by selecting from a drop-down list. To use the images property, you must set up an image list, which is not covered here. For more information, see the *MAXScript Reference* Help at:

MAXScript Tools and Interaction with 3ds Max > Creating MAXScript Tools > Scripted Utilities and Rollouts > Rollout User-Interface Controls > Image Buttons

In the toolTip field, you can enter a text string that will appear as a tooltip whenever a user places the cursor over the UI element.

4. Choose the Event Handlers panel. There is only one event available for the button, which is the pressed event.

5. Place the cursor over the word pressed, and then click.
The Edit Event Handler dialog appears.

6. In the edit window of this dialog, type the script you want to execute when the button is pressed.

```
Messagebox "Here is the message!"
```

In this example, the event handler will display a message box when the button is pressed.

7. Click OK to return to the VMS form editor. The pressed event will now be chosen. You have now created a panel and script. Next, you will see how to execute it.

Saving and Executing Panels Created with Visual MAXScript

When you are finished editing, you have the option of saving your VMS project in two different ways. You can save it as a *.vms* file, or as a MAXScript (*.ms*) file.

When you open a VMS file, the form editor opens. If you save the file with the *.ms* extension, MAXScript will actually create the script that you can execute. Before you continue, change the name of the panel.

To save and execute panels created with Visual MAXScript:

1. Click the panel in the visual editor to select it.

2. Click the Value tab.

3. Change the name to message, and the caption to Message Box.

4. Choose File menu > Save in the Visual MAXScript Editor. You will be asked if you want to break the link to the MAXScript Editor. Click Yes.

5. At the bottom of the Save dialog that appears, choose MAXScript Files from the drop-down list.

6. Save your file to a convenient directory.

7. Close the Visual MAXScript Editor.

8. From the MAXScript Editor window, open the MS file. The script appears as follows:
   ```
   rollout message "Message Box" width:162 height:300
       (
       button btn1 "Button" pos:[41, 27] width:76 height30
       on btn1 pressed do messagebox "Here is the message!"
   ```

```
        )
```

Note that your script might look slightly different, as the button position values will match your button's position.

9. Wrap the script inside a utility, as follows:

```
utility test "Message Test"
(
  rollout message "Message Box" width:162 height:300
  (
    button btn1 "Button" pos:[41, 27] width:76 height30
    on btn1 pressed do messagebox "Here is the message!"
  )
)
```

There is one step left to make this an operational script. By default, rollout panels are not added to your utility until you explicitly specify that they be created. Therefore, you must add an open handler to the Utilities panel where you will add this rollout panel.

10. Add script statements as follows:

```
utility test "Message Test"
(
  rollout message "Message Box" width:162 height:300
  (
    button btn1 "Button" pos:[41,27] width:76 height:30

    on btn1 pressed do messagebox "Here is the message!"
  )
  on test open do
  (
    addRollout message
  )
)
```

11. Press CTRL+E to execute the script.

12. On the Utilities panel, choose MAXScript.

13. Choose Message Test from the Utilities drop-down list, and the Utilities panel will be displayed as follows:

Two separate rollouts appear. The `addRollout` function causes a new rollout to be added to the main MAXScript Utility panel. You can close the small Message Test rollout by clicking its Close button, and the Message Box rollout will remain functional. Although the Message Box rollout was added inside the Message Test utility, it is an independent object.

Using the VMS Editor in Another Way

There is another convenient way to access the VMS Editor when working on a script. If you are in a MAXScript Editor window, you can access the editor and have it insert code at your cursor position.

To use the VMS Editor in another way:

1. In a new MAXScript Editor window, type the following script:

```
utility vms_insert "VMS Insert"
(

)
```

2. Make sure the cursor is positioned on the line between the open and close parentheses.

3. Choose Edit > New Rollout from the menu. The VMS form editor appears.

4. Create a button as before, and choose File > Save.

5. The script for this rollout appears automatically in the MAXScript Editor where your cursor was positioned. The background of your edit window will now be gray, and you will not be able to edit in this window until the VMS form editor is closed.

You can continue to add more UI elements with the Visual MAXScript Editor. When you have finished, choose File > Save from VMS to place the corresponding commands in the MAXScript Editor, then close the VMS window.

The commands that VMS places in the MAXScript Editor are not indented, so you will have to do so yourself. You will also still have to add the open handler manually to make the rollout appear.

Note: Once rollout definitions are included in your script, you can add or delete your rollouts from anywhere you like. Just use the addRollout and removeRollout functions.

ActiveX Controls in MAXScript Rollouts

MAXScript has the ability to embed third-party ActiveX® controls directly into a rollout. You do not need to know anything about ActiveX technology to use this feature. ActiveX is a set of Microsoft technologies that allow applications to use independent software modules that can perform specialized tasks. You will find that many ActiveX controls already exist on your system. For example, an Excel spreadsheet, the Windows Media Player, or even a Web browser can be implemented as ActiveX controls.

To use an ActiveX control, you must know how to identify it. MAXScript has provided a set of functions for you to do this.

To locate and identify ActiveX controls:

1. Open a MAXScript Editor window, and type the following:

```
ws = newscript()
ShowAllActiveXControls to:ws
```

The newscript() function opens a new window. The value returned by the function identifies this window, called a *windowstream*. When you execute the showAllActiveXControls method, you specify that the output goes to this window. Note that you could also have directed this output to a filestream if you had an open file available.

2. Execute the script.

 A new window opens, and all ActiveX controls on your system are displayed. Many of these will not have an associated user interface, so you cannot use them with MAXScript.

3. Scroll through the list (or choose Search from the menu bar) and look for the Windows Media Player entry.

```
"CAdEPlotViewerCommandMap Object" "EPlotViewer.AdEPlotViewerCommandMap.1" "{679A16FB-49EB-45A
"TeamWrapper2x.TDGanttWrapper" "TeamWrapper2x.TDGanttWrapper" "{68879CE6-84AD-4484-8542-C3053
"Microsoft DirectAnimation Windowed Control" "DirectAnimation.DirectAnimationWindowedIntegrat
"DTC Surrogate 7.1" "VSDTC.Surrogate71.1" "{6A021235-2EB0-49F8-8036-38CECD06DB5D}"
"Microsoft StatusBar Control, version 5.0 (SP2)" "COMCTL.SBarCtrl.1" "{6B7E638F-850A-101B-AFC
"Windows Media Player" "WMPlayer.OCX.7" "{6BF52A52-394A-11D3-B153-00C04F79FAA6}"
"Pegasus ImagXpress Control v7.0" "ImagXpr7.ImagXpress.1" "{6D3CF4F3-C2F3-46E7-A126-3E53102A6
"ActorBvr Class" "(null)" "{6DDE3061-736C-11D2-A5E8-00A0C967A25F}"
"Microsoft Forms 2.0 Frame" "Forms.Frame.1" "{6E182020-F460-11CE-9BCD-00AA00608E01}"
"InstallEngineCtl Object" "ASControls.InstallEngineCtl.1" "{6E449683-C509-11CF-AAFA-00AA00B60
"CMissingFontsCtrl Object" "EPlotViewer.MissingFontsCtrl.1" "{6F59AA1D-7896-4E38-88E7-53FA9CB
```

4. The list contains the names of the ActiveX controls that are registered on your computer, followed by an identifier. This identifier is known as a Class ID for the control, and uniquely identifies it. You use this Class ID in MAXScript to identify the control you want to use.

5. Make a note of the Class ID for the Media Player. You may want to copy and paste it somewhere for future reference. The Class ID will be the same for this ActiveX control on all computers. For Media Player, the Class ID is:

 {6BF52A52-394A-11D3-B153-00C04F79FAA6}

To embed an ActiveX control on a rollout:

1. Open a new MAXScript Editor window, and type the following:

    ```
    utility ActiveXDemo "ActiveX Demo"
    (
    ```

2. Make sure your cursor is positioned on the last line (after the parenthesis). From the Edit menu, choose New Rollout. The VMS form editor will appear.

3. Change the rollout name to MovieDemo (no spaces) and the caption to "Movie Demo."

4. From the row of controls, click OLE.

 OLE stands for Object Linking and Embedding, which is the old (but still used) name for ActiveX technologies.

5. In the default rollout panel, drag to create the control. The exact size doesn't matter, but it should take up most of the panel.

6. Click the Value tab.

You must specify a control type, which is the Class ID discussed earlier.

7. Type (or paste) the Class ID into the controlType field. You must include the curly brackets when you enter the ID.

8. Add a button, and set the caption to Get Movie.

9. Choose File menu > Save, and the script for this rollout will be generated. Close the VMS dialog.

10. Add the close parenthesis for the utility. Your script should look something like this:

```
utility ActiveXDemo "ActiveX Demo"
(
    rollout movieDemo "Movie Demo" width:162 height:300
    (
    ActiveXControl actx "{6BF52A52-394A-11D3-B153-00C04F79FAA6}" \
        pos:[3,5] width:156 height:191
    button btn1 "Get Movie" pos:[24,231] width:110 height:27
    )
)
```

11. Add the open handler to add the ActiveX rollout:

```
utility ActiveXDemo "ActiveX Demo"
(
    rollout movieDemo "Movie Demo" width:162 height:300
    (
        ActiveXControl actx "{6BF52A52-394A-11D3-B153-00C04F79FAA6}" \
            pos:[3,5] width:156 height:191
        button btn1 "Get Movie" pos:[24,231] width:110 height:27
    )
    on ActiveXDemo open do
    (
        addRollout MovieDemo
    )
)
```

12. Execute the script.

13. In the Utilities panel, in the MAXScript > Utilities drop-down list, choose ActiveX Demo. The rollout is displayed.

The final task is to respond to the Get Movie button.

14. Add a pressed handler to your script as follows:

```
utility ActiveXDemo "ActiveX Demo"
(
    rollout movieDemo "Movie Demo" width:162 height:300
    (
        ActiveXControl actx "{6BF52A52-394A-11D3-B153-00C04F79FAA6}" \
            pos:[3,5] width:156 height:191
        button btn1 "Get Movie" pos:[24,231] width:110 height:27
        on btn1 pressed do
        (
            file = getOpenFileName caption:"Choose An Avi File" \
            types:"AVI(*.avi)"
            if file != undefined do
            actx.URL = file
        )
    )
    on ActiveXDemo open do
    (
        addRollout MovieDemo
    )
)
```

15. Execute the script again and press the button. Choose any AVI file on your system and watch it play. Notice the statement: actx.URL = file. You may be wondering how to find out that "URL" is a property of the ActiveX control. All ActiveX controls have a list of properties and methods (function calls) associated with them. MAXScript provides a function called `showProperties` that enumerates the control's properties.

You can find the script *activeXDemo.ms* for this tutorial on the companion website.

More info on ActiveX controls can be found in the *MAXScript Reference* Help at:

MAXScript Tools and Interaction with 3ds Max > ActiveX Controls in MAXScript Rollouts

Function Publishing System and Interfaces

A 3ds Max plug-in creates new types of objects. Many plug-ins are part of the standard 3ds Max, while others are written by third-party developers using the Software Developer Kit (SDK). Like all objects, these objects have properties and methods. The Function Publishing System (FPS) provides the means by which MAXScript can query these objects to determine their properties, methods, and associated actions.

The Function Publishing System was developed with 3ds Max 4. Since that time, all properties and methods for new and existing MAXScript objects have been published through the FPS, rather than building them into the objects directly.

In Function Publishing, an interface is a group of properties, methods, and associated actions that you can access for an object. Do not confuse this term with the user interface. You can find out which interfaces are available for an object with the getInterfaces function:

```
getInterfaces <object>
```

This displays a list of interfaces for the object. Once you locate the interface you want to use, you can query the properties, methods, and associated actions available through that interface with the following command:

```
showInterface <object>.<interface>
```

This command is the cousin of the `showProperties` function, which shows properties built into an object. The `showInterface` command shows properties, methods, and actions added to existing objects in or after 3ds Max 4, and for new objects created by SDK plug-ins.

You can display all the interfaces for objects below the Node class with the following:

```
showInterfaces node
```

You can use any or all of these commands to display the interfaces in the way that will be most helpful to you when scripting. You use getInterfaces and showInterface with a specific object to display the interfaces for that object, regardless of whether they are available for all nodes. You can also use showInterfaces (with an "s" at the end) to display interfaces for all nodes.

Let's take a look at some of the properties and methods you can access through the Function Publishing System.

To access interfaces:

1. Reset 3ds Max, and clear the Listener.

2. In the Listener, type the following:

```
b = box()
getInterfaces b
```

This displays all the interfaces for the box object:

```
#(<MixinInterface:IAssembly>, <MixinInterface:INodeGIProperties>,
<MixinInterface:INode>, <MixinInterface:INodeLayerProperties>,
<MixinInterface:INodeBakeProperties>, <MixinInterface:SkinPose>)
```

You can use these interfaces to find further properties, methods, and actions for a box. You will explore the INode interface in the next step.

3. In the Listener, type the following:

```
showInterface b.INode
```

This displays a series of properties and methods that you can use with the box. One of these properties is `.handle`, a unique identifier associated with the object.

4. In the Listener, type the following:

```
b.INode.handle
```

This returns the number 1, the handle for the box object. You could change the name of the box in the scene and still access it by its `.handle` property, which will not change.

In addition, you can use many interface properties without specifying the interface before the property.

5. In the Listener, type the following:

```
b.handle
```

This returns the number 1. Here, you used the `.handle` property without the `.INode` specification before it. Where an interface property does not conflict with an existing property in MAXScript, you can use it without specifying the interface between the object and the property.

6. In the Listener, type the following:

```
showinterfaces node
```

This displays each interface and its properties, methods, and actions. The third interface displayed is INode. Under this section of the listing, you can see the same properties, methods, and actions that displayed when you typed `showinterface b.INode`.

To use interfaces in practice:

1. In this procedure, you will use an interface exposed by the Function Publishing System to get additional methods for the look-at constraint. Reset 3ds Max, and clear the Listener.

2. In the Listener, type the following:
```
clearListener()
lookAtObj = cone pos:[50,0,0]
lookAtTarg = dummy()
c = lookat_constraint()
lookAtObj.rotation.controller = c
```

The last two lines create an instance of a look-at constraint in the variable c, and assign it to the cone.

3. Type the following line of code:
```
showProperties c
```

This displays the built-in properties for a look-at constraint.

4. Type the following:
```
c.target_axis = 2
```

This command uses a built-in property to set the target axis to Y.

The showProperties function shows properties for getting and setting various axis parameters, but no properties for getting and setting target parameters. These methods are exposed through an interface.

5. Type the following:
```
getInterfaces c
```

This command shows the interfaces for the look-at constraint. There is only one, constraints.

6. Type the following:
```
showInterface c.constraints
```

This shows the properties, methods, and associated actions available for this interface. It contains .appendTarget, a method for appending targets.

7. Type the following:
```
c.constraints.appendTarget lookAtTarg 50
```

Using the method in the interface, this line adds a look-at target to the target list with a weight of 50.

8. Move the cone around, and observe it pointing to the dummy.
The constraints interface is a special type called a MixinInterface. This simply means that the interface is a window into more than one entity. In other words, it "mixes" more than one entity into the interface.

When looking for a property or method to accomplish a task, you can use getInterfaces, showInterface, and showInterfaces to augment the list of properties and methods for any object.

Expression Controllers and Script Controllers

An expression controller allows object properties to be controlled by a mathematical expression. A script controller allows object properties to be controlled by code, allowing more sophisticated control. Each method has its applications, as well as its pros and cons.

With 3ds Max 8, the expression controller has been rewritten and is now exposed to MAXScript via the IExprCtrl interface. The script controller shares the underlying code, and its dialog is now very similar to the expression controller dialog. The script controller is exposed to MAXScript via the IScriptCtrl interface. In addition to the dialog change, the script controller has been significantly enhanced.

Following is a simple example to compare and contrast the two controllers.

1. Enter the following in a new MAXScript Editor window, and evaluate:
   ```
   delete objects
   clearListener()
   objE=box name:"objE"
   objS=box name:"objS" pos:[50,0,0]
   ```

2. Assign a float expression controller to the length property of objE:
   ```
   objECtrl=objE.length.controller=float_expression()
   ```

3. Assign a float script controller to the length property of objS:
   ```
   objSCtrl=objS.length.controller=float_script()
   ```

4. Open the Listener, and evaluate the following:
   ```
   showInterfaces objECtrl
   ```

 Notice there is only one interface, called IExprCtrl.

5. Evaluate the following:
   ```
   showInterfaces objSCtrl
   ```

 Notice there is only one interface, called IScriptCtrl.

 Close inspection shows that each interface shares a number of common methods. These include GetExpression, SetExpression, GetDescription, SetDescription, GetOffset, SetOffset, GetValue, DeleteVariable, RenameVariable, Update, and VariableExists. They also share the property ThrowOnError.

6. Evaluate the following:
   ```
   objECtrl.setExpression "F"
   objSCtrl.setExpression "currentTime"
   ```

7. Play the animation.
 The length equals the frame number. "F" is a special character used in expressions to denote the current frame number. The animation for both boxes is the same.

8. Open a Track View - Curve Editor. Navigate to the length property on objE. Select it, right click, and select Properties to open its dialog. Do the same for objS. Notice the dialogs look very similar.

9. Next, add some randomness to the growth of the box. This requires code. This cannot be accomplished with an expression controller, but is possible with a script controller. Evaluate the following:
```
objSCtrl.setExpression "currentTime + random 0 20"
```

10. Play the animation.
 The final code should look like this:

```
delete objects
clearListener()

objE=box name:"objE"
objS=box name:"objS" pos:[50,0,0]

objECtrl=objE.length.controller=float_expression()
objSCtrl=objS.length.controller=float_script()

showInterfaces objECtrl -- There is one interface: IExprCtrl.
showInterfaces objSCtrl -- There is one interface: IScriptCtrl.

objECtrl.setExpression "F"
objSCtrl.setExpression "currentTime"

objSCtrl.setExpression "currentTime + random 0 20"
```

11. For backward compatibility you can get and set the script controller's script by accessing the `.script` property. For example, to get the script, evaluate:
```
objS.length.controller.script
```

 The Listener returns the following:

```
"currentTime + random 0 20"
```

12. To set the script, evaluate:
```
objSCtrl.script="random -20 20"
```

 The box now 'jitters'.

 This has been a very brief introduction to the topic of expression controllers and script controllers. For more information, see the *MAXScript Reference* Help.

Index